# MEDITATIONS ON
# Vatican Art

*The Deposition of Christ*
Michelangelo Merisi da Caravaggio
Vatican Museums' Pinacoteca
Circa 1600–1604

*Presented to*

_____

*By*

_____

*On*

_____

# MARK HAYDU, LC, STL

## Liguori

LIGUORI, MISSOURI

# DEDICATION

ON THIS YEAR of the thirtieth anniversary of the Patrons of the Arts in the Vatican Museums, I dedicate this book to the patrons, who have not only embraced the responsibility of sustaining the restoration of the vast collection of sacred art under the Holy Father's care but have also supported me in my work and vocation. I am grateful to each and every one for allowing me to accompany you on a part of your journey and making mine that much more beautiful and full of grace.

Imprimi Potest:
Harry Grile, CSsR, Provincial
Denver Province, The Redemptorists

Published by Liguori Publications
Liguori, Missouri 63057

To order, call 800-325-9521
www.liguori.org

**Cataloging-in-Publication Data on file with the Library of Congress**

p ISBN: 978-0-7648-2410-4
e ISBN: 978-0-7648-6871-9

Liguori Publications, a nonprofit corporation, is an apostolate of The Redemptorists. To learn more about The Redemptorists, visit Redemptorists.com.

Printed in the United States of America
17 16 15 14 13 / 5 4 3 2 1
First Edition

# CONTENTS

# ACKNOWLEDGMENTS

I AM PLEASED TO EXPRESS my deepest appreciation to the director of the Vatican Museums, Professor Antonio Paolucci, whose devotion toward preserving the beauty of the Vatican collections and his tireless effort have placed the museums in a renewed international spotlight. That, of course, wouldn't be possible without the able help of Msgr. Paolo Nicolini and Professor Arnold Nesselrath. Thank you for all you do for the patrons!

My particular gratitude goes to the Patrons of the Arts staff, including Gabriella Lalatta, Sara Savoldello, Romina Cometti, Carolina Rea, as well as Anne Williams. Your support went beyond the technical aspects of creating this book. Your faith, fortitude, and patience helped me to stay focused every step of the way. Your humor and kindness kept me joyfully motivated in the heavier moments. Thanks also to Rosanna Di Pinto of the Photographic Archive and Cristina Pantanella of the Vatican Museums library for your expertise and advice.

A very special thank you to the Patrons of the Arts in the Vatican Museums family, especially our chapter leaders and their boards. Your passion for the arts and love for your faith confirm me daily in the amazing opportunity we have to be preserving the most uniquely spiritual collection in the world. Every time I see a person walking through our galleries in wonder, I witness the fruits of your generosity firsthand, and it brings me great joy. You have made this book possible, and I am infinitely grateful for each and every one of you. Msgr. Terry Hogan is always a particularly appreciated support as chaplain of our patrons in the United States, and Lorna Richardson keeps us all organized and growing! May God reward all of you for your kindness. As we all know, it is well beyond any human measure to repay.

These last years have been quite the challenge for my religious family, but with great suffering there can be great growth if it is a suffering with Jesus. I want to thank my legionary superiors and spiritual directors for introducing me into the beauty of the interior life. I followed my vocation with a strong desire to love and serve Christ and his flock as a generous and merciful priest. The Legion and Regnum Christi family has taught me how to do that more than I could have ever hoped. Thank you!

Finally, I first learned to love our Lord in my family. My vocation began with all of you, and if I am able to be faithful, it is thanks to your prayers and support.

# INTRODUCTION

THE YEAR WAS 1991, and I found myself winding through the jungle vegetation growing on the mountains of Guatemala. The rickety school bus billowed out black puffs of diesel exhaust as it labored under the unforgiving weight of cargo and passengers heading from the ancient town of Antigua to the Central American metropolis of Guatemala City. I was aboard the bus with my brother, Keith, and a few other Catholic missionaries from Akron, Ohio, who had come to learn Spanish and experience the culture—something that happened much faster than I would have liked. After we'd had only one week of Spanish studies a Franciscan priest we had befriended convinced us to join his mini-medical mission to the trash dump in downtown Guatemala City. The job would be quite simple, he assured us, one we could surely handle. Our task was merely to direct the dump dwellers toward the medical station for a free medical exam. Upon arrival, armed with a pocket dictionary and some Sacred Heart prayer cards, he pointed my brother in one direction and me in another.

I had never been in a trash dump before, and certainly not one in the Third World. Mountains of trash and debris from the city's refuse service are regularly dropped in this vast empty space. The landfill at one time was outside the city, but as the expansion of buildings and neighborhoods took place it quickly became engulfed by them. Now it is a central area in the city, like Central Park is in New York, but it is anything but a park. The stench permeates the air.

Pools of stagnant rainwater form in the paths that wind around piles of plastic, metal, dirt, and organic waste. Makeshift houses are created from an assortment of cardboard, bedsprings, and pallets. Old pieces of carpet are repurposed as walls, and a patchwork of corrugated metal forms roofs. Pathways wind in no particular direction. On this day the sun was beginning to beat down while steam rose off the surface of the dingy chaotic landscape.

As I took in this desperate sight, I began to question what I was doing and what God had in store for me. Just a year out of high school, I was seriously thinking about the call to the priesthood. Did I have what it took to be a priest? I figured this would push me out of my comfort zone and test my spiritual strength. But after this test, I was beginning to hope I didn't have the call.

Thankfully, this wasn't the first time I had been asked to step out of my comfort zone. Blocking out the natural aversion to this place, I whispered a little prayer: "Lord, you brought me here, so please help me get through this." Armed with valor, I charged into the dump.

After some time I had lost the group, so I decided to climb to the crest of a trash pile to look for them from a higher vantage point. After a few moments I reached the top, but no one was in sight. A little nervous, I started to pray and ask God to help me find the others. Descending from the trash peak, I jogged in another direction and then climbed a little knoll. But again, no one was nearby. After several failed attempts

to find my group, I began to worry. Suddenly I heard a voice next to me say, "If I asked you to stay here, would you stay?" I quickly turned to my right, but no one was there. It was odd to hear a voice speak English so clearly in this primarily Spanish-speaking place, where I found myself quite alone. Though a little curious, my attention turned back to scan the landscape, when once again the same questioning voice jolted me: "If I asked you to stay here, would you stay?" This second time was a bit more disturbing, for I knew there was no one physically present around me. Was God speaking to me? Though I had never heard a voice come from the Lord before, I had often felt the Spirit's gentle nudge in my soul. So I quieted myself and whispered a prayer when the question was posed for a third time, this time with a little different wording: "If I asked you to stay here and serve these people, would you stay?" Though my defenses went up and the call was fresh, through prayer I responded as the prophet had with all the generosity and idealism of a nineteen-year-old: "Here I am Lord, send me."

Although I first thought I was meant to stay in the dump, God led me to finish my missionary year and then to set off on a seminary search to find out where I could be formed as a missionary priest. My parish priest led me to visit the Legionaries of Christ, and it was there I discovered God's place for me. Formation in the seminary was grace-filled, but even so it came with crosses. In time, I was ordained a priest and began my mission work in the Vatican Museums. My desire to help people discover the beauty of hearing God's voice, even amidst the noise and rugged spiritual terrain of this very busy world, has never left me. Wandering the halls of the museums and carrying out my responsibilities as the international coordinator of the Patrons of the Arts in the Vatican Museums makes me ever more

aware of my calling as a missionary. Now I feel I am a missionary of God's beauty within the halls of the Vatican Museums. As I stroll the frescoed galleries and vast collections here, it leads me to question the best method for sharing this loveliness with you.

*Meditations on Vatican Art* will enable you to experience masterpieces from the Vatican while meditating upon them, for most of these sacred art pieces were created for the faithful to pray with more fluidly. Though a priest, my days are spent conserving the vast collections of the Vatican Museums. Taking into account the world population, relatively few people have the chance to visit the Vatican. But even if you have been one of the five million people who visits the Vatican each year, or will be coming soon, this book will enable you to experience these masterworks in a new light. As you pray each day, find a sacred space to meditate and experience the beauty of these treasured masterpieces.

# The Purpose of This Book

There are hundreds of thousands of art pieces collected within the twelve museums that make up the Vatican Museums. How might one select the proper artworks to share? Instead of choosing an author or a medium, I decided to select a spiritual theme and opt for some of the more well-known pieces.

All of us are surrounded by beauty, but learning to see the glory all around us is a real art. Our world is always going, and as we busy ourselves with family life, work, and play, the noises keep us from praying and soaking up the magnificence that God offers us.

In this book, I would like to assist your prayer by directing you to see the beauty that surrounds you. By taking just a few minutes each day to reflect on the

day's meditation, you will slowly learn to raise yourself to God, opening yourself to the good things the Lord has in store for you.

Beauty surrounds us in nature, in the people we serve, in the smallest details shared by someone who loves us, and in the architecture of our cities, towns, and villages. If we learn to look with the eyes of an artist—the eyes of a prayerful wonderer—we can learn to see the love of our Creator at every turn. Let us travel down the simple path of what the ancients called the *Via Pulchritudinis* (Way of Beauty). The whole world can become a pathway to God. Both our interior and exterior senses are often in need of purification, and there is no better way than through the fire of divine beauty.

## The Spiritual Exercises

At the end of the first summer I spent in the seminary, my fellow seminarians and I spent eight days in silence and reflection with a retreat method called the Spiritual Exercises. St. Ignatius of Loyola, a Spanish saint, founded the Jesuits, an order in the Catholic Church also known as the Society of Jesus. This retreat that I now repeat every year has been a source of great peace and interior freedom that always deepens my prayer life.

But the Spiritual Exercises do take time to experience. Many lay people do not have the time to break away for thirty days to enter into silence and prayer, for St. Ignatius originally intended the exercises to be thirty days of complete silence. Still, over the years these exercises have broken into other more manageable forms that now allow one to attend eight-, five-, or even three-day retreats. The experience can be quite transformative, so seize the moment if

ever you have a chance to participate in the Spiritual Exercises.

*Meditations on Vatican Art* will enable the faithful to experience the Spiritual Exercises for fifteen to thirty minutes each day as participants pray with sacred works of art from the Vatican Museums. Taking time to meditate or reflect upon a piece of sacred art while focusing on the Spiritual Exercises will grace and transform your day.

The Spiritual Exercises were composed in the context of chivalry, kings, castles, and battles to be fought and won. Essentially they were inspired by the circumstances surrounding St. Ignatius' life (1491–1556). Yet they have a universal appeal, as they relate well to the experiences that surround the life of all human beings. They particularly relate to our spiritual lives, for there is always a battle to be fought in the world—but we can be comforted to know that God is fighting for us.

In the middle of the third century, St. Anthony fled into the desert to become holy and avoid the temptations of city life. But the temptations followed him into the desert. In fact, there is a lovely fresco painting in the Borgia Apartments created by Pinturicchio where the artist depicts St. Anthony being tempted in the desert. The obvious message to the pope was that St. Anthony, just like the pope and each of us, couldn't run from the battle, for it follows us wherever we go.

There is something beautiful about the battle that should inspire us, though, for it allows us a chance at heroism, chivalry, and the truest form of happiness, namely, holiness. The point of the exercises is just that: to help us as we learn the path of holiness. Even if you are just beginning to tap into life in the Spirit, the simplicity of these exercises will enable you to feel confident that God is with you and wants you to be a

part of his eternal family. By progressively reflecting on the truths St. Ignatius proposes in his exercises, we are led onto the path of conversion.

## Spiritual Truths and the Beauty of Art

Beauty makes the truth more palatable, as honey might help us take our medicine properly. Following the structure of the Spiritual Exercises, these meditations are intended to draw us closer to Jesus.

The first section focuses on foundational truths sustained by the Creator, who gives us all good things. In section two we will look at our response to God's creative love. The third section reflects upon the life of Christ and the supreme example of his love for us. This love culminates in the fourth section with Jesus' passion and death. The final section and last day of this retreat enables us to enter the new and eternal day of resurrection—the hope of all who believe Jesus is the way to God.

## How to Use This Book

Find a time within your daily routine that will enable you spend fifteen to thirty minutes with God. Consider going to your local adoration chapel or parish, find a prayer chair in your own home, or select an outdoor nature setting that leads you to prayer easily.

Each reflection is intended to lead you into prayer and meditation. Begin by placing yourself in the presence of God, asking the Lord to be with you and speak to you. Praise, bless, and thank the Lord for all the good you have been blessed to receive. Focus on God, an action that will release you from your daily concerns and activities and draw you to contemplate

the beauty of the Blessed Trinity, tuning you toward what the Lord is speaking to your heart.

Each day features the work of art, its name, the artist, where the piece is located, and when it was created. The meditations begin with a brief explanation on the piece of art and the artist in order to familiarize you with the period and context wherein the masterpiece originated. It is not intended to be a full art history lesson but rather a springboard for understanding the piece of art along with the meditation for the day.

On each day, a theme and a focus for the meditation are provided. The focus will help you assimilate the motif of that day's prayer while connecting it to the whole retreat. This focus also relates to the Scripture passage and work of art and so will be a natural preparation for reflecting on both.

Scripture is provided to focus your prayer, allowing the word of God to nurture your heart as you prepare to reflect on it. Furthermore, the Ignatian Spiritual Exercises were built around God's progressive self-revelation through Scripture. Read through each Scripture passage with an open heart and mind. Composition of place in the Spiritual Exercises is a method that enables those praying to imagine the scene by using the senses of sight, touch, smell, taste, and hearing. If you are touched by a word, passage, or your imagination of the scene, spend some time in conversation with the Lord about it.

The notion of sacred artwork and contemplation is often lost on us in a digital age where images constantly bombard our cultures. However, traditional Catholic mental prayer focuses our senses to enable us to see what is beyond the physical realm. In fact, liturgical and sacred art were intended to lead the soul to contemplate the spiritual truths that were painted or sculpted therein. Still, distractions challenge our prayer, often

invading our hearts and minds when we set aside time to pray. Allowing our eyes to see the beauty created by each artist will assist our prayer by engaging our sense of sight, a powerful gift for understanding the goodness of God. As our culture is animated by the senses, we must fine-tune them to know the things of God.

As you contemplate each piece of art, let your eyes wander naturally to where the color and form take them. If you find that too much is happening in a piece of art and it is distracting, allow yourself to focus on just one aspect or detail. At times fixing on one element can anchor you in the whole piece, allowing you to then assimilate the whole work little by little. This same practice can also be applied to reading the Scripture passage. By reading slowly and letting each word speak to you, the whole passage can take on greater meaning.

## The Meditation

The written meditations will help you focus on details portrayed by the artist while pulling out a spiritual aspect of the art piece or Scripture passage selected for that day. Let the meditation guide your thoughts and prayers. Read it calmly and take time to reflect as the Spirit moves your heart. Like art, prayer has its own rhythm. Open your heart and let the Holy Spirit lead you.

A short prayer, questions for reflection, and a Spiritual Exercise at the end of the meditation will enable one to move spiritually. Athletes know that preparing for competition includes exercise, stretching, practice, and training for the event to come. The spiritual life is no different, for our prayer should draw us closer to God and one another. If we do not train and prepare, are we really able to live the life that God has called us into—one of peace, joy, and fullness?

## Setting Sail

The effort we put into our prayer can be likened to that of a sailor who takes his sail boat out to sea. The sailor raises the mast, directs it toward the wind, and applies the rules of sailing. Yet can the sailor produce the wind? Even the most advanced sailor will not go far without a breeze. The power to be moved in prayer comes from the grace of God. We must will God to move in us by doing our part, but the Spirit is the one who enlivens our prayer.

So now let us raise our sails and allow the Holy Spirit to lead us through these Spiritual Exercises. God wants to move us, open our minds, soften our wills, and enthuse our spirits. Therefore, the art, Scripture, and meditations that follow serve as a point of departure each day. As you pray and talk with God, allow the Spirit to inspire you with certain thoughts of praise, thanksgiving, intercession, repentance, abandonment, and trust. And may the images and meditations enable the Spirit to move and lead you on your own journey to God.

# ENCOUNTERING GOD'S LOVE

IN EVERY NEW BEGINNING there is a goal in mind, that is, something we wish to attain. The goal for this first phase of our Spiritual Exercises is to guide us deeper into the personal conviction that we are God's creatures, immensely loved by our Creator and Father.

This truth becomes a foundational principle on which to build our lives. We are often so governed by fear that we group God among those persons or experiences to be feared. We generally prefer to control our lives by offering God the wonderful (or maybe not so attractive) results of our efforts.

And so we begin our retreat today by meditating on the nature of our triune God's supreme authority and providence. We will also ponder the fact that we are creatures who God freely chose to bring into existence. Our lives have meaning, purpose, and value because God Almighty loves us and has willed us from all eternity. Not only did God create us, but as our meditations will reflect upon during this section, our Lord did so with a concrete mission in mind.

God has a plan for our lives, and our happiness depends on our willingness to fulfill this mission by doing the best we can to follow the will of the Lord in small and great ways. *Go forth, go into the world and realize something beautiful for yourself and for me*, God tells us. And he offers us his will and his constant presence to guide us on our way. For God's love is like that of a parent who finds joy when his or her child flourishes.

As any parent knows, we are not alone in this walk through life. There are plenty of distractions along the way. Still, God has created many creatures—both material and spiritual, and they can aid us on our path to our Creator. Learn to marvel at the beauty of creatures and respect their power. Inasmuch as each creature helps us to reach our final heavenly destination, we can use them to help us on our journey.

Life is a unique gift granted to us once. Our freedom is beautifully powerful. The most difficult and amazing challenge for us is to surrender ourselves to God's love, willing ourselves to choose his will every moment until we are finally united to the Lord in a loving embrace.

We have now come full circle, for God was in heaven before creation, but then he created you and me. Out of love, God created us in order to love him in this life and eventually return, wholly his children, back to the house of the Father. So let's begin and encounter God through beauty.

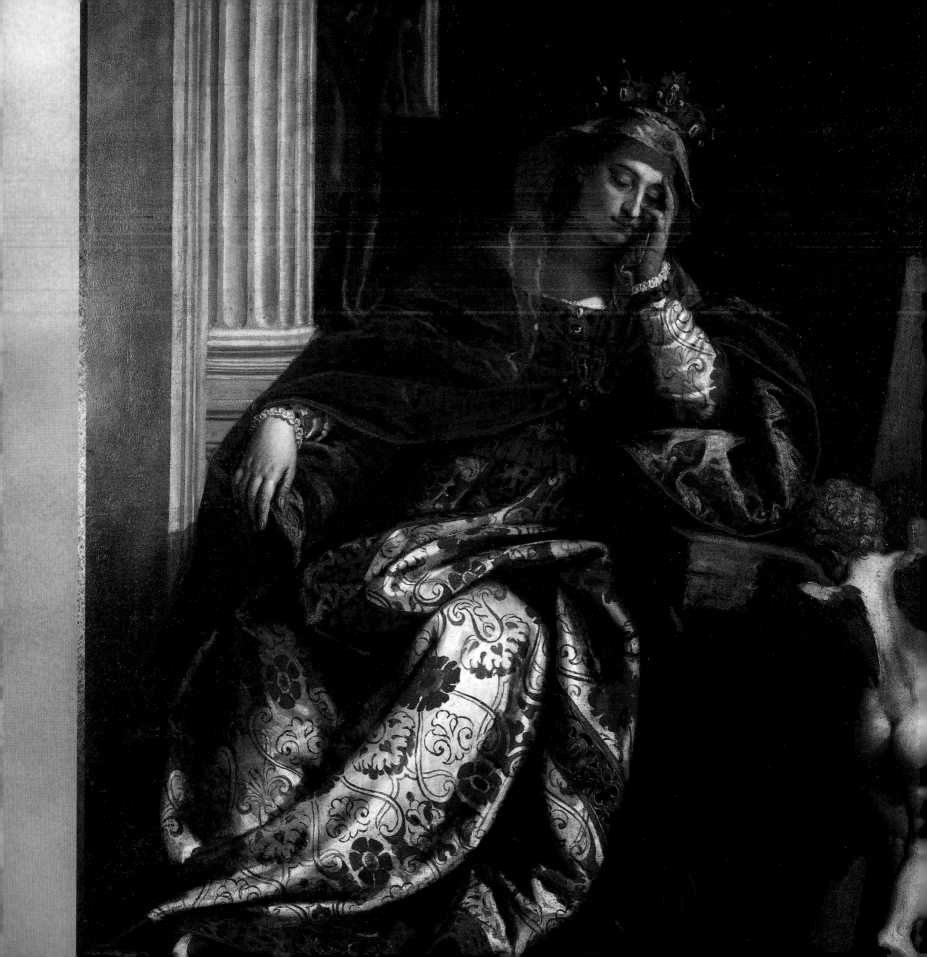

# DAY 1

# VISION OF ST. HELENA

Paolo Veronese
Vatican Museums' Pinacoteca
Circa 1580

**THEME:** Treasures that last

**FOCUS OF THIS MEDITATION:** Every moment is an invitation to allow God to enter our lives more fully. In this meditation we will prepare our hearts to let God enter us in a new way as we divert our sight from the treasures of this world to treasures that never perish.

◀ In *Vision of St. Helena*, the Venetian painter Paolo Veronese captures the recently converted St. Helena. Veronese depicts St. Helena with a vision of the cross presented to her by a delicate putti. Helena was the mother of Roman Emperor Constantine. She was said to have followed this vision to Palestine where she was able to locate the relic and return home with it.

Veronese depicts the saint as he would depict a great mythical beauty—a woman who serenely received her divine vision. Portrayed in a secular space and draped in heavy, luxurious fabrics, the faith of the saint is illustrated in a very personal way, directing all attention to the holy revelation she is experiencing.

# SCRIPTURE MEDITATION

## MATTHEW 6:19–21

*Do not store up for yourselves treasures on earth,*
*where moth and decay destroy, and thieves break in and steal.*

*But store up treasures in heaven, where neither moth nor decay destroys,*
*nor thieves break in and steal.*

*For where your treasure is, there also will your heart be.*

## MATTHEW 13:44–46

*The kingdom of heaven is like a treasure buried in a field, which a person finds and hides again,*
*and out of joy goes and sells all that he has and buys that field.*

*Again, the kingdom of heaven is like a merchant searching for fine pearls.*

*When he finds a pearl of great price, he goes and sells all that he has and buys it.*

This richly decorated portrait of St. Helena immediately draws us into a very personal and intimate experience of prayer. St. Helena, a woman of humble background from Moesia, near the Black Sea, became the wife of the Roman Emperor Constantius. Historically, her conversion was a rags-to-riches experience as she went from being an innkeeper's daughter to catching the eye of the most powerful man on earth—so sublime was her beauty.

We know St. Helena was a fervent Christian, and history assures us she was active in building churches in both Jerusalem and Bethlehem. Tradition holds that, while clearing the hill of the Holy Sepulchre, she found the relics of the cross on which our Lord was crucified. And Veronese captures St. Helena by portraying her like a Roman goddess in the majestic moment that she received her vision of the cross.

Notice and regard the beauty of the rich Eastern fabrics with woven prints and royal colors along with the gold and blue details of her dress. Likewise the velour of her crimson cape broached under her chin denote the luxury and wealth that her position afforded. She rests on a high-back leather throne while the two armrests provide a comfortable support on which to lean her right hand and left elbow. An elegant textile wall covering provides a background from floor to ceiling.

The softly flowing fabrics and her serene posture invite a certain calm in us and focus our attention on her tranquil face and spirit of prayerful contemplation. No matter the power, wealth, and beauty of the imperial world that surrounds her, she has forsaken all to contemplate the love of Jesus in the mystery of the cross. This painting offers a whole interpretation of what the life of St. Helena exuded and what our moments of prayer in these Spiritual Exercises are intended to be.

Carving out some quiet time each day to be with Jesus amidst the busyness of our lives is necessary if we wish to discover divine treasures. Our hearts can so easily be distracted by the alluring riches of this world. As Christians, we need alone time with Christ to contemplate the value of all things in the light of his redemptive love on the cross. Contact with God in prayer helps us remember that our treasure is not found in the trappings of the upper class but in the glorious vestment of baptismal grace that Jesus won for us. God has adopted us as sons and daughters of the king through our baptism. Like St. Helena, we have become poor commoners raised to

royalty. Spend time thanking God for the gift of life in Christ and allow your heart to follow the inspirations that our Lord shares with you.

Shift your attention to the face of St. Helena. Aside from her prayerful spirit, we can also see a tinge of sadness or dissatisfaction on her brow. What might be weighing on her, leaving her empty  in some way? What might Veronese be hiding in that mysterious distant look? It could be that the young putti represents her child Constantine, who some day will embrace the power of the cross but as yet has not. Perhaps she suffers knowing that her child's empire is far from the love of Christ on the cross. Or might it be a reflection of the interior struggle one often finds in prayer, though at the same time we experience great graces. No matter the cause, Helena's face records the notion that prayer and the Christian life always have an element of effort, of ideals not fully realized. Though prayer nourishes in us a taste of heaven on earth—it is merely that, only a taste. We are not yet in our celestial home, and so we long for that kingdom in the distance.

Now regard the placement of the cross in the lower right-hand corner. It almost seems as if Helena is leaning on the cross. Love and mercy, depicted here by the cross, give us a firm foundation on which to build. Can you lean on these truths and rest in them? It is the cross that sustains us when we are weak and can lead us to consolation when we are weary.

Imitate the prayerful spirit of St. Helena communicated by Veronese and turn to Christ in your heart, leaning upon him for respite. Silence your interior world, your memory, your thoughts, and your passions. This is a time for silent contemplation as you let the light of Christ into your heart and soul.

Veronese wished to express the symbol that marked St. Helena's life. If an artist were to paint you, what symbol would he or she use to sketch a portrait of your life? Take a few moments to consider some images that connect and convey your life in relationship to our Lord Jesus.

How do you want others to see your life in Christ? Your life is a gift of the Holy Spirit. Inspired by the Spirit, you can direct the movements of your soul and choose actions in this life, painting a portrait for others to see.

# PRAYER AND REFLECTION

Lord Jesus, it is not easy to endure the cross in our day-to-day lives. We are often weighed down by tragedy, the humdrum of life, injustices large and small, and a multitude of distractions that keep us from seeing you clearly. Help us to meet you today, Lord, as we seek the treasure only you can give. Gift us with wisdom while we make this retreat to embrace you more fully as we learn to trust in your divine love for us. Amen.

- What do you expect to glean from these days of prayer? Concretely name a few needs (spiritual, physical, emotional, etc.) God can assist you with on this retreat.

- Where is your heart today? Do you desire God's kingdom above earthly riches? What heavenly treasures can you be watching for in these upcoming days and weeks?

- Regard *Vision of St. Helena*. How does her contemplation help you see the face of God? In what way does her interior glimpse of God's beauty invite you into prayer?

- What are some blessings that God has given you today? How might you use these blessings, whether large or small, to build God's kingdom on earth today?

## Spiritual Exercise

- Spend time in silence while reflecting on God's presence and Christ's abundant spiritual treasures during the gaps in your day rather than filling them with noise (smart phones, music, television, and the like).

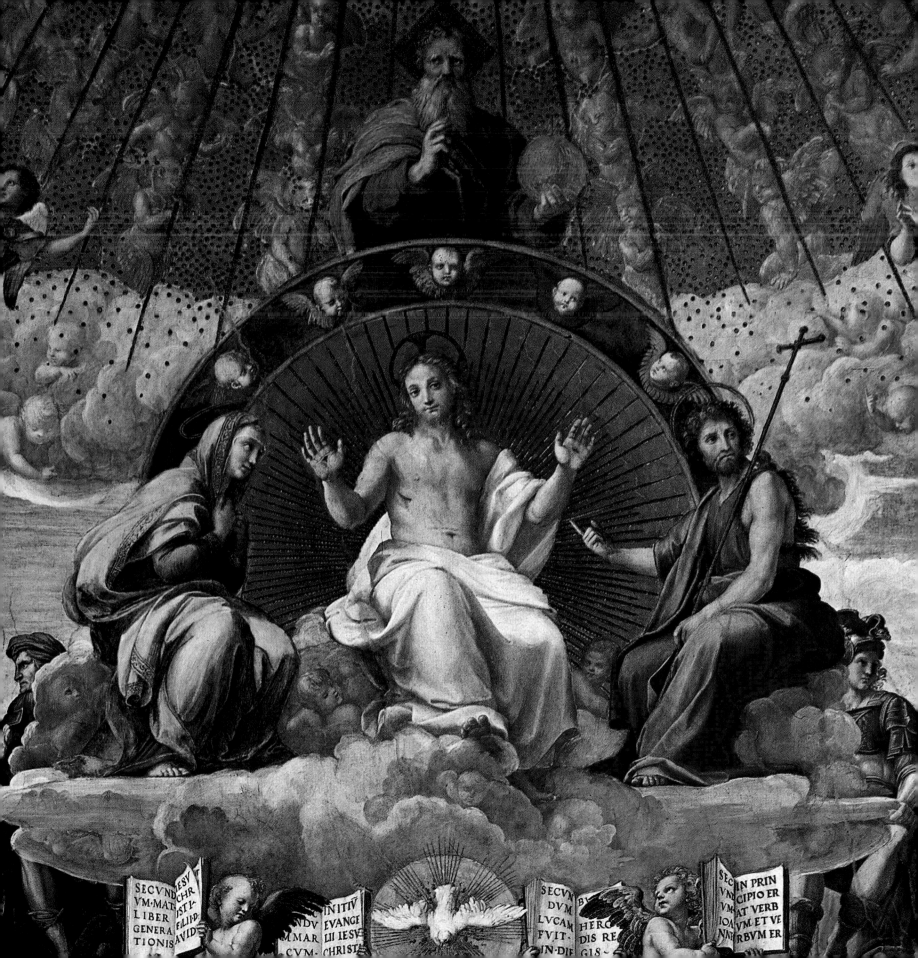

# THE DISPUTATION OF THE HOLY SACRAMENT (*LA DISPUTA*)

Raphael Sanzio
Room of the Signature, Raphael Rooms
Circa 1508

**THEME:** The nature of God

**FOCUS OF THIS MEDITATION:** God is the beginning and the end and holds all things in his providential and loving embrace. We desire to acknowledge, honor, and rest in God's life and authority.

◄ The Room of the Signature was one of the four rooms Raphael painted for Julius II. This urbanite painter illustrates on four walls the great fields of study comprehended during the Renaissance: theology, philosophy, the arts, and the moral virtues. This room was originally a study that housed the library of Julius II. It was also where the Signatura of Grace tribunal, the council chamber for the Apostolic Signatura, took place. At the time, most of the important papal documents were signed and sealed in the Room of the Signature. The overarching themes of this piece demonstrate the unity of antiquity and Christianity, and at the same time they show philosophy and theology coexisting peacefully.

*The Disputation of the Holy Sacrament* is the first of the sixteen frescoed walls completed by Raphael in the Papal Apartments. In this painting dedicated to theology, Raphael visualizes a theological conversation around the theme of the Eucharist. The heavenly court is shown seated upon the clouds, while theologians and pastors talk on earth below. In the heavens, Raphael captures the essence of our peaceful, omnipotent God, who reigns over all of human history.

In descending order, the artist features the triune God. God the Father is seen crowning the composition. The Son, who was sent by the Father, is clothed in regal white and enthroned upon the clouds. And the Holy Spirit, sent by the Father and Son, leads us into all truth. Here Raphael employs the muted colors typical of the late sixteenth century, giving a certain sense of peace and solemnity to God who sits as judge and Father—all fitting themes for a room where the popes exercised their temporal authority in a particular way.

# SCRIPTURE MEDITATION

## GENESIS 1:1–2

*In the beginning, when God created the heavens and the earth—*

*and the earth was without form or shape, with darkness over the abyss and a mighty wind sweeping over the waters—*

## JOHN 1:1–5

*In the beginning was the Word,*
*and the Word was with God,*
*and the Word was God.*

*He was in the beginning with God.*

*All things came to be through him,*
*and without him nothing came to be.*
*What came to be*

*through him was life,*
*and this life was the light of the human race;*

*the light shines in the darkness,*
*and the darkness has not overcome it.*

As you begin to enter into prayer, place yourself in God's presence and let your mind and heart focus on the triune Godhead—the Father, Son, and Holy Spirit. Offer prayers of faith, hope, love, gratitude, and humility as a way to enter more deeply into the presence of God. Once your soul is in God's presence, try to imagine what the world was like before anything was created, when God was alone as the Blessed Trinity, before the first days of creation.

Although all things change, God never changes. Our Lord is a rock—solid, faithful, and still—the point of the pendulum from which all things hang and are supported. God is the Alpha and the Omega, the beginning and the end of all human history.

The serene and wise countenance of the Holy Trinity oversees all things. God justly controls the whole universe, wisely governing authoritatively with his mighty hand to assure purpose for all. God is who is, and therefore his decisions are neither arbitrary nor swayed by public opinion. The Lord is not in need of our affirmation, but he desires our worship, for he knows that we need him to be fully human and happy.

Regard how God holds the sphere of the world in this painting, how it rests secure. Yet God does not exercise his absolute authority with disinterest or indifference. On the contrary, the Lord lovingly takes interest in everything. Nothing is unimportant—from the greatest events on earth to the smallest minutia of our day. If it is important to us, it is important to God, who keeps all in balance with a providential hand.

Notice the title of this painting by Raphael is the *Disputa* (*Discussion*). In the lower register, a virtual theological hall of fame is viewed discussing the eucharistic doctrine on earth while their biblical counterparts of prophets and patriarchs chime in from heaven. Horizontal dramas of earth are balanced by the horizon of heaven while the divine vertically aligns and inspires all in order to unite each part to the whole—the Blessed Trinity.

What arguments or disputes do you have with God and the people of God? Take a moment to pray about the dramas present in your life and meditate on how God the Father, Son, and Holy

Spirit are present in difficult moments to assist and guide you. Then ask for the grace to see God's divine hand more clearly.

God rules all that is seen and unseen. Every human discussion and all truths that God speaks and shares are made one in Jesus Christ, the eternal Word of the Father. It is this same Christ who is present on the altar of sacrifice at every Mass. Though all may seem like discord, there is harmony. God's plan is emerging in what may seem like chaos to us. For God is the Lord of history—and the Lord of history has made each of us a part of the story.

It was common in Christian iconography to represent the Godhead as a triangle with the all-seeing eye in the center, often with rays of glory shining forth. Yet in this painting Raphael

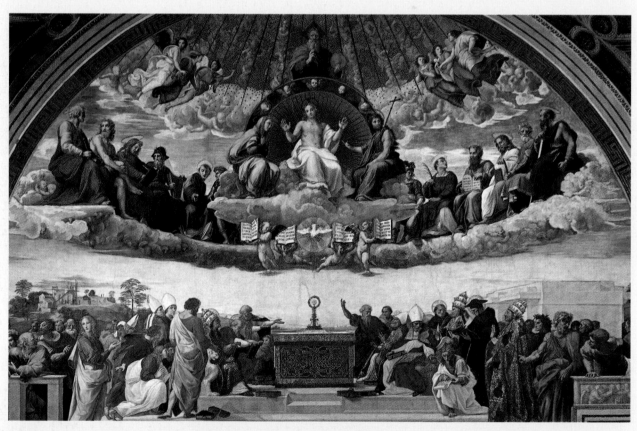

▲ Notice the title of this painting by Raphael is the *Disputa* (*Discussion*). In the lower register, a virtual theological hall of fame is viewed discussing the eucharistic doctrine on earth while their biblical counterparts of prophets and patriarchs chime in from heaven. Horizontal dramas of earth are balanced by the horizon of heaven while the divine vertically aligns and inspires all in order to unite each part to the whole—the Blessed Trinity.

chooses to make it much more personal—more real—by depicting the three persons of the Trinity. The triune God is an eternal relationship of love, a divine family where the Father is over all and in all. The Son is sent from the Father into the world through the Virgin Mary who adores him among the heavenly hosts in this fresco. Likewise in this image, John the Baptist, the precursor who announced Jesus' ministry, gestures toward Jesus as if to proclaim to us, "Behold the Lamb of God, who takes away the sins of the world." The Holy Spirit is represented here as the dove, the peacemaker and Sanctifier who leads us into all truth.

God is personal, not merely an idea or a mental criterion for moral choosing. God is one, and yet there are three divine persons, each of them active in each of our lives. Though the Trinity is always with us in moments of prayer such as this one, God is particularly active in helping us understand his ways. God is leading us, Christ is saving us, and the Holy Spirit inspires and sanctifies us when we allow the Lord to move us through prayer.

God the Father has sent the Son, a meditation topic we will focus on later in these Spiritual Exercises, but it is still important for us to recall even now. Scripture tells us, "In the beginning was the Word, and the Word was with God, and the Word was God." Jesus is the eternal Word of the Father, the one who has triumphed over all things. The darkness has not overcome the light, though it appears as if all is dreary. The powers of this world still try to thwart God's glory, as Jesus' "overcoming" came at a price. The wounds of Jesus' hands, depicted in this piece of art, are held up as signs of conquest and of victory. Likewise, the crosses—or the struggles in each of our lives—do not escape God's sight. Though we sometimes feel defeated by loss and sorrow, God stands victorious over human history and can change our lot—deriving victory from agony.

In these few remaining moments of prayer, consider the movement of your heart and the ideas related in this meditation that most moved you. Feel free to return to the words that gave you the most peace and led to the strongest convictions.

Now ask God to illumine and remedy the situations in your life that are most in need of our Lord's presence and healing touch so that his personal plan for you will continue to take shape. Spend a few moments thanking God for these moments of prayer as well as the blessings in your life, and then make a resolution today to allow God to enter more deeply into your heart.

# PRAYER AND REFLECTION

God you are all powerful. All things belong to you and nothing escapes your dominion or knowledge. Every aspect of our lives is known to you. You care for and govern over all. Father, Son, and Holy Spirit, we abandon ourselves to your power and providence. Amen.

- How do you relate to the Blessed Trinity? Consider the role of each person—Father, Son, and Holy Spirit—in your daily life and thank God for their eternal love for you.

- What arguments, or disputes, are taking place in your prayer and active life today? Ask God to illumine these struggles, bringing clarity so you might glimpse God's victory through the cross into resurrected glory.

- Meditate on *The Disputation of the Holy Sacrament*. What is most striking to you? Can you see yourself and all of salvation history being transformed by the light of God?

- How has God shone victorious in your life? Make a list of instances where, over time, God has helped you heal in relationship to others, resolving struggles that you endured for a time.

- What areas of your life still need clarity and prayer? Pray once more an act of faith, that God might help you trust in his divine will for you today.

## Spiritual Exercise

- Offer your concerns and stresses to God in order to find clarity and peace. Take control of these moments by letting them go to the Lord. Frequently repeat these words: Father, Son, and Holy Spirit, I trust in you!

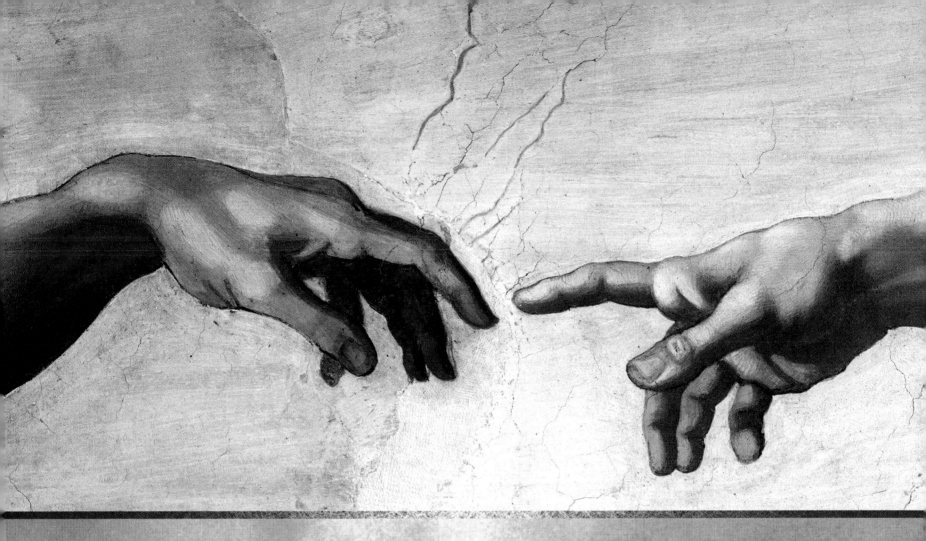

# CREATION OF ADAM

Michelangelo Buonarroti
Sistine Chapel ceiling
Circa 1510–1511

**THEME:** God's kingdom come!

**FOCUS OF THIS MEDITATION:** You are God's creature, a special masterpiece, unique and irreplaceable.

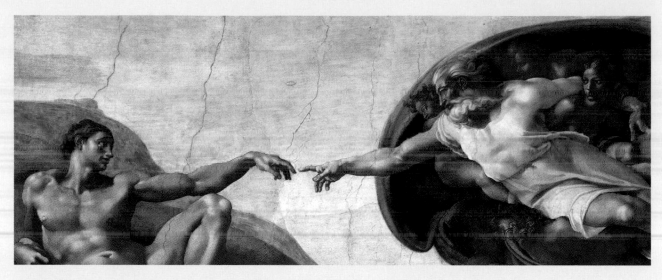

▲ Pope Julius II called on the great artist Michelangelo to decorate the ceiling of the Sistine Chapel—a work that consumed four years of his life, from 1508 until its completion in 1512.

In his initial design for the ceiling, Michelangelo envisioned painting the twelve apostles. However, Michelangelo understood that such a large space would require more figures. His genius as a sculptor propelled him to bring architectural form to the large empty space by painting a structure of faux or artificial pinnacles, ledges, and beams. Then he populated the resulting spaces with the seven days of creation, prophets, sibyls or prophetesses, decorative nudes, and large circular spaces called medallions.

The result was the very first decorative ceiling narration ever created in a church. Each year, more than five million people come to see the amazing result of Michelangelo's dedicated brilliance. Today, as then, the popes are elected under its protection.

# SCRIPTURE MEDITATION

### JEREMIAH 1:5

*Before I formed you in the womb I knew you,*
*before you were born I dedicated you,*
*a prophet to the nations I appointed you.*

### PSALM 139:13–14

*You formed my inmost being;*
*you knit me in my mother's womb.*

*I praise you, because I am wonderfully made;*
*wonderful are your works!*
*My very self you know.*

*Our Creator's powerful and purposeful hand
reached out and lifted you into existence,
just as you are.*

---

As Michelangelo approached the central point of his painting of the Sistine Chapel ceiling, he found himself meditating on the very focus of our prayer for today—creation. Where did we come from? Do our lives have a plan or purpose? If so, what is it exactly?

Michelangelo's answer is as elegant and powerful as the hands he joins at the center of his spectacular creation cycle in this masterpiece, one of the most iconic images of creation.

Our lives begin very simply. God and us; his hand and ours. Although we were not there at this momentous beginning, we can go there in our minds. There was a time when you and I did not exist. When humanity did not exist. Only God and all things in him existed. Then, in one dynamic moment, in an instant of creative love, God called humanity into existence. God is creating us still, for the Lord called you into existence when you were conceived in the womb of your mother: "Let us make human beings in our image" (Genesis 1:26). You and I are not the result of a cosmic coincidence or a chain of spontaneous chemical reactions. We began at the hand of a loving and purposeful God.

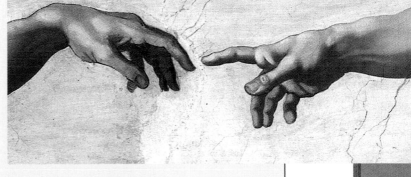

Michelangelo's painting shows the movement of God's divine hand—strong, skilled, purposeful, and intelligent—the hand of a sculptor or a craftsman. It is the hand of someone with a plan. In contrast, Adam's hand is limp and lifeless—yet poised to receive the same nature as the hand it images.

God willed you. God wants you. You are who you are because God's infinite love created you as a totally unique and divinely made human being. Our Creator's powerful and purposeful hand reached out and lifted you into existence, just as you are.

Yet our creation is not merely something of the past, it is a reality that touches us now. God holds us and sustains us in every moment of our life. In every breath and every move, God is with each one of us. No present circumstances, past pains, or future unknowns can change that we came from and are constantly held in God's almighty and providential hand.

Michelangelo hides another secret about our creation in this image. Look between God and Adam's fingers. What do you find? There is simply a space. A space of freedom. God created each of us to freely choose him or not. In the very act of creation, God opened himself to possible rejection, allowing reciprocation of his love to be free. This means that God opened himself to the possibility that we may not love him back.

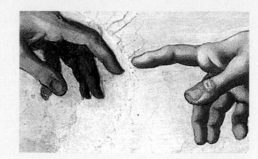

No matter what choices you have made about God in the past, here you are. You have chosen to love our Lord by making this retreat now. Even in prayer, there are no coincidences. God is speaking. Do you hear his melodious voice calling you, speaking to you?

Continue to sit in God's presence while regarding this image, paying particular attention to the hands that began creation in Michelangelo's work. Absorb the truths that God wants to speak to you. And talk to God in prayer, perhaps whispering, "I came from you, live in you, and am going to you. I am yours, you are mine. You have created me with infinite love. Thank you. Life in you is the first and greatest gift you have given me."

# PRAYER AND REFLECTION

God, I came from you, live in you, and am going to you. I am yours, you are mine. Amen.

⚜ Do you see your life as a gift from God? What positive or negative events have influenced your understanding of life, particularly your own, as a gift?

⚜ How is God's creative and loving hand present in your life now? Where do you need the Lord's presence more?

⚜ How have you used the freedom God has given you? Do you use it to come closer to God?

## ～ *Spiritual Exercise* ～

⚜ Call your parents to thank them for the gift of life and the sacrifices they have made for you.

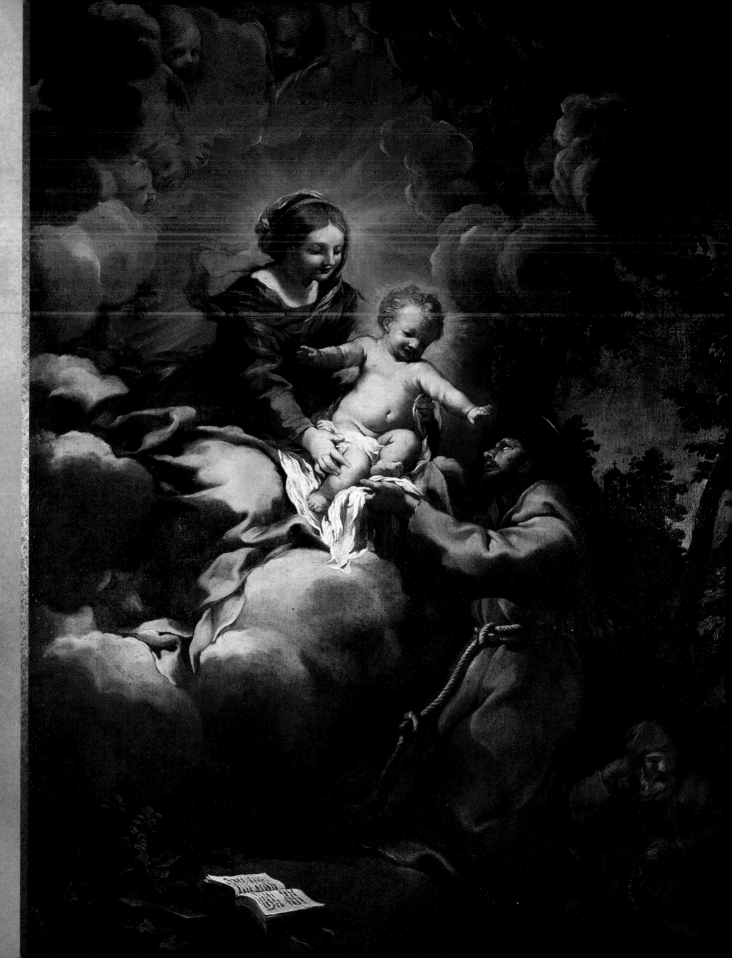

Baroque painter Pietro da Cortona (1596–1669) was born Pietro Berrettini but is primarily known by the name of his native town of Cortona, which is in the Grand Duchy of Tuscany. The best-known Baroque artist during his lifetime, Cortona was a major figure in Roman Baroque architecture and was also a key designer of interior decorations.

Rome and Florence were his bases of operation. He is most famous for his frescoed ceilings, including the main salon of the Palazzo Barberini in Rome. He also did considerable painting and decorating in Florence and for the Oratorian fathers in Rome.

In the years after painting Vision of St. Francis around 1641, Cortona worked on frescoes in the Oratorian Chiesa Nuova in Rome, which were finished in 1665, four years before his death. Toward the end of his life he focused on architecture, such as his famous façade and courtyard project at Santa Maria della Pace. He died in Rome.

# DAY 4

# VISION OF ST. FRANCIS

Pietro da Cortona
Vatican Museums' Pinacoteca
Circa 1641

**THEME:** God created us for a mission

**FOCUS OF THIS MEDITATION:** By fulfilling our unique role in God's plan, we hope to recognize and embrace our individual paths to heaven endowed with the theological virtues—faith, hope, and love.

◀ In this iconic Italian Baroque painting, Pietro da Cortona depicts the vision of St. Francis with identifiable drama in his unique combination of chiaroscuro (strong contrasts of dark and light) and pops of color.

Cortona arrived in Rome in 1612 and was fortunate to receive many prominent commissions in the following years. He would later become the head the Academy of St. Luke from 1634–1638, where he was known to have argued with Andrea Sacchi about the value of the beauty of art in itself quite aside from its functional purpose of communicating a specific message.

Painted at the height of his career, Cortona has created here a quiet, almost personal scene with engaged bodies and light, rather than the heavy tenebrism (violent contrasts of darkness and light) he would come to apply later on in his life.

# SCRIPTURE MEDITATION

## MARK 10:17–22

*As he was setting out on a journey, a man ran up, knelt down before him, and asked him, "Good teacher, what must I do to inherit eternal life?"*

*Jesus answered him, "Why do you call me good? No one is good but God alone.*

*You know the commandments: 'You shall not kill; you shall not commit adultery; you shall not steal; you shall not bear false witness; you shall not defraud; honor your father and your mother.'"*

*He replied and said to him, "Teacher, all of these I have observed from my youth."*

*Jesus, looking at him, loved him and said to him, "You are lacking in one thing. Go, sell what you have, and give to [the] poor and you will have treasure in heaven; then come, follow me."*

*At that statement his face fell, and he went away sad, for he had many possessions.*

In the last meditation, we reflected on how God created each of us out of love. And now we will concentrate our efforts on understanding God's purpose for creating us. What is our purpose and what prompted God to create each of us? The answer is simple—God has created us for heaven. You have one goal, one dream, and one destiny: to be with God, who loves you for all eternity in heaven. God created you out of love simply because he desired to. You are totally lovable because you exist—you are a creation of God. Full stop. No other reason. And because God is in love with you, he simply wants to be with you forever in paradise.

As heaven is our destiny, getting to heaven should be our most important goal in life, for it will be the only thing of interest to us at the end of our journey here on earth. Therefore, obtaining

heaven should be what concerns each of us more than anything else today. We only have one life and one chance to share our gifts with God and others. Each day we are given a chance to embrace more fully this heavenly goal.

St. Francis of Assisi understood the riches of heavenly glory, as he forsook all the earthly treasures that his affluent family offered him—choosing the path of poverty and abandoning all earthly loves to attain that one divine and eternal love. And since he was the founder of the Franciscan family of religious men and women, the wealth of his poverty is still paying dividends. In this gorgeous image by Pietro da Cortona, we view all the splendor of our heavenly treasure, Jesus Christ, set amid a luminous cloud of glory. Our Lord Jesus is the pearl hidden in the field that is worth selling everything to obtain. The worldly treasures that weighed on the heart of the rich young man in the Gospel we just read were nothing compared to the treasure Jesus offers.

In the center of the painting, we see St. Francis reaching out to take the Child from Mary's hands. His left hand nestles under the Infant's left foot while his devoted and anticipatory gaze awaits the reaction of the Child. Francis is a mirror of our prayer. Like us, he has so little to offer but everything to gain. Jesus, a plump and tender little Child, extends his left hand, reaching out in expectant reception of St. Francis' embrace. This act is symbolic of Christ's Incarnation, in which he leaves his heavenly throne in order to come among all people. Furthermore, it represents how Christ longs to reach out to us in prayer by coming into our hearts and abiding there with his light and love. Take a few moments to express how much you desire to take Jesus into your heart. In words and with sincere sentiments, tell our Lord how you wish to take him into your life and embrace him in new and more intimate ways.

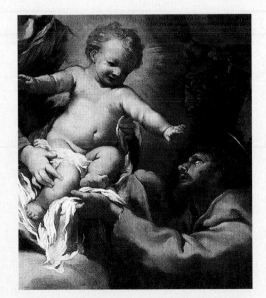

Surrounding the central figures of the painting, you might also notice the darkness that encircles Francis, Mary, and the Infant Jesus. This technique serves to set off with greater contrast

the warm dialogue between Jesus and Francis; at the same time it also helps us to see the outer world in which Francis exists and to which he must return. The darkness begs to know the light.

Francis' mission was to help the world know once more the Savior many seemed to have forgotten. Like each one of us, Francis lived his life amidst the tensions of darkness and light. We perceive almost a visible bridge between Jesus and both his brother monk impatiently waiting below and the wilderness of the world that expands off into the cold blue horizon; a reality that is also true for each of us.

God has created each of us as a beacon of light for the world to see. You were not made merely to be with God forever, nor to pray in this moment—though both of these realities are pertinent for a full life in God. But you are the light that Christ shines on the world today if you but cooperate with God's grace. Your life has a mission and purpose.

> *You are totally lovable because you exist—you are a creation of God.*

God is calling you in a unique way—one that differs from all others. Like Francis, your call is entirely personal, and no other can say "yes" to God for you. Though others aid us with their examples, you are the only one who can opt to follow Jesus, attaining heavenly perfection through Christ's free gift of eternal salvation. Though a sobering thought, our Lord's personal invitation to you is also a great gift. For you are called to change the world for Christ as our Lord's apostle, special agent, and missionary.

Think about the specific mission or vocation God has given you and let Jesus speak to you on aspects of your personal call. Consider those places that need the light of God to direct and nurture. How might you bring Christ's healing and saving light into these situations? If your vocation is still an open question, open your heart to hear God's call, for Scripture tells us that "what eye has not seen, and ear has not heard, and what has not entered the human heart, what God has prepared for those who love him" (1 Corinthians 2:9).

# PRAYER AND REFLECTION

God, you have created us for a special end—to live in eternal happiness with you along with the angels and saints in heaven. Our path to this celestial joy is best known through the particular mission you have given each of us here on earth. Help us in our prayer to know that mission more truly and to embrace it more fully. Amen.

- How has God called you to live richly in heavenly treasures? Name some events in your life that have graced you to follow Jesus.

- Reflect on the gift of your baptism. As baptized Christians, we believe and profess that Christ has adopted us as children of God. Spend time in prayer today thanking God for this gift; also thank the Lord for those who have helped you to see Christ in the brambles of the world.

- Is God calling you today for a special mission or purpose? Keep in mind that no job is too small in the sight of God. A word of encouragement might make all the difference for a friend or colleague today. Consider some ways that you might enkindle the light of Christ for those who surround you today.

- Make a list of your gifts and thank God for giving them to you. Ask God to help nurture your creativity and light, that you might share generously with others the life that you have been given. Take concrete steps to continue to nurture God's gifts within your own life.

## ~ *Spiritual Exercise* ~

- Open yourself to the gift of others today by spending time with them, learning their gifts and attributes to both learn from them and encourage them to realize their own mission in life. Also consider sharing your call or mission from God with a friend or someone you love.

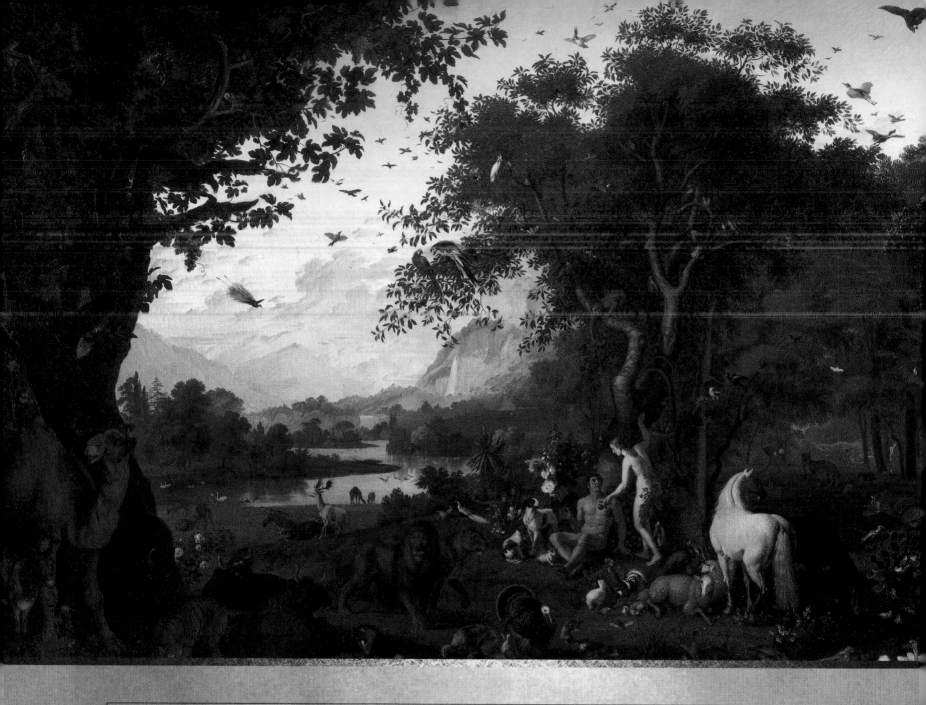

▲ In 1831, the first year of his pontificate, Gregory XVI bought twenty works by the noted Austrian naturalist Peter Wenzel (1745–1829) to decorate the Room of the Consistory in the Papal State Apartment.

An animalist painter, Wenzel was famous for his detailed depictions of the various members of the animal kingdom.

His representation of *Adam and Eve in the Garden of Eden* contains more than 200 distinct animal species made remarkable not only for their representation but for the scientific precision required to render them. A detail from that painting is featured here.

# ADAM AND EVE IN THE GARDEN OF EDEN

Peter Wenzel
Vatican Museums' Pinacoteca
Acquired by the Pope Gregory XVI in 1831

**THEME:** We are stewards of creation

**FOCUS OF THIS MEDITATION:** In the Garden, God named our first parents as stewards of creation. Though beings made in the image and likeness of our Creator, we are yet creatures among creatures. We are to love God above all creation, but we may do so likewise through our care for the animals and the earth in its proper order. A profound acceptance is necessary, as we are to love the earth and all it contains in relationship to God.

## SCRIPTURE MEDITATION

### GENESIS 1:26–31

*Then God said: Let us make human beings in our image, after our likeness. Let them have dominion over the fish of the sea, the birds of the air, the tame animals, all the wild animals, and all the creatures that crawl on the earth.*

*God created mankind in his image; in the image of God he created them; male and female he created them.*

*God blessed them and God said to them: Be fertile and multiply; fill the earth and subdue it.*
*Have dominion over the fish of the sea, the birds of the air, and all the living things that crawl on the earth.*

*God also said: See, I give you every seed-bearing plant on all the earth and every tree that has seed-bearing fruit on it to be your food;*

*and to all the wild animals, all the birds of the air, and all the living creatures that crawl on the earth, I give all the green plants for food. And so it happened.*

*God looked at everything he had made, and found it very good. Evening came, and morning followed—the sixth day.*

*The earth was created
good and beautiful;
true in its form and
fantastic in its possibilities.*

In this idyllic landscape of *Adam and Eve in the Garden of Eden*, Peter Wenzel magnificently depicts the harmony and multiplicity of all of God's creatures. The pastel-colored heavens, blue in their beauty, along with the majestic soft mountains give a natural security to the background. Peacefully led into the foreground by a winding river, we encounter a vibrant variety of animal life, all playfully and artistically placed in this heavenly scene.

A camel poses with a smile in the left foreground while a tiger plays with a hare at his feet. The lion and lioness stroll with vigilance through the animal kingdom inspiring security rather than fear. Birds swirl through the air, and some even land amongst friends in the trees while others walk in the open field. There is space to run, shade wherein to rest, a path under an arch of foliage that invites us on a walk. Our senses find in this image a perfect habitat of protection, freedom, and communion with creation and Creator.

And at the center we see Adam and Eve. Traditional farm animals are nearby, with domesticated creatures including man's best friend at Adam's right hand, with a cat sitting at his feet. Like our first parents, we are not alone in our search for God. For God is gifting us at

every moment with life, relationships, and the magnificence of creation. The beauty of the earth reflects the glory of God in order to lead us back to him.

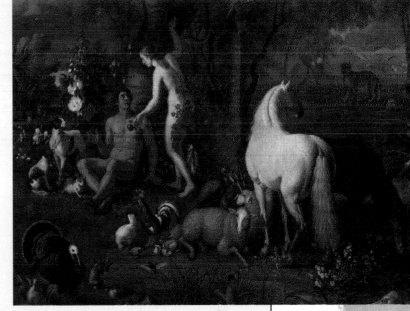

In prayer we ought to first give thanks for all the variety, depth, and scope of God's creation. How artistic and imaginative our Creator is! Out of pure love God has created the earth, the universe, and all therein, entrusting this wonderfully and intricately balanced natural world for us to enjoy and protect—both a gift and a responsibility.

The earth was created good and beautiful; true in its form and fantastic in its possibilities. In the midst of our hectic lives, we often neglect to stop and enjoy the natural beauty that surrounds us at every moment. Take time today to give glory to our Creator for the beauty that surrounds you. Spend moments enjoying a sunset, walking in a garden or park, or appreciating the flowers that bloom in your garden. Our Creator is ushering us through the seasons of our lives and surrounding us with reminders of his love.

Though our painting assists us in our prayer today with the created world, it is important for Christians to remember that God's creatures do not only belong to the material world, nor only to the plant and animal kingdom. Creatures include all beings that are not God the Creator. In the unraveling of salvation history, God has occasionally helped us glimpse unseen angels who are distinctly different from God and human beings. The veiled world of God is presently unknown to us visibly, yet Christians believe it exists nonetheless.

Made in the image and likeness of our Creator, human beings possess the ability to tinker with creation and create beauty. Our time and talents, smart phones, money, friendships, houses, careers, cars, a good game of golf, and nonprofit service are also creatures, for everything that is not the Creator is a creature. Our defects, health, gadgets, hopes, dreams, and even our retirement by this definition are likewise creatures. When we consider the material world, we might ask ourselves how we are using the materials at our disposal. Consider also the creatures of your

interior world of thoughts, emotions, dreams, and frustrations. Each creature is a gift, but it is our duty to use it for God's glory and our own particular life mission.

Why is this so important? As in the Old Testament, it is easy for us today to turn creatures into the Creator. The Israelites converted the gold brought from Egypt into a golden calf (Exodus 32:1–4). Unfortunately, we also tend to convert our possessions and treasures into the gods we worship. Though subtle, this is a tendency that happens often in our world and in our own hearts.

Let us not be discouraged but rather use this opportunity to enter into a beautifully purifying and freeing prayer experience. Do this by slowly considering the creatures of your life and how they occupy your heart and time. Do you feel peace when you think upon your relationship with friends, family, coworkers, and God? What about your connection to the material things you own or those things that have been entrusted to your care? In what ways might you have turned the creature into the Creator? When we do not feel peace in relationship to others or material things, it can be an indicator that we have made idols of them and they have more of a hold on us than they should. God knows our hearts and our eternal need for love. Seize this moment to repent and offer God your heart once again to him, knowing that the Lord will gift you with the peace that surpasses all understanding.

In Genesis 2:20, God tells us another important truth about creatures, namely that there was no suitable partner found among the animals for man. Although creatures are beautiful and good, we shouldn't expect them to totally fill us. In this passage, the helpmate that God created for the man was a woman. Human beings are made in the image and likeness of God and therefore help us to come to a greater knowledge of the Lord. God has placed our families, coworkers, spouses, and even our enemies in our lives to help us grow in order to serve the Lord and one another.

Spend time thanking Jesus for the many creatures he has given to you. Resolve to use them for God's glory and your own good. The Lord of paradise has called you to enjoy the fruits of the earth by delighting in the goodness and beauty of God that can be glimpsed, though not fully possessed, in creation.

# PRAYER AND REFLECTION

Help us, Lord, to love and enjoy each creature you have entrusted to us. May each creature help us draw closer to you. Keep us from stumbling by making graven images out of the creatures of our lives, for we seek to see you face to face. Grant us the ability to see your face in your people, for you have created them and they reflect your beauty, O God. Amen.

⌁ What creatures do you most love? Have you made any of those creatures into idols? Explain.

⌁ Some objects both help and hinder our relationship with God and others. A computer, for example, has great potential to help serve God's people, still it is easy to get addicted to social media and harmful parts of the online world. What are some ways to detach yourself from the harmful aspects of those creatures that have too much of a hold on you?

⌁ Do you love God's creation and all it contains? How have you helped protect the environment as God's gift to humanity? Have you protected human life from conception to natural death as the first and most treasured gift of God?

⌁ All human beings are beloved by God. Do you revere God in the face of others in your life? Have you gossiped about or slandered others? How might you change behaviors that are self-centered or hurtful toward others or yourself?

## ✿ *Spiritual Exercise* ✿

⌁ Take time this week to go for a reflective walk in a natural setting. Free yourself from all distractions in order to bask in the glory of God in the creation that surrounds you. Consider all creatures in your life. Do some occupy more of your heart than they should? Order them according to God's goodness and love.

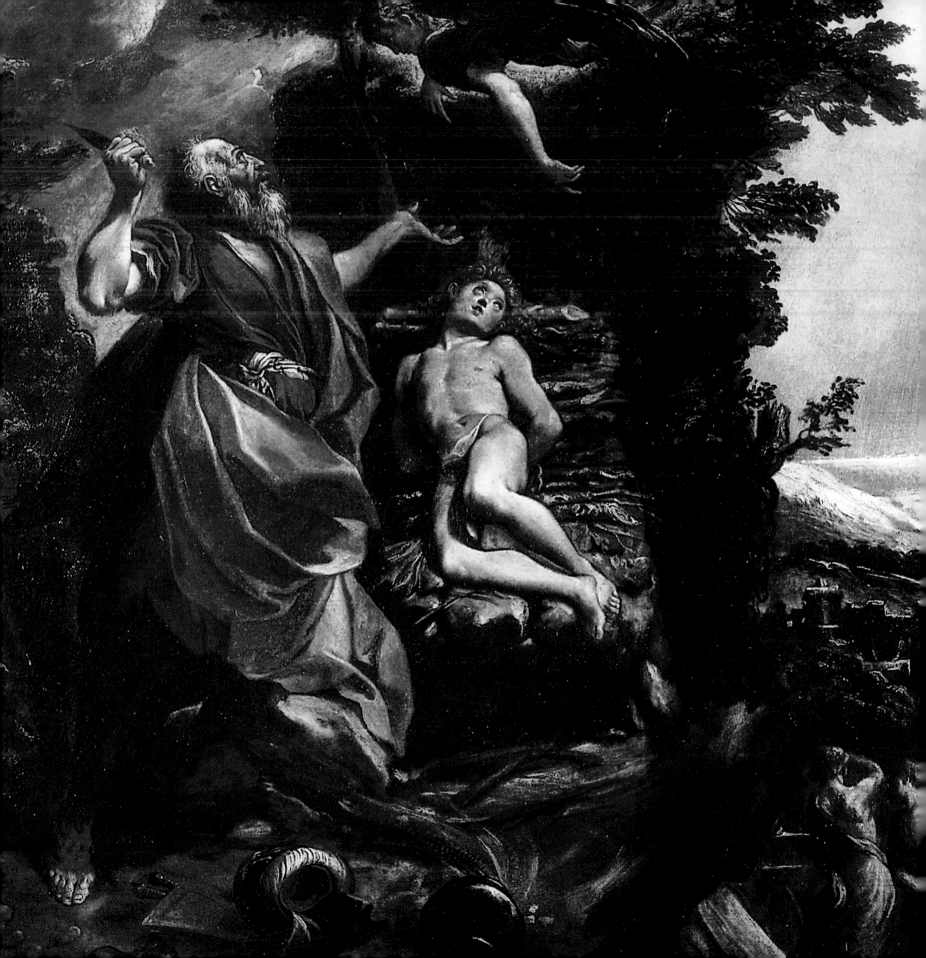

# THE SACRIFICE OF ISAAC

Ludovico Carracci
Vatican Museums' Pinacoteca
Circa 1586

**THEME:** Time and other creatures

**FOCUS OF THIS MEDITATION:** All creatures from least to greatest belong to God, yet God is the only absolute. Reverence for creatures can lead us closer to the Lord.

 The works of Ludovico Carracci (1555–1619)—a Bolognese, early-Baroque painter, etcher, and printmaker—are characterized by strong moods and spiritual emotions created with broad strokes and flickering light. As an apprentice under Prospero Fontana in Bologna, he had the opportunity to travel to Florence, Parma, and Venice before returning to his hometown in his youth.

Upon his return, along with his cousins Annibale and Agostino Carracci, Ludovico founded the Eclectic Academy of painting *(Accademia degli Incamminati)* in 1585. This was a studio with apprenticed assistants, many of whom would be propelled to pre-eminence in Rome and elsewhere. This so-called Bolognese School of the late sixteenth century included Albani, Sacchi, Reni, Lanfranco, Guercino, and Domenichino. The Carracci cousins had their apprentices draw studies focused on observation of nature and natural poses and used a bold scale for drawing figures.

The Carraccis are credited with reinvigorating Italian art, in particular that of the fresco, which had disappeared with the rise of formalistic Mannerism.

# SCRIPTURE MEDITATION

## GENESIS 22:1–19

*Some time afterward, God put Abraham to the test and said to him: Abraham!*
*"Here I am!" he replied.*

*Then God said: Take your son Isaac, your only one, whom you love, and go to the land of Moriah. There offer him up as a burnt offering on one of the heights that I will point out to you.*

*Early the next morning Abraham saddled his donkey, took with him two of his servants and his son Isaac, and after cutting the wood for the burnt offering, set out for the place of which God had told him.*

*On the third day Abraham caught sight of the place from a distance.*

*Abraham said to his servants: "Stay here with the donkey, while the boy and I go on over there. We will worship and then come back to you."*

*So Abraham took the wood for the burnt offering and laid it on his son Isaac, while he himself carried the fire and the knife. As the two walked on together,*

*Isaac spoke to his father Abraham. "Father!" he said. "Here I am," he replied. Isaac continued, "Here are the fire and the wood, but where is the sheep for the burnt offering?"*

*"My son," Abraham answered, "God will provide the sheep for the burnt offering."*
*Then the two walked on together.*

*When they came to the place of which God had told him, Abraham built an altar there and arranged the wood on it. Next he bound his son Isaac, and put him on top of the wood on the altar.*

*Then Abraham reached out and took the knife to slaughter his son.*

*But the angel of the LORD called to him from heaven, "Abraham, Abraham!"*
*"Here I am," he answered.*

*"Do not lay your hand on the boy," said the angel. "Do not do the least thing to him.
For now I know that you fear God, since you did not withhold from me your son, your only one."*

*Abraham looked up and saw a single ram caught by its horns in the thicket. So Abraham went
and took the ram and offered it up as a burnt offering in place of his son.*

*Abraham named that place Yahweh-yireh; hence people today say, "On the mountain the LORD
will provide."*

*A second time the angel of the LORD called to Abraham from heaven*

*and said: "I swear by my very self—oracle of the LORD—that because you acted as you did in not
withholding from me your son, your only one,*

*I will bless you and make your descendants as countless as the stars of the sky and the sands of the
seashore; your descendants will take possession of the gates of their enemies,*

*and in your descendants all the nations of the earth will find blessing,
because you obeyed my command."*

*Abraham then returned to his servants, and they set out together for Beer-sheba,
where Abraham lived.*

All the drama and contradiction of the heroic event recorded in the Book of Genesis on *The Sacrifice of Isaac* gets concentrated here into this painting by Ludovico Carracci. Both in the story and within this painting, Abraham is regarded as a strong figure.

In a majestic pose with flowing red garments, Abraham leans over the boy as his attention is directed to the heavens while listening to the words of the angel. His left hand is lifted in an

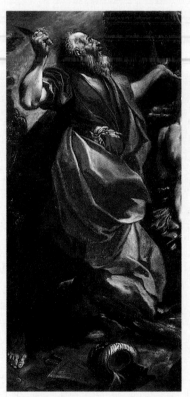

imploring manner while the other hand holds the knife. His arm is tensed, as one ready to carry out the command of God. The jars at Abraham's feet are knocked over, showing the hastened struggle for him to move toward his sacrifice. Two servants turn away in the lower register, for they cannot bear to witness this radical and incomprehensible action. In the valley, a neighboring town is covered in darkness, but in contrast thickly clouded heavens filter light from above.

On the pyre, Isaac, the son of Abraham's old age, is prostrate. God had answered Abraham's fervent prayer by promising him that through Isaac he would have descendants as numerous as the stars of the sky. Yet Genesis records God asking him to sacrifice the hope and promise bestowed upon him in this strange event. And Abraham, though surely not understanding, was

willing to obey Yahweh—a supreme test of faith. For this reason, Abraham is called our father in faith.

Notice how Abraham is looking upward, his gaze focused on God. Even though his grief must have been great as it reflected his love for his own son, Abraham did not turn toward creatures, but to the Lord. Like our father of faith, we need to look to the Lord in order to clearly see the things of earth.

Abraham understood through the lens of faith that neither creature nor God-given talent ought to take God's place in the human heart. Even the greatest of goods—a child and heir—are secondary to our love for God. God asks us to trust him entirely with our lives. Therefore, we must be willing to submit our plans to the Lord, even when we are asked to give up our most cherished creatures and loves in order to follow God's path. This path does not always make sense, as believers often become painfully aware that God's ways are not our ways. Yet this is our route of faith—the journey that all must walk to find God.

The stormy heavens in the background remind us of how the winds of our passions and the pressure of our secret expectations can clash with God's plan. A darkened front moves into our soul, making it hard to discern the voice or to see the light of God. The heroism of faith begins here, for "we walk by faith, not by sight" (2 Corinthians 5:7). Abraham had his sight fixed on high, and even when God's plans did not make sense, nor could he see clearly, he trusted God, not in his own way. He was willing to go through with the unthinkable.

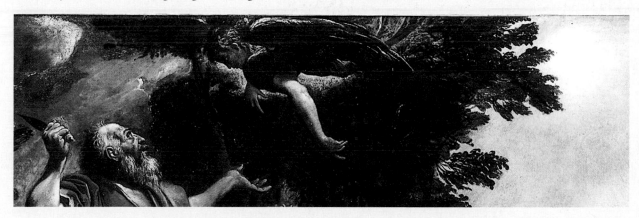

At the height of this event, just before the sacrifice is made, the angel leans into the scene and stops the hand of Abraham, knowing now how devoted the servant is to God.

We might also focus our prayer on Isaac, a young boy who would certainly have been big enough to put up a fight as his elderly father's plan became evident. Yet we see him gracefully resigned to the sacrifice God is asking. Although he wants to understand, as his words indicate, "Here are the fire and the wood, but where is the sheep for the burnt offering?" (Genesis 22:7), he doesn't make his reason an absolute.

Isaac, then, is the trusting lamb led to the slaughter, a foreshadowing of the Son who will not be spared by the heavenly Father. The Father did not stay the knife when Jesus was being tortured and crucified. Are we willing to lie peacefully within the plan of God when it requires such a sacrifice? Can we trust God's plans more than our own? What creatures or loves have occupied the place of God in our hearts?

Lastly, we can meditate on the contrast between the valley down below and the height of surrender we experience as we discover the mountain of the Lord. The valley of the world is bathed in darkness, but on the mountain the struggle for salvation ensues. The two figures, those we mentioned before that are unable to witness the sacrifice, have confusing postures for it is not clear if they are coming up or walking down the mountain. They seem to be caught in between, as so many of us are when challenged with the demanding ascent of faith, as our appetite for earthly goods often distracts us from our life in God.

This mountain can recollect for us that other mountain, Golgotha, where the Son is sacrificed for all people in accordance with the Father's will. It was there, the place of the skull, that the stormy heavens also tell of an epic struggle between good and evil. And the Son wins the battle against darkness by submitting to the will of his heavenly Father. *Our Father, who art in heaven, hallowed be thy name....*

# PRAYER AND REFLECTION

Jesus, we thank you for the many blessings we have received from your hand. We are surrounded with many gifts, some of which we fail to recall or have not, as yet, fully seen. Help us to be aware of the gifts that you have bestowed upon us and to nurture them in accordance with your holy and divine will. Most of all, dear Lord, help us to love you through our families and others you have placed within our lives. May we spend our time wisely in gratitude and service of you, our beloved Master. Amen.

- Who or what do you treasure most in your life? Have there been moments when God has called you to loosen your grip on earthly treasures in order to embrace divine goodness? Explain.

- What trials or tests of faith have you endured? In what way have these experiences shaped your faith?

- Might God be asking you today to let go of your will in order to glimpse God's glory breaking through the valleys of your life? Ask God to take you to the holy mountain and speak to you, to change your heart once more.

- God's ways are not our own. Where is God calling you to trust his will, surrendering your life to his divine goodness and love?

## Spiritual Exercise

- Dedicate more time to preparing a family meal. After the meal is prepared, spend time with your family and reflect on gratitude. Ask the members of your family to each share something they are thankful to have. Or take the initiative to invite someone over who is in need of company.

# SECTION II

# ENCOUNTERING SELF AND GOD'S MERCY

GOD'S CREATED ORDER, paradise, was corrupted by sin and death in the Garden with our first parents. Adam and Eve distrusted God, rebelled against him, and tasted the forbidden fruit. The consequence was a shame that led them to lose their original innocence and hide themselves from God, who loved them. Their sin led to an ever greater blindness, violence, hatred, and brokenness among themselves and their offspring. This disorder, which we call sin, taints our hearts and blinds us from seeing God's glory. Thus, in this section our meditations will focus on the reality of God's parental love and goodness and our feeble response to God's grace.

Sometimes we opt for evil, so what do we do about that? Our world hates to talk about sin, and sometimes even in the Church we shy away from teaching about our sinful nature. For instance, do you remember the last time you heard a homily about sin? Some will say, "That is too negative. Catholic guilt has done too much harm already," or, "Are we not a resurrected people? Our song is 'Alleluia!' Forget the doom and gloom, and let's focus on the glory!"

Yet to understand the mysteries of our faith, we must consider why it was necessary for Jesus to die. The good news of our faith becomes even more extraordinary when we accept and come to understand that it is sin that separates us from God and others.

As sin is a reality we all face, ignoring this reality only leads us to frustration. All of us have sinned, and therefore we are separated from the love of our heavenly Father. Earth is not our eternal dwelling place. We are far away from home and have chosen to be so, more or less consciously, more or less freely. Essentially, like the prodigal son in the parable Jesus tells us, ignoring the reality of sin could rob us from knowing the goodness of God. For sooner or later, if a doctor fails to diagnose a serious disease, the patient will die. Likewise, in the spiritual life, we have to recognize our sin in order to understand our condition and embrace the remedy.

Ignatius of Loyola did not shy away from preaching and explaining sin and nor should we. These meditations will therefore delve into the reality of evil. By regarding original sin, the blemish that entered human history through our first parents, we can see how times and peoples have inherited this broken state. Christians profess that original sin is removed at baptism, yet the effects of a weakened human nature continue. We still opt to sin, and sometimes we do so without acknowledging its consequences in our daily lives.

Remorse and a desire for repentance are healthy for unscrupulous souls. We are in need of our divine physician, who will assist us to be rid of self-destructive habits in order to fully embrace God's will in our lives. As many addiction programs tell us, the first steps to healing require that we first acknowledge and name the addiction. Then we likewise begin to understand that we are not capable of overcoming this weakness entirely on our own. Though we need to understand and accept the reality of sin, we do so in order to fully appreciate the beauty and the mercy that conquers this dreadful reality. In essence, focusing too much on sin can be negative as well.

It is Jesus, our healer, who has come to rescue us from our destructive behavior so we might be with God forever. In these next meditations, though one focus is sin, we simultaneously need to let the message of God's mercy flood upon us and envelop us—setting us free. Like a cleansing bath, we are graced to receive new life through Christ's forgiving love.

Personal and collective sin has its consequences for each of us and for creation. Following Catholic tradition, St. Ignatius meditated on the ultimate and final effects of sin. These last things are called death, final judgment, heaven, or hell. These meditations are not intended to instill fear but instead to impart knowledge in order to prepare us for the last things. May our meditations be serene as Christ instructs our hearts, preparing them for himself.

Michelangelo di Lodovico
Buonarroti Simoni
(1475–1564) is most
frequently referred to
as Michelangelo. The
artist's gifts were multi-
dimensional, and his works
contributed greatly to the
High Renaissance.
He was a sculptor, painter,
architect, poet, engineer,
and contemporary of the
great artist Leonardo da
Vinci. In fact, he contends
with da Vinci for the title
of "archetypal Renaissance
man" in art circles
today. The artwork of
Michelangelo is some of the
best-known in existence.
Two of his masterworks,
David and the Pietà,
were both created before
the artist was thirty.
Furthermore, Michelangelo
was the first Western
artist to have a biography
of his life published
during his lifetime. He
was so acclaimed that two
biographies were written
about him while he was
alive. His life and works
inspired artists in his
own era and continue to
influence the creativity of
many today.

Near the middle of the ceiling of the Sistine Chapel, Michelangelo strategically
painted a dramatic scene called *Original Sin and Banishment From the Garden of
Eden*. The tree of knowledge of good and evil divides the composition in half. And
the serpent, depicted as having a human upper body, is shown reaching out to offer
the forbidden fruit to our first parents.

Eve is seated below the tree with her back toward the serpent, yet she turns
to receive what the devil offers. Adam eagerly embraces the temptation as he
stands and reaches toward the fig tree. There is no doubt that both Adam and Eve,
representing all of humanity, are guilty of this original sin.

The right side of the painting depicts our guilty first parents being cast out of the
Garden into the barren wasteland. Adam defends himself from God's condemning
gesture, not daring to look upon the one he disobeyed. Eve hides herself in Adam's
shadow, hunching over and crossing her arms to cover her shame. ▶

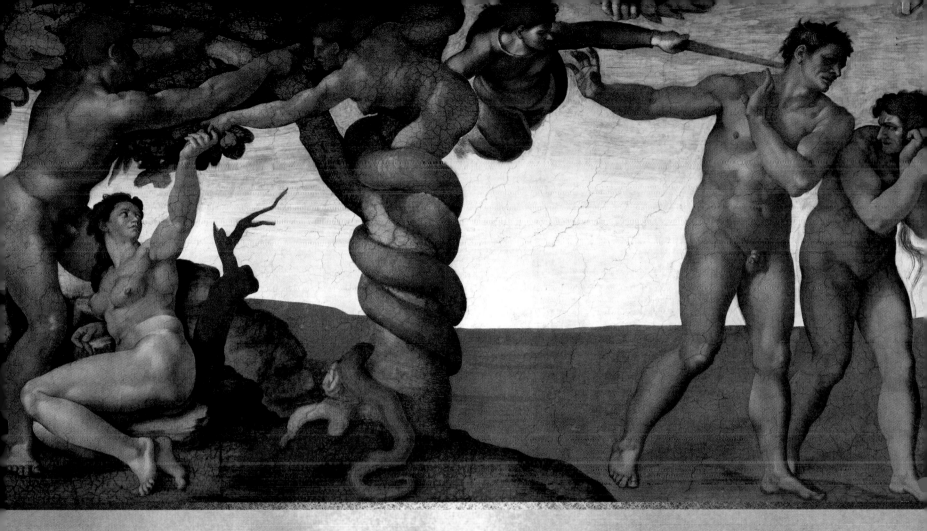

# DAY 7

# ORIGINAL SIN AND BANISHMENT FROM THE GARDEN OF EDEN

Michelangelo Buonarroti
Sistine Chapel ceiling
Circa 1511

**THEME:** Original sin

**FOCUS OF THIS MEDITATION:** God wills the supreme good for our lives and always acts in our favor. Our resistance to God's will is due to sin, which stems from a lack of trust in him and breaks our communion with the Lord. This meditation will help us further understand sin so we might fully trust God to bring us to our eternal home.

# SCRIPTURE MEDITATION

## GENESIS 3:1–13

*Now the snake was the most cunning of all the wild animals that the LORD God had made. He asked the woman, "Did God really say, 'You shall not eat from any of the trees in the garden?'"*

*The woman answered the snake: "We may eat of the fruit of the trees in the garden; it is only about the fruit of the tree in the middle of the garden that God said, 'You shall not eat it or even touch it, or else you will die.'"*

*But the snake said to the woman: "You certainly will not die!*

*"God knows well that when you eat of it your eyes will be opened and you will be like gods, who know good and evil."*

*The woman saw that the tree was good for food and pleasing to the eyes, and the tree was desirable for gaining wisdom. So she took some of its fruit and ate it; and she also gave some to her husband, who was with her, and he ate it.*

*Then the eyes of both of them were opened, and they knew that they were naked; so they sewed fig leaves together and made loincloths for themselves.*

*When they heard the sound of the LORD God walking about in the garden at the breezy time of the day, the man and his wife hid themselves from the LORD God among the trees of the garden.*

*The LORD God then called to the man and asked him: Where are you?*

*He answered, "I heard you in the garden; but I was afraid, because I was naked, so I hid."*

*Then God asked: Who told you that you were naked? Have you eaten from the tree of which I had forbidden you to eat?*

*The man replied, "The woman whom you put here with me—she gave me fruit from the tree, so I ate it."*

*The LORD God then asked the woman: What is this you have done?*

*The woman answered, "The snake tricked me, so I ate it."*

In the last section we meditated on the goodness of God's creation and how the Lord invites us to enjoy the creatures of this world inasmuch as they lead us onward to our final destination—heaven. Now we turn and meditate on the reality of sin and how we can lose our focus on the goodness, love, and mercy of God, freely choosing evil over good. In truth, there are times we have chosen evil, which at first enticed us but later left us wondering why exactly it was so alluring.

Evil is a great mystery that we can only begin to understand in the light of God through divine revelation and Scripture. We will begin by meditating on original sin—the inherited wound that came from our first parents yet affects all humanity. Encountering the mystery of original sin (and actual sin) can only be fully examined in the light of Christ. So let us peer into this dark mystery with Christ, our hope and light.

God created all things for good, including the tree of knowledge of good and evil in the Garden of Eden. The prohibition of eating from that tree was a call for humanity to trust God's love and goodness. By denying that fruit, he was not hiding a good but saving them from a poison.

Michelangelo uses the image of a fig tree to depict the forbidden fruit, enticing them with its smooth bark and large leaves. It would have been an ideal place to rest, enjoy the shade, and appreciate the beauty of the Garden. Goodness surrounded our first parents, who had as yet not known evil. Still, God enjoined upon them certain moral laws so they might partake fully of the joy bestowed on them in the Garden.

Adam and Eve are together when the tempter comes, an astute interpretation visualized by Michelangelo. Though still frames, action is given to this story we all know so well in the artist's masterpiece. The devil hands the fruit to Eve so she needn't get up, signifying the ease of sin. And Adam, standing above her, reaches with one hand to pull the branch toward him, signifying the deliberate nature of his choice. His other hand picks a fruit farther away from him, just under the eye of the temptress.

The devil seems to appear out of nowhere in the biblical text, and so it is in this fresco. The Sistine Chapel is composed of so many beautiful figures that it is almost surprising to see the serpentine figure wrapped deceivingly around the trunk with its female body hidden among the

branches of the tree. From here, dialogue with the couple is initiated. Sin always begins with a dialogue and an invitation to come closer, to entertain a little chat with evil. Our first lesson then is, if the dialogue doesn't begin, it can't develop. Mark Twain wrote, "There are several good protections against temptations, but the surest is cowardice. It is easier to stay out than get out."

Once the communication has started, the tempter moves quickly to create distrust and disunity between God and his children by getting us to doubt God's goodness. The tempter entices with the words, "You certainly will not die! God knows well that when you eat of it your eyes will be opened and you will be like gods, who know good and evil" (Genesis 3:4–5). But rather than lifting up their eyes to see all the blessings God had bestowed on them, the couple focuses on the one thing they cannot have and begin to question God's intentions. They wonder about the hidden thing, though they were forewarned that if they opted to eat it, death would ensnare them. In this moment of indecision, they begin to doubt God. *Perhaps the Lord is hiding something from us and does not have our best interest at heart after all.* Doubting God's goodness is the beginning of sin. Take some time now to reflect on some of your own choices, asking God to direct you to the truth, even if knowing these truths cause you pain and sorrow. Contrition is the beginning of healing. We cannot heal from a wound that we refuse to admit exists.

> *Goodness surrounded our first parents, who had as yet not known evil.*

As Adam and Eve are now entertaining the venom of doubt and mistrust, they open wide the door for the serpent to manipulate their passions: "The woman saw that the tree was good for food and pleasing to the eyes, and the tree was desirable for gaining wisdom" (Genesis 3:6). Though she has been instructed contrarily, Eve perceives the fruit as good for her against the command of God. She desires the fruit on her own terms, and instead of turning to God, she decides to partake this poison for her soul, abusing the freedom God gave her. The deal is done. She takes and eats.

Yet the choice of one immediately becomes the choice of both. Adam is already standing by, and rather than helping his wife combat the tempter, he also is focused on satisfying his immediate passion. Sin is never an entirely private matter, for once we sin, our relationships are undoubtedly affected.

Michelangelo depicts the effects of sin in this same fresco. Holding a rod of chastisement, God (or an angel) banishes Adam and Eve from the Garden into a barren wasteland. Human beings are no longer the strong, robust creatures they were before sin corrupted them. Here they are hunched over, shamed, and saddened by their fall. And since the evil one promises only lies, he departs, leaving our first parents with nothing other than the knowledge that they had indeed been duped and had *fallen*.

# PRAYER AND REFLECTION

Lord, help us see how senseless it is to turn from you in order to follow our own will. May we come to realize the full tragedy of sin and how it impedes your loving plan for humanity. *Be merciful, O Lord, for we have sinned.* Amen.

- Adam and Eve knew God's command, yet they doubted. Have you doubted God's love for you of late? Name a few faith exercises that will help you trust the Lord more fully. How might you use these exercises to develop a richer prayer life, that is, your lifeline to God?

- Spend a few moments contemplating God's love for you. Do you believe God desires your best good? Ask God to restore your trust in his holy will.

- What aspects of your life (particularly sin) do you refuse to surrender to God? Might you say a prayer asking God to help you surrender even the broken pieces to him?

- Our life in God does not always make sense, yet living in God is the only way to fill our empty spaces. Ask God to open your heart today to his eternal voice, calling you by name.

## Spiritual Exercise

- What temptations do you encounter in your own life? Reflect on a person, place, or thing that is an occasion for sin and decide how you can choose differently during those occasions or circumstances.

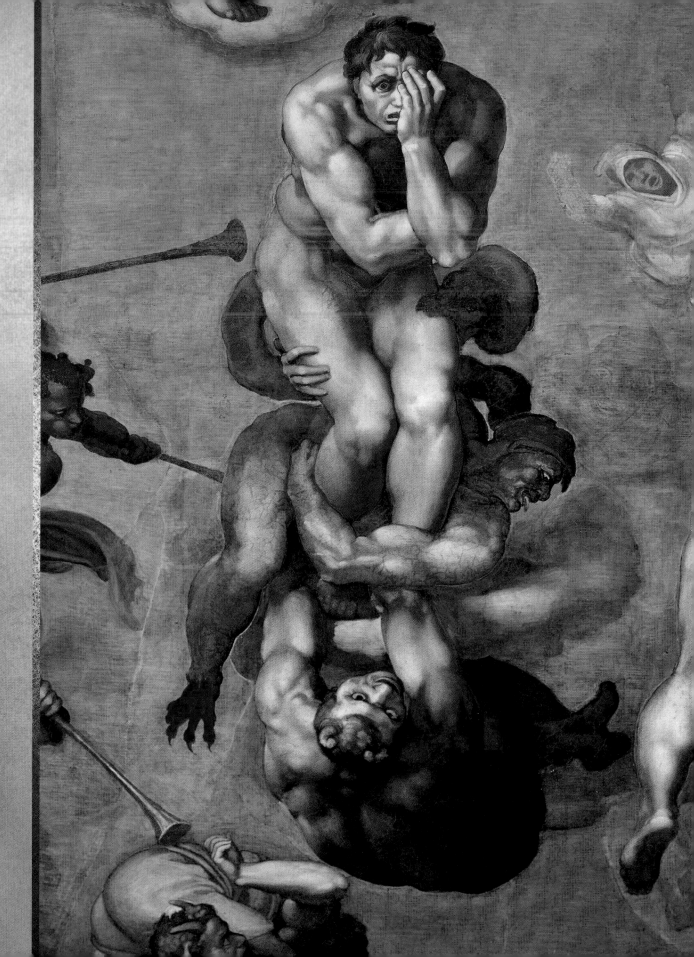

Michelangelo di Lodovico Buonarroti Simoni (1475–1564) is most frequently referred to as Michelangelo. The artist's gifts were multi-dimensional, and his works contributed greatly to the High Renaissance. He was a sculptor, painter, architect, poet, engineer, and contemporary of the great artist Leonardo da Vinci. In fact, he contends with da Vinci for the title of "archetypal Renaissance man" in art circles today. The artwork of Michelangelo is some of the best-known in existence. Two of his masterworks, David and the Pietà, were both created before the artist was thirty. Furthermore, Michelangelo was the first Western artist to have a biography of his life published during his lifetime. He was so acclaimed that two biographies were written about him while he was alive. His life and works inspired artists in his own era and continue to influence the creativity of many today.

# DAY 8

# THE SINNER

Michelangelo Buonarroti
Sistine Chapel altar wall
Circa 1536

**THEME:** Individual sin

**FOCUS OF THIS MEDITATION:** The following meditation will help us to own our role in the world's brokenness. We have inherited a broken world, yet sometimes we add to the repugnance that exists around and within us. Destructive behavior keeps us from knowing the full love of our heavenly Father. Here we will attempt to become more aware of ourselves in relation to the world's pain.

◄ Michelangelo's *The Sinner* is one of the most recognizable characters in the Sistine Chapel's *The Last Judgment* scene. As the figure covers one eye, viewers must focus on the other, which is wide with terror, realization, and comprehension.

Our perception of each figure's line of sight and state is often triangulated by the combination of directions regarded with both eyes combined. Still, this character remains a mystery, both removed and yet staring intimately at every individual viewer, inviting us to understand this important reality that will be for all. He is depicted in a moment of realization, with toned muscles clenched in fear. This is the moment of judgment, the moment when we become fully aware of ourselves as sinners in Christ's light.

# SCRIPTURE MEDITATION

## MATTHEW 13:24–30; 37–42

*[Jesus] proposed another parable to them. "The kingdom of heaven may be likened to a man who sowed good seed in his field.*

*While everyone was asleep his enemy came and sowed weeds all through the wheat, and then went off.*

*When the crop grew and bore fruit, the weeds appeared as well.*

*The slaves of the householder came to him and said, 'Master, did you not sow good seed in your field? Where have the weeds come from?'*

*He answered, 'An enemy has done this.' His slaves said to him, 'Do you want us to go and pull them up?'*

*He replied, 'No, if you pull up the weeds you might uproot the wheat along with them.*

*Let them grow together until harvest; then at harvest time I will say to the harvesters, "First collect the weeds and tie them in bundles for burning; but gather the wheat into my barn...."*

*..."He who sows good seed is the Son of Man,*

*the field is the world, the good seed the children of the kingdom. The weeds are the children of the evil one,*

*and the enemy who sows them is the devil. The harvest is the end of the age, and the harvesters are angels.*

*Just as weeds are collected and burned [up] with fire, so will it be at the end of the age.*

*The Son of Man will send his angels, and they will collect out of his kingdom all who cause others to sin and all evildoers.*

*They will throw them into the fiery furnace, where there will be wailing and grinding of teeth...."*

It is never particularly enjoyable to meditate on the reality of sin, yet we reap bountiful fruit in our souls when we regard ourselves in the light of God. And on this wall so populated with figures representing the epic drama of *The Last Judgment*, Michelangelo highlights something very important. Although judgment is a universal cataclysmic event that all of humanity will certainly face, it is also an extremely personal moment.

The only figure in *The Last Judgment* scene that breaks the visual plane and looks out at the viewer is the *penseroso* (contemplative man). His desperate face does not reveal how his struggle against three ghastly creatures will end. Yet his expression leads one to fear for the worst. His plight warns us: *Do all you still can to prevent coming to a hopeless condition one day.*

The *penseroso* represents each one of us who struggles during this life against three witnesses, namely—the world, the flesh, and the devil. In this fresco, our struggles with the world are symbolized by the green serpent that bites the man's thigh muscle. The movement reminds us how the flesh can limit our strength and actions as we embark on our journey toward heaven. The image also invites us to consider all the sins of the flesh, for often we choose to satisfy our more immediate and lower desires to the detriment of our spiritual needs.

Take a few moments of prayer to humble yourself and to admit your wounded nature, asking God for the grace and help you need. Ask God to direct your steps and to help you select and embrace those who are trustworthy in your life. Our family and friends—our community—can help us overcome our weaknesses by strengthening our love for God and others.

Now pay heed to the grayish figure who wraps his strong arms around the shins of the sinner, keeping him from walking freely. The action here can be likened to the temptations offered by the world. Recall the parable from the Gospel of Matthew that compares us to seeds sown in the ground. The seed of God is sown in the world, but often the world houses other plants that arise and choke our growth toward virtue.

Our age is one that sets itself against the Gospel in many ways, making our journey toward virtue arduous. By letting the world and the spirit of the world influence our thinking and our choices, our sights become set merely on the gems of this world. In this respect, then, the world is an obstacle and can be a source of temptation because in truth, our hearts long for eternal

things, for living water. Whether we know it or not, the soul longs for the reign of God to come.

The final actor in this trio of demonic figures is a horned creature, appearing to be almost human. This figure is firmly dragging the soul down toward its condemnation. In our Gospel passage, it is the devil who is responsible for the bad seed, and his direct action makes the world a negative place. The evil one also influences our flesh, doing all he can to entice us to do evil. Therefore, "be sober and vigilant. Your opponent the devil is prowling around like a roaring lion looking for [someone] to devour" (1 Peter 5:8).

Still, the most mysterious part of this painful drama is that we frequently freely accept and choose the evils these three sinister agents present to us under the guise of some apparent good. It behooves us to humbly take responsibility for our sinful choices and to be aware of our soul's enemies. Only then can we be aware that the field of our soul needs to be protected and we need to actively cultivate virtue and love. Being aware does not mean we should live in fear of the evil one, expecting him to turn up around every corner. Rather, we should fix our gaze upon God, wisely acknowledging that we are not alone in our pursuit toward the good in this life.

Jesus directs our understanding to the truth that both the divine and evil spirit work on the soil of our souls; the fruit of their work, then, grow together. Each of us makes choices every day, and these choices define our future. "For our struggle is not with flesh and blood but with the principalities, with the powers, with the world rulers of this present darkness, with the evil spirits in the heavens" (Ephesians 6:12). And this daily struggle defines who we are and who we will become. Embracing a healthy spiritual life is also to recognize that at times we make the choices that we would have preferred *not* to make.

By choosing sin in our lives, we deviate from our true end—God. Likewise, we limit ourselves as persons by closing ourselves off, thus separating from others. Sin damages our own balanced development, fills us with sadness and frustration, and makes us less spontaneous, happy, and open-minded. The effects of sin are large, for sin also cuts us off from God's grace. Though God always desires to move in our souls, our choices can deter God's action. We must repent, ask God's pardon, open ourselves to the Lord's aid, and freely receive from the fount of mercy that is being extended to us by our Lord Jesus Christ.

# PRAYER AND REFLECTION

Jesus, help us regard our sinful nature—a sad and ugly reality—with humility and hope. Our sins have wounded you, O Lord. Through action and inaction we have not only hurt you, but we have injured ourselves and those we love. Help us see our brokenness and beg for healing and forgiveness so we may refrain from offending you again. Amen.

- Consider the figures who plague *The Sinner* in Michelangelo's painting. Can you relate to the man's experience? When have you been weighed down or enticed by lesser goods (the goods of this world)?

- A simple definition of sin is *a refusal to love*. Even in our weaknesses, our refusal to love is the root cause of our fall. Recall your struggles and weaknesses today, asking God to ignite your heart with love for others so you might stop separating yourself from the people of God.

- It is God's grace, ultimately, that draws us back to the heavenly banquet. You are God's beloved. Do you believe this? Read Isaiah 43 and listen to God's word.

## ~ Spiritual Exercise ~

- Do a general inventory of your life and think about the ways you have offended God. Repent during your personal prayer time and resolve to go to confession in the near future. Ask forgiveness from someone you have offended. Ignatius of Loyola asked Jesuits to do a daily examen every day as a Spiritual Exercise. Consider making this a part of your daily ritual (http://www.ignatianspirituality.com/ignatian-prayer/the-examen/).

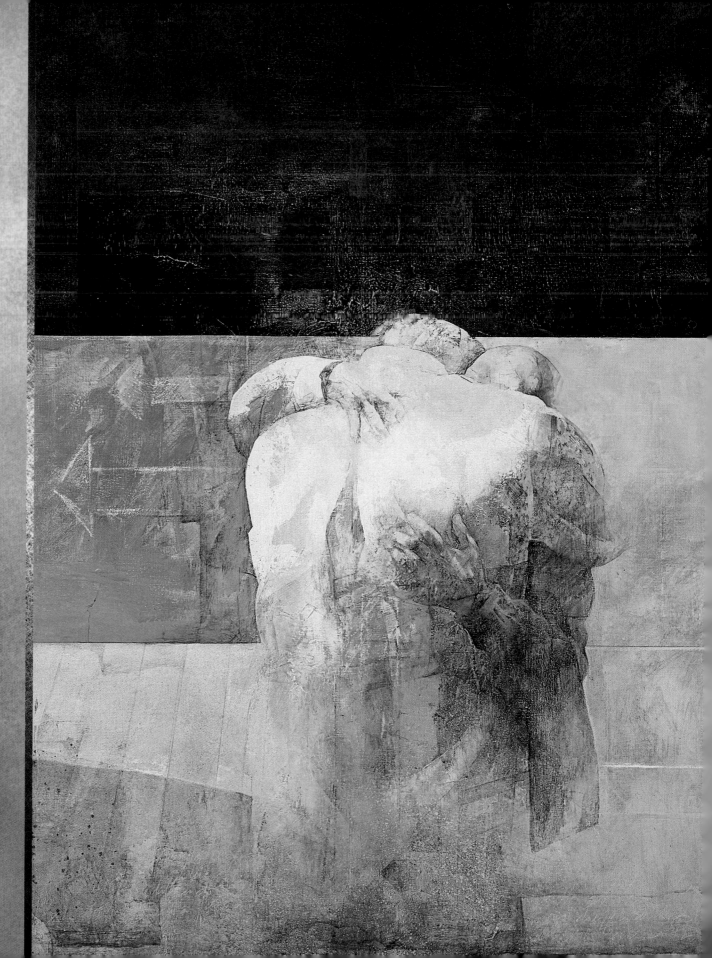

Born in Blanca, Spain, in 1944, Pedro Cano is a prominent contemporary Spanish painter. He paints in both oil and watercolors and has created more than 2,000 masterful pieces of art. This work is a rich oil on canvas created in his identifiable hazy style.

Cano first received a box of crayons when he was ten, after the death of his father in 1954. The young Cano discovered a keen interest in art and taught himself to draw. In his youth, he moved to Madrid to study at the Academy of San Fernando and later at the Spanish Academy in Rome.

The artist is known for his experimentation with concepts of solitude as expressed through shape, light, and composition, beyond his themes of nature and trees that echo his very first pieces. Seventeenth-century Dutch painter Johannes Vermeer is one of Cano's favorite artists, an influence that is evident in both his chosen subject matter and in his careful and detailed work, which respects classic styles while remaining fresh and filled with light.

# THE EMBRACE

*Pope John Paul II is depicted embracing Stefan Cardinal Wyszynski*
Pedro Cano
Contemporary Art Collections
1980

**THEME:** Love is born of repentance

**FOCUS OF THIS MEDITATION:** God does not look for our condemnation but our salvation. The Lord seeks to be eternally united to us. May we seek to feel this love and resolve to avoid the near occasion of sin.

◀ *The Embrace* is a powerful image that accentuates paternal love and union. The painting recollects the moment when Pope John Paul II, at the Mass of installation to the papacy, embraced his mentor and lifelong friend, Stefan Cardinal Wyszynski. The contrast with the background along with more subdued coloring gives the painting a certain eternal quality. Portraying a moment frozen in time, it represents something much bigger than the historical event that inspired it. For Christians, eternal and deeper realities are ever-present in the Gospel and evident in those being transformed by it. The parable of the prodigal son is a quintessential one of humble recognition of one's sin and the merciful acceptance of the Father.

In this painting, the two figures are subtly distinguishable, one from the other, and seem to be fused together, almost as though two figures have been carved out of one piece of marble. The mutual self-giving love makes this exchange striking, recalling indeed the embrace of the prodigal son and his forgiving father. There is no distance between the characters portrayed in this painting, no rancor or questioning, only the total happiness of being forgiven and of having each other back again.

# SCRIPTURE MEDITATION

## LUKE 15:11–24

*Then he said, "A man had two sons, and the younger son said to his father, 'Father, give me the share of your estate that should come to me.' So the father divided the property between them.*

*After a few days, the younger son collected all his belongings and set off to a distant country where he squandered his inheritance on a life of dissipation.*

*When he had freely spent everything, a severe famine struck that country, and he found himself in dire need.*

*So he hired himself out to one of the local citizens who sent him to his farm to tend the swine.*

*And he longed to eat his fill of the pods on which the swine fed, but nobody gave him any.*

*Coming to his senses he thought, 'How many of my father's hired workers have more than enough food to eat, but here am I, dying from hunger.*

*I shall get up and go to my father and I shall say to him, "Father, I have sinned against heaven and against you.*

*I no longer deserve to be called your son; treat me as you would treat one of your hired workers."'*

*So he got up and went back to his father. While he was still a long way off, his father caught sight of him, and was filled with compassion. He ran to his son, embraced him and kissed him.*

*His son said to him, 'Father, I have sinned against heaven and against you; I no longer deserve to be called your son.'*

*But his father ordered his servants, 'Quickly bring the finest robe and put it on him; put a ring on his finger and sandals on his feet.*

*Take the fattened calf and slaughter it. Then let us celebrate with a feast, because this son of mine was dead, and has come to life again; he was lost, and has been found.'*

*Then the celebration began...."*

On first glance, one might be intrigued by this embrace. We wonder who is being portrayed here. Our beloved ones come to mind when we regard the intimacy and life generated in this image. The Christian might immediately think of Jesus or God the Father. What events lead to the embrace? Our prayer today will delve into this process.

Previous meditations have focused on our sin and the effects it has on our relationship with God. Like the prodigal son, we often spend the good gifts that we have received on our selfish desires. Our actions and inactions, be they big or small, leave us empty and alone. Separated from our Father, we sit alone with our sin. And as we turn into ourselves, the realization strikes us that true love and forgiveness are essential. Since we have had our own way and used our freedom as we wished, we are left with our own brokenness. These moments are graced by God as well, for in these moments of heartache and pain, we begin to long for the healing embrace of sincere love.

Do not be afraid to look at yourself and show your weakness to the Father. What attachments to sin or self-serving plans impede you from being free, from getting up and returning to God? It is important to know that even here, even in your worst state, Jesus looks at you with love and only wants to heal you and have you back.

The prodigal son turns into himself and decides it is better to be in the house of his father, even as a slave, than to be far from him. He stands up, turns around, and heads back to his former home. This is the turning away from sin that we all must embrace. Perhaps this is what the arrows in the background mean—the need to return, go back, to exit where we are and head to safety in the arms of the ones who love us. We need to set aside our recklessness toward others and set on a path back to the one who loves us always and unconditionally. There is nothing to fear.

On the road back, the son practices his confession to the father, reflecting upon the reasons he will give to be accepted back, as if the father needed convincing to overcome his anger. When the father sees the son there is no hesitation. He runs to his humiliated and tattered son, buries his head in his shoulder, and embraces him with all the love and forgiveness he can muster. The union and forgiveness is as total as is the love of the father for the son.

*Even in your worst state, Jesus looks at you with love and only wants to heal you and have you back.*

The embraced one penetrates the strong and broad shoulders of the pontiff by grasping him with both hands. There is a clenching need for strength, a search to find firmness in the other, a firmness not found in oneself alone. We all search for a love, forgiveness, and strength that cannot be found in our own wills. It is our longing to be more faithful rather than constantly needing to turn to God for mercy. Yet God takes pleasure in being the rock we grasp for strength. The Lord is happy to lift us up and save us from the trials of this life, a Father who desires us and rejoices when we call upon him for assistance.

Nothing should separate us from God's love. Nothing. Turn to God, turn and be saved. Let the love of the one who came not to condemn the sinner, but to save all people, come to your rescue!

# PRAYER AND REFLECTION

Jesus, you do not look to condemn any of your children but desire to blot out their offenses and be in full communion with each of us. Help us not to dwell on our weaknesses but on your infinite love for us. Amen.

⚜ When have you experienced the loving embrace of one who deeply loves you? How has this experience touched you personally?

⚜ Do you believe God loves you unconditionally? Explain.

⚜ What moments have blocked you from God's love? List some ways that will rekindle your relationship with the Lord.

## Spiritual Exercise

⚜ Journal today about the moments you have felt God's merciful embrace. If it helps, reach out to someone you are close to—a spouse, sibling, or child—and offer some expression of appreciation and affection.

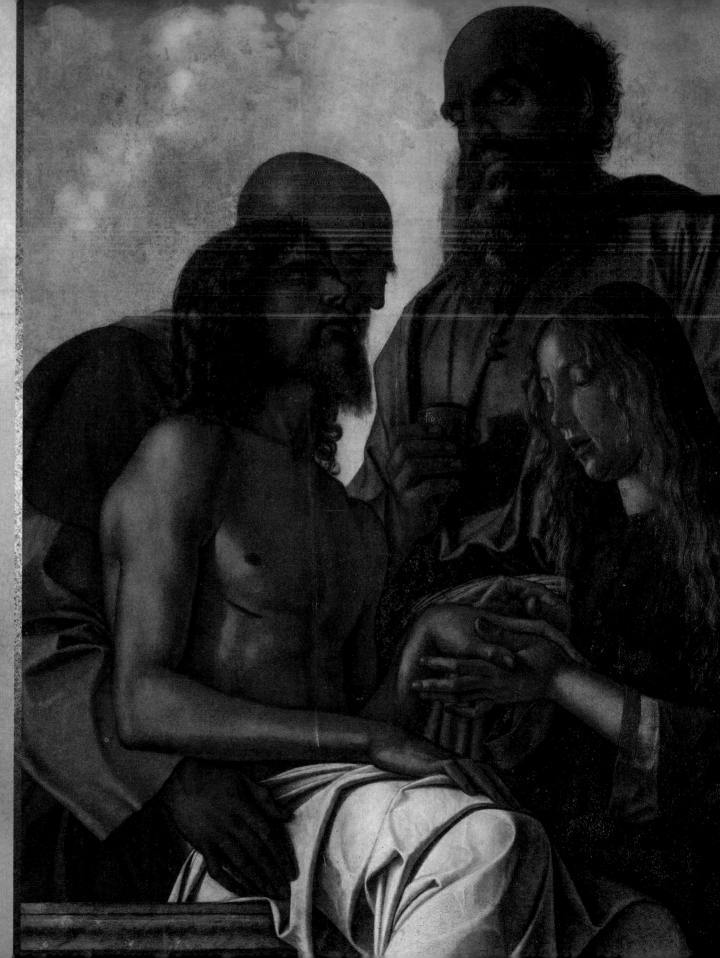

Giovanni Bellini (circa 1430–1516), who was born in Venice and died there, was an Italian Renaissance painter. He was most likely the best-known of the Bellini family of Venetian painters, which included his father, Jacopo Bellini, his brother, Gentile Bellini, and his brother-in-law, Andrea Mantegna.

In 1470, about three years before painting Lament Over the Dead Christ, Giovanni received his first appointment to work in the Scuola di San Marco. His subjects included Deluge With Noah's Ark. None of Giovanni's works from this period have survived.

After the period during which he painted Lament, much of Giovanni's time and energy must have been taken up by his duties as conservator of the paintings in the great hall of the Doge's Palace, where he painted six or seven new subjects to show the part played by Venice in the wars of Frederick Barbarossa and the pope. These works were universally admired, but none survived a fire in 1577.

Despite the tragedies of lost art, historically Bellini was essential to the development of the Italian Renaissance. Scholars believe his most important contribution remains in his experimentation with the use of color and atmosphere in oil painting.

# LAMENT OVER THE DEAD CHRIST

Giovanni Bellini
Vatican Museums' Pinacoteca
Circa 1473–1476

**THEME:** Death

**FOCUS OF THIS MEDITATION:** As we consider the end of our earthly journey in the light of faith, we come recognizing that death is not the end but our passage to God—our eternal reward. This moment of truth awaits every person at death. And death ought to be a welcome guest for those who have been faithful to God.

◀ Giovanni Bellini's *Lament Over the Dead Christ* was originally painted in Pesaro, Italy, as the cymatium (the upper part) of the famous high altar for the Church of St. Francesco. Bellini came from a family of Venetian painters, and he is said to have revolutionized this type of painting with his colorful and sensual works, using oil to create rich tones and deep shadows. His pupils, Titian and Giorgione, later helped to popularize Bellini's style.

Painted between 1473 and 1476, the altarpiece is now housed in the Vatican Museums' Pinacoteca. The main event of the altarpiece is the *Crowning of the Virgin*, which is framed by a complex series of paintings, including this lamentation.

Bellini gathers his figures around the body of the dead Christ. Viewers look up to regard the mournful faces of Mary Magdalene, Nicodemus, and Joseph of Arimathea, whose presences fill this solemn composition. The action of this piece highlights the sorrowful tone of Jesus' death while at the same time magnifying the intimate relationships that exist between each character and Jesus.

# SCRIPTURE MEDITATION

## 2 CORINTHIANS 5:1–9

*For we know that if our earthly dwelling, a tent, should be destroyed, we have a building from God, a dwelling not made with hands, eternal in heaven.*

*For in this tent we groan, longing to be further clothed with our heavenly habitation*

*if indeed, when we have taken it off, we shall not be found naked.*

*For while we are in this tent we groan and are weighed down, because we do not wish to be unclothed but to be further clothed, so that what is mortal may be swallowed up by life.*

*Now the one who has prepared us for this very thing is God, who has given us the Spirit as a first installment.*

*So we are always courageous, although we know that while we are at home in the body we are away from the Lord,*

*for we walk by faith, not by sight.*

*Yet we are courageous, and we would rather leave the body and go home to the Lord.*

*Therefore, we aspire to please him, whether we are at home or away.*

*Our love for Christ
and his mercy toward us...
will envelop us at our hour of death.*

———————————————

D eath is a subject that most avoid discussing, as many cultures indirectly teach us that the subject itself is morbid. Still, our faith has always invited us to contemplate the last things (death, judgment, heaven, and hell)—a healthy spiritual practice. Contemplating our last moments in this life will cultivate within us a greater awareness of our moral choices, gracing us to use our freedom to love God and to prepare for an eternity with the Lord. We ought not to be filled with fear as we meditate on these last things, for God is calling us to enter his glory. Instead, we should consider the natural end of our life in the light of faith.

Serenity and love pervade Bellini's painting, as those who mourn embrace the body of the dead Christ. Communicating a strong emotion, the sentiment of the figures will characterize our prayer regarding death. Mary of Magdala, Joseph of Arimathea, and Nicodemus—friends of Jesus—stand beside our Lord in an attempt to grasp the mystery of death. Their stance invites us to do likewise.

First, we regard the image of Mary of Magdala, who turned to Christ for healing during his ministry. "Accompanying him were the Twelve and some women who had been cured of evil spirits and infirmities, Mary, called Magdalene, from whom seven demons had gone out...." (Luke 8:1–2). A faithful woman, she followed Jesus throughout the Scriptures, witnessing his passion, death, and resurrection. Though the Scriptures indicate that Mary had seven demons cast out of her, we know not what they were. Were her sins greater than ours? Though we cannot know this, it is Mary who speaks to us now. *Come to Jesus*, she tells us, *he will heal you.*

In Mary Magdalene we can view ourselves in God. She was set free from her old life through the words of Jesus, and she did not turn back but stayed faithful to the end. *Those who are forgiven*

*much, love much,* the Gospel tells us (Luke 7:47). Mary gently supports Jesus' wrist, delicately tracing over the nail print on the back of his hand. Did she anoint our Lord with oil, we wonder, tracing the same wound that Thomas would soon probe after the resurrection just days later?

Bellini chooses to paint her as she speaks, with her mouth slightly opened as she whispers her sentiments of love. Does she ask for the Lord's forgiveness one

last time? This loving exchange reminds us that it is our love for Christ and his mercy toward us that will envelop us at our hour of death. We have nothing to fear if we live in humble dependence on God's mercy during our lives. Join Mary now with your own prayers of confidence and trust.

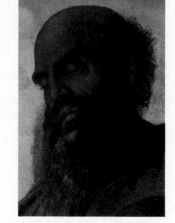

Next we encounter Joseph of Arimathea, a good and just man, and a secret believer in Christ. He stands here holding a flask of oil. The oil could be a reference to Ramatha, the place where the prophet Samuel anointed both Saul and David as king of Israel.

In Scripture, Joseph went before the Romans and offered his own tomb, freshly hewn, to receive the corpse of Christ (John 19:38). He had just recently prepared his own burial site and was now offering it to his Savior—a dangerous show of public support.

Jesus' death challenged Joseph, inspiring him to profess his faith openly. Do you follow Jesus openly or in secret? How might you allow Christ's light to shine through you for others today? Jesus is our *all in all*, and he calls us to share our faith with others so all people may know him.

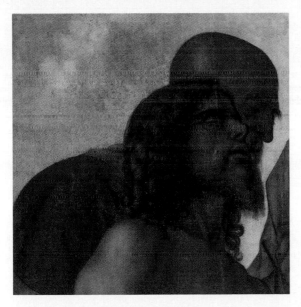

Finally we encounter Nicodemus, dressed in red. The Pharisee who came by night to visit Jesus (John 3:1–21) is now bathed in light as he supports the corpse of Christ from behind. Jesus invited him to become like a little child, born again by water and the Spirit in order to enter the kingdom of heaven (John 3:1–13). Our Lord prophesied to Nicodemus, telling him, "just as Moses lifted up the serpent in the desert, so must the Son of Man be lifted up, so that everyone who believes in him may have eternal life" (John 3:14–15). Does Nicodemus recall the prophecy of Jesus as he holds Christ's limp body at the tomb? Is Nicodemus holding Jesus, or is it the other way around?

So often we feel we are doing the bulk of the work, when in fact it is always Jesus who is lifting us up, gracing us with new life. This is especially true at the hour of our death, when our strength will come from our Lord, who first died for us.

Death invites all of us. Our earthly life will come to an end and we will breathe our last, halting our existence in this world. Though certain, this moment is not one to be feared but rather serenely anticipated with faith and hope. Our gaze should always be on the Lord. As we grow in relationship to God, death can become a kindred spirit for us, as it is our final path to the Almighty. Jesus instructs us to be spiritually prepared and vigilantly ready: "Therefore, stay awake! For you do not know on which day your Lord will come" (Matthew 24:42).

Let us pray and hope, as we close this meditation, that we will be graced with the three virtues represented by the characters in Bellini's painting. First, may we recognize our sinfulness, as Mary did during Jesus' ministry, and become faithful servants of the Lord. We ask our Lord to fill our hearts with love and generosity, like Joseph of Arimathea, who offered his own tomb to Jesus at our Lord's hour of death. And finally, we ask the Lord to make us new, providing us with faith like a child. Nicodemus was told his faith must be childlike in order to be born again.

Our hour of death is on the horizon, yet today God calls us to live in love as we shine Jesus' light on those we meet. Our prayer centers on the Lord now, as we trust in his divine plan for our temporal and eternal lives, for it is our hour of death that unites us with our beloved Savior for all eternity.

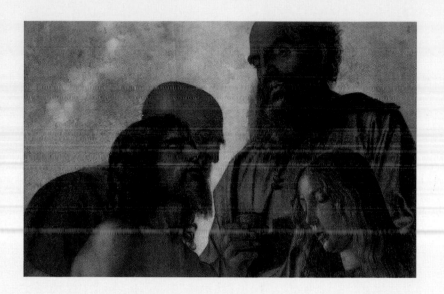

*"Therefore, stay awake!*
*For you do not know on which day your Lord will come."*

**MATTHEW 24:42**

# PRAYER AND REFLECTION

Lord, help us meditate with faith and hope upon the moment we will pass from here into eternal life with you. You have told us we are not to fear death but to embrace it out of love for you. Jesus, you died for us so we may have new life. Enlighten our minds and hearts, that we may embrace your resurrected life. Amen.

- ⚜ Read a passage from the Gospels that recalls the death of Jesus. How does Jesus' death and the events that surrounded it help you understand your own pending death?

- ⚜ Recall your beloved dead, your close friends or family members who are now with God. Perhaps they helped you come to know God. Whisper a prayer for them, thanking God for the life they shared with you.

- ⚜ Though we cannot know our hour of death, take a few moments to imagine your passage to God. Silence your heart and pray that you will be ready to meet the Lord when God calls you home.

## ⚞ Spiritual Exercise ⚟

- ⚜ Take time to visit a cemetery and reflect on the brevity of this life. Visit a loved one who has passed, offer a prayer for our beloved dead, or merely pause to reflect on how fleeting life is.

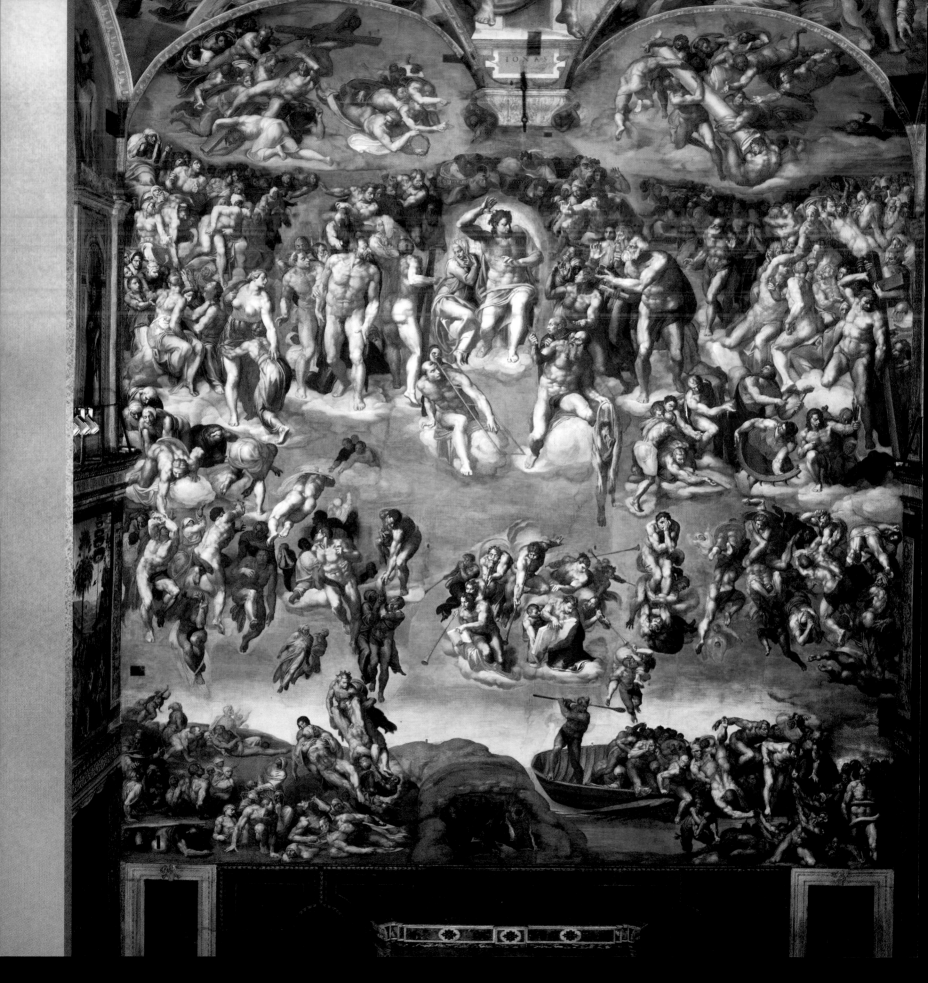

# DAY 11

# THE LAST JUDGMENT

Michelangelo Buonarroti
Sistine Chapel altar wall
1536–1541

**THEME:** The final judgment

**FOCUS OF THIS MEDITATION:** Our judgment has yet to come. With realism and faith, this meditation will help us consider our thoughts, words, and actions through our Lord Jesus Christ. Our Lord will assist us, if we will him to do so, to align our will to that of our heavenly Father and to choose Christ with greater dedication and love.

◀ The great Renaissance master, Michelangelo Buonarroti, decorated the altar wall of the Sistine Chapel from 1536 to 1541, under Pope Paul III Farnese. He had created scenes on the Sistine Chapel ceiling just more than a quarter of a century earlier.

The fresco *The Last Judgment*, which replaced a painting created by Perugino, is an artistic rendering of the end times located on the altar wall in the Sistine Chapel. In his well-known *"terribilità,"* or awe-inspiring grandeur, Michelangelo captures the drama, violence, fear, hope, and love of the last moment of human history, when the living and the dead will be judged.

Jesus Christ is the centerfold of the composition, the whole vortex of movement toward whom some 400 figures are connected.

# SCRIPTURE MEDITATION

## MATTHEW 25:31–46

*"When the Son of Man comes in his glory, and all the angels with him,
he will sit upon his glorious throne,*

*and all the nations will be assembled before him. And he will separate them one from another,
as a shepherd separates the sheep from the goats.*

*He will place the sheep on his right and the goats on his left.*

*Then the king will say to those on his right, 'Come, you who are blessed by my Father.
Inherit the kingdom prepared for you from the foundation of the world.*

*For I was hungry and you gave me food, I was thirsty and you gave me drink,
a stranger and you welcomed me,*

*naked and you clothed me, ill and you cared for me, in prison and you visited me.'*

*Then the righteous will answer him and say, 'Lord, when did we see you hungry and feed you,
or thirsty and give you drink?*

*When did we see you a stranger and welcome you, or naked and clothe you?*

*When did we see you ill or in prison, and visit you?'*

*And the king will say to them in reply, 'Amen, I say to you, whatever you did for one of these
least brothers of mine, you did for me.'*

*Then he will say to those on his left, 'Depart from me, you accursed, into the eternal fire prepared
for the devil and his angels.*

*For I was hungry and you gave me no food, I was thirsty and you gave me no drink,*

*a stranger and you gave me no welcome, naked and you gave me no clothing, ill and in prison,
and you did not care for me.'*

*Then they will answer and say, 'Lord, when did we see you hungry or thirsty or a stranger or
naked or ill or in prison, and not minister to your needs?'*

*He will answer them, 'Amen, I say to you, what you did not do for one of these least ones,
you did not do for me.'*

*And these will go off to eternal punishment, but the righteous to eternal life."*

The same Spirit that imbued our reflection in previous meditations will also accompany us now. So with faith, serenity, and hopeful confidence we meditate on these "last things" not to instill fear but to prepare ourselves. Jesus Christ is our merciful Savior: This is the age of the Spirit, an age of mercy. Consider God's mercy in the presence of your loving Father and open yourself to the cleansing waters of forgiveness that will enable you to arrive at the moment of judgment without shame or fear.

Gaze upon this amazing scene for a time and notice all of its intricate details. In the Sistine Chapel, *The Last Judgment* painting occupies the entire altar wall. It stands as a reminder to all of the dramatic moment when Christ will come again to judge the living and the dead, for the Father has given all authority to the Son (John 5:22). Notice the upper register of the fresco where Michelangelo has placed symbols of Christ's passion to emphasize Jesus' victory, to be shared with Christians of all times. His loving sacrifice earned him the authority to judge the living and the dead, for Christ is the Just Judge.

The Book of Revelation is the Scripture that most inspired Michelangelo's depiction of the last judgment. Pay heed to the trumpet call the seven angels sound at the center of the composition (Revelation 8:2–6). These divine messengers hold open two books; one smaller, one larger. The smaller book contains the names of those who will be called to the resurrection of life, but the more sobering larger of the two books lists those being sent to eternal condemnation. Although we pray that no one will be eternally condemned, including ourselves, Christ made it clear that it is a possibility.

The Christ figure in this fresco, inspired by the *Belvedere Torso* (a well-known ancient statue), comes riding on the clouds with his mother at his side. Her head is turned away, eyes downcast, as the days of her intercession have ended. At judgment, the invitation to appeal to God's mercy ceases. We will stand naked before God, as the many figures in the fresco illustrate for us, departing the world just as we came into it. Whether we are actually naked is irrelevant, as we stand completely exposed as we are before the Lord. Our virtues and moral stature will adorn us, likened to a gown that will clothe us properly for the wedding feast of the Lamb (Matthew 22:11). We cannot hide from our all-knowing Creator, having been created in God's image and likeness.

Christ's judgment is not arbitrary nor will it be one directed by prejudice or preference. Truth decides our eternal fate, for the Lord knows who we were created to be. Will Jesus recognize the being

God created when we were conceived? Notice how some of the figures nearest to the Lord are looking to him, but he is turned away. Have we been honest with ourselves about who we are in Christ?

Jesus, in his mercy, did not want there to be any surprises, so he came in person to reveal the material to be covered on our final exam. Recall the Gospel passage we just read: *Whatever you did for the least of these, you did for me.* Who are the *least* in your midst today—the lonely one, the depressed one, the unlikable one, the foreigner, and even the mean or cruel one? When we approach others with charity and kindness, we liken ourselves to Christ, who desires that we manifest his love to the world. In Scripture we are instructed that our "love for one another be intense, because love covers a multitude of sins" (1 Peter 4:8). Acting with love by imaging Christ is the best preparation for a blessed final judgment. It is also the way to know true joy in this life. Jesus tells the faithful, "Come, you who are blessed by my Father. Inherit the kingdom prepared for you from the foundation of the world" (Matthew 25:34).

Our Lord will also search our hearts for faith. Do we believe that Christ can and will heal us from our afflictions, our sins? In the Gospel, we are told that the Son of Man did not come to condemn but to save and to gift us with new life (John 5:27). Yet Jesus clarifies that faith is not one of testament only. We must align our wills with that of our heavenly Father: "Not everyone who says to me, 'Lord, Lord,' will enter the kingdom of heaven, but only the one who does the will of my Father in heaven" (Matthew 7:2). Indeed, the thoughts of our hearts are known to God; great consolation for those who love him sincerely though imperfectly.

The physical glory of the human form is merely a sign of the spiritual strength that heroes of faith must show in order to stand innocent in their final hour. In a myriad of poses, Michelangelo illustrates the glory of the human figure. Our lives on earth are a struggle, a battle. And those who fight the good fight of faith will commune with the saints in heaven for all eternity. Having been faithful until death, we will join all who have witnessed before us.

On the contrary, those who are separated to the left, whose actions have been found to be too light in the final balance, are cast into hell.

Christ and his cross stand above the altar as the eternal gatekeeper. May we live in the power of that cross so we are found worthy of the promises of Christ in our last moment.

# PRAYER AND REFLECTION

Lord, help us meditate with faith and hope upon the moment we will pass from this life into eternal life with you. You have told us we should not fear death but instead embrace it out of love for you. Jesus, you died for us so we may have new life. Enlighten our minds and hearts so we may experience your resurrected life. Amen.

- Christ has come that we might all have eternal life in God. Say a prayer of thanksgiving for the life that God offers you, asking the Lord to enlighten your heart and mind, opening you to eternal things.

- How can you align your will with God's today? Are you doing the will of the heavenly Father?

- Think about your judgment, the moment you are face to face with the Lord. What does this moment look like for you?

- Meditate on Christ's resurrection and your own. What will your resurrected body be like?

## Spiritual Exercise

- Take five minutes in the middle or at the end of your day to examine your conscience and how you have loved God and others in thoughts, words, and actions this day. Ask God's pardon for anything you might discover and thank him for his grace. If we are examining ourselves in the light of Jesus each day, there will be little new material on which to judge us on our last day.

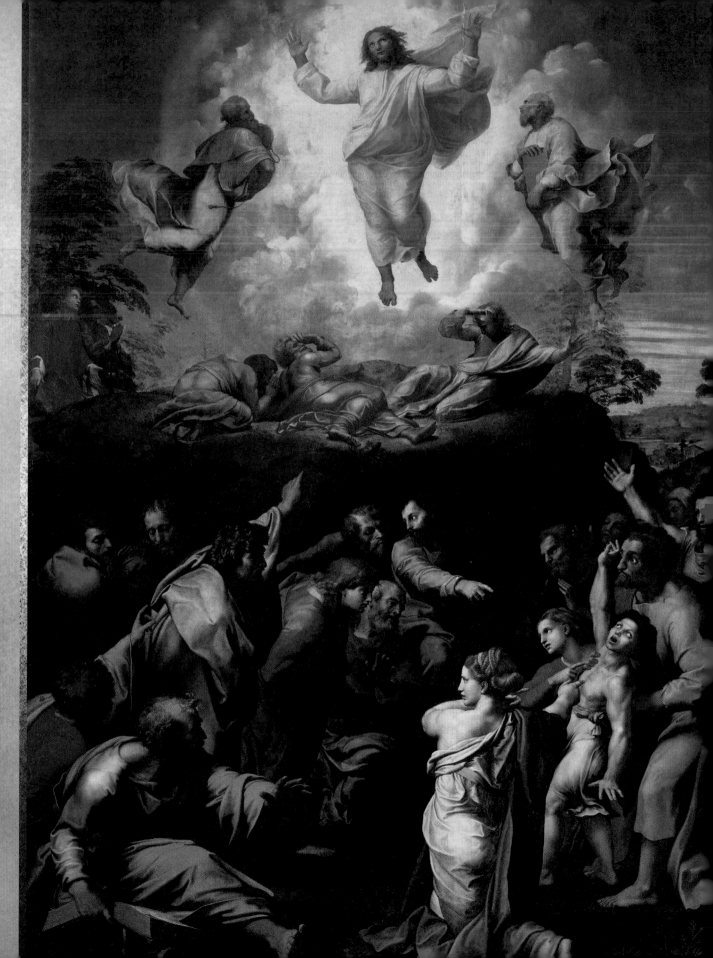

Raphael Sanzio (1483–1520), better known as Raphael, was an Italian painter and architect of the High Renaissance. His work, admired for its clarity of form and ease of composition, brings him together with Michelangelo and Leonardo da Vinci as the traditional trinity of great masters of that period.

Raphael was enormously productive, and a large body of his work remains, despite his death at age 37. Many works are found in the Vatican.

He was very influential in his lifetime, though outside Rome his work was mostly known from his collaborative printmaking. After his death, the influence of his rival, Michelangelo, was more widespread until the eighteenth and nineteenth centuries, when Raphael's harmonious qualities were again regarded highly.

# DAY 12

# THE TRANSFIGURATION

Raphael Sanzio
Vatican Museums' Pinacoteca
Circa 1518

**THEME:** Being instruments of divine mercy

**FOCUS OF THIS MEDITATION:** After meditating on the last things and our response to God, we shall now consider how God continues to deepen our lives in him. This prayer will help us grow in faith by trusting in God's power as we attempt to live it with greater love throughout our daily lives.

◄ *The Transfiguration* was one of two works originally commissioned by Giulio Cardinal de' Medici (the future Pope Clement VII) for his cathedral, St. Giusto of Narbonne. Raphael was entrusted with this painting while *Raising of Lazarus* (now in the National Gallery of London) was given to Sebastiano del Piombo. After Raphael's sudden death in 1520, however, the cardinal decided to keep *The Transfiguration* for himself, but he later donated it to the Roman church of St. Peter in Montorio, where it was placed over the high altar. Following the 1797 Treaty of Tolentino, this work was sent to Paris, where it would remain until the fall of Napoleon in 1816, at which point it was returned to the Pinacoteca of Pius VII.

Raphael's unique *The Transfiguration* depicts two stories from the Gospel of Matthew: (1) (above) the Transfiguration, with

Christ glorified between the prophets Moses and Elijah, (2) (below) the apostles encountering the possessed youth in the foreground.

Most significantly, this was Raphael's last painting before his death, and it is regarded as a spiritual testament of the artist himself. It represents a climax in his work, an exploration of the drama of the characters, and layers of narration and story. Notice the almost acidic colors that Raphael explored, a style with which he is identified.

Giorgio Vasari, a well-known artist and biographer in the sixteenth century, wrote a biography of Raphael. Within it he noted that Raphael's artwork was "the most famous, the most beautiful and most divine."

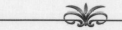

# SCRIPTURE MEDITATION

## LUKE 9:28–43

*...[Jesus] took Peter, John, and James and went up the mountain to pray.*

*While he was praying his face changed in appearance and his clothing became dazzling white.*

*And behold, two men were conversing with him, Moses and Elijah,*

*who appeared in glory and spoke of his exodus that he was going to accomplish in Jerusalem.*

*Peter and his companions had been overcome by sleep, but becoming fully awake,*
*they saw his glory and the two men standing with him.*

*As they were about to part from him, Peter said to Jesus, "Master, it is good that we are here;*
*let us make three tents, one for you, one for Moses, and one for Elijah."*
*But he did not know what he was saying.*

*While he was still speaking, a cloud came and cast a shadow over them,*
*and they became frightened when they entered the cloud.*

*Then from the cloud came a voice that said, "This is my chosen Son; listen to him."*

*After the voice had spoken, Jesus was found alone. They fell silent and did not at that time*
*tell anyone what they had seen.*

*On the next day, when they came down from the mountain, a large crowd met him.*

*There was a man in the crowd who cried out, "Teacher, I beg you, look at my son;*
*he is my only child.*

*For a spirit seizes him and he suddenly screams and it convulses him until he foams at the mouth;*
*it releases him only with difficulty, wearing him out.*

*I begged your disciples to cast it out but they could not."*

*Jesus said in reply, "O faithless and perverse generation, how long will I be with you and*
*endure you? Bring your son here."*

*As he was coming forward, the demon threw him to the ground in a convulsion;*
*but Jesus rebuked the unclean spirit, healed the boy, and returned him to his father.*

*And all were astonished by the majesty of God.*

The spiritual life is rich in contrasts—human and divine, grace and nature, sin and mercy. And Raphael's masterpiece, like the Scripture passage that inspires it, likewise has many seeming dissimilarities. Two registers compose the artwork. Atop we have the heavenly glory of Christ enveloped in a magnificent aura of divine light, symbolizing Jesus' full Sonship. Transcendent experience leaves the disciples prostrate while two Old Testament figures, Moses and Elijah, are seen floating in suspended adoration. The remaining apostles are seen below, ineffectively dealing with a possessed boy. Obvious chaos is depicted in this scene, as fingers are pointing in various directions while faces are turned north, south, east, and west. The painting itself forms a contrast between the heavenly white surrounding the Lord and the darkness that encircles those on earth.

As we tune into our spiritual lives, we will also notice a contrast. We feel a call to the beauty of God's life, desiring wholeheartedly to follow the Lord day by day. But we also know that when we come down the mountain into our daily lives, we struggle with confusion, temptation, and earthly concerns. Following Jesus seems easy when we are in his presence on the mountaintop, but the daily grind of our days proves that the task of faithfulness is, in fact, very difficult. The workplace is filled with differences in work ethic and opinion, on the highways we encounter reckless or slow drivers, and within our families we find little agitations around every corner. Do you exercise patience in the small moments of your life?

It is in these seemingly unimportant moments that we most need the power of God's mercy and love. *Rise, and do not be afraid,* the Lord tells us. Peter did not want to go down the mountain. He wanted to bask in Christ's presence, delighting and soaking up the Lord's fragrance. Yet when he heard the Father's voice instructing him to listen to the Son, he resolved to do so without questioning God's will. And although he desired to glimpse more of Christ's glory, he knew that the way to God was Jesus.

Moments of glory or enlightenment elevate our spirits, but frequently we are called to enter the struggle of our daily lives. So faith and love, strengthened through our prayer, are most needed in our everyday moments, experiences that can sometimes be wrought with darkness. Yet our Lord lets us glimpse his glory so we might know how to follow him to the cross.

As the Scripture passage continues, the disciples come down the mountain with Jesus only to encounter the scene in the lower portion of Raphael's painting. A desperate man is explaining to Jesus' disciples the situation of his hopelessly tormented son. He pleads for help from these men of God who look bewildered as if to say: *No, do not ask us.* Their fingers point back to the child or

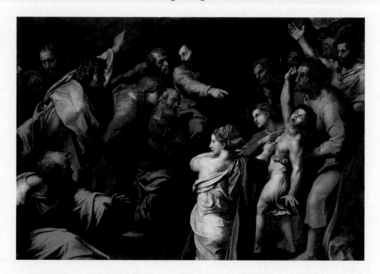

up to Jesus. Overwhelmed by the man's request, the disciples are incapable of helping the boy, even though they were Jesus' enabled ministers.

How often do we find we are unable to help others? Are we truly unable, or are we unwilling? The truths that we believe and love must be acted upon in order to convince others of their power. Our Christian call demands that we learn to help others as we put our own needs aside. Yet how many times do we neglect to stop and assist those in need of our help? We think, *we cannot even help ourselves, how are we going to be of any use to another?* Our problems are sometimes unresolved, temptations torment us, and we fall into unhealthy behaviors again and again.

Though the disciples in this painting are confused and afraid, they know to point to Jesus. Like them, we must lean on Jesus in order to experience his power. Notice the flow of hands on the left side of the painting. The lowest figure seems to almost depart the image in order to reach out to us. He draws us in as our gaze follows his arm and we look upon the other two figures that are pointing to Christ. Our answer to any despair is found in the power, love, and mercy of Jesus. For the Lord accompanies us through our darkness, shining upon us with the warmth of victorious light.

In the Gospel, the man approaches Jesus while the disciples remain silent in the background. Though the man asks them for help, the disciples are unable to cast out the demon. Jesus immediately acts but also comments on the people's lack of faith. Our Lord seems disappointed in the inability of his disciples to exercise their faith, yet he uses the exorcism as a teaching moment for the crowd. Do you believe yourself to be capable of healing and helping others through your faith in Jesus? How have you blocked the Holy Spirit from fully working in your life?

*Faith and love, strengthened through prayer, are most needed in our everyday moments.*

Jesus invites us to take a step of faith. Though obstacles exist, our Lord asks us to look beyond them, instructing us: *Follow me, for I am the Way.* Look to Jesus and believe in his power to overcome your struggles and those of your neighbor today. If we but believe, the Lord can transform our lives, healing our brokenness and division. It is the Lord's desire that we be whole again in order to reside with God. Yet we must believe in order to experience Christ's healing touch. Our Lord wants us to possess this faith, one that will move mountains. Take a few moments now and ask the Lord to continue to gift you with an ever-deepening faith.

Then, *go and make disciples of all nations* with great faith and love. For as a disciple of Jesus, you will bear the light of Christ upon our suffering and confused world.

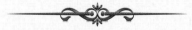

# PRAYER AND REFLECTION

Jesus, give us the faith to move mountains and enable us with your love as we begin the ascent toward you. Whenever we encounter obstacles—either within or without—give us your power to overcome in faith and love. As adopted sons and daughters, we can do all things through you, our Lord Jesus Christ. Amen.

⚔ In *The Transfiguration*, do you most identify with the disciples and apostles or with the man with the boy? Meditate for a few moments on the attributes of the character with whom you most identify. How is the Lord challenging your faith through this image?

⚔ It is possible that the disciples tried many times to heal the boy, yet their faith was lacking. Faith is a gift from God, but we must nourish it so it will grow. What act of faith will you enact today through prayer?

⚔ Think upon those suffering around you today. Do you believe it possible for the Lord to touch the world through you? Make a decision today to act for the welfare of those who most need the healing touch of our Lord Jesus.

⚔ Pray for those in your life you struggle to love. Ask Jesus to open the floodgates of your heart.

## ➤ *Spiritual Exercise* ➤

⚔ Memorize a Bible verse and repeat it to yourself often during your day. By pondering God's word, you will grow to listen to the voice of God and begin to see all things in the Lord.

# ENCOUNTERING JESUS CHRIST

IN THIS THIRD SECTION of the Spiritual Exercises, we will focus on the person of Jesus Christ, who reveals to us the magnetism and beauty of his personality. Our souls have a great capacity to love God. We are drawn to God's love in Christ Jesus. Sensing the depth of Jesus' love for us, we are invited to respond with fidelity and sincerity.

Recall how at the end of the second section we renewed our minds and hearts with a sincere resolution to resist and overcome the fatal attraction that sin has over us. Nonetheless, we saw how creatures also exercise quite a sway over our mental and spiritual faculties. Thus there are times when we choose these over our beloved God. What can we do to direct our attention to God, beyond our natural attractions?

In these upcoming exercises, we are invited to abandon ourselves to the love of God in Christ through the power of his Holy Spirit. By presenting the person of Jesus in this third stage, Ignatius of Loyola urges us to deepen our understanding of Christ, our loving Redeemer. Scripture tells us that "when the fullness of time had come, God sent his Son, born of a woman, born under the law, to ransom those under the law, so that we might receive adoption" (Galatians 4:4–5). These exercises will help us enter the mystery of Jesus' Incarnation. Through the power of the Holy Spirit, Jesus was born of the Virgin Mary. Our Lord preached, healed, suffered, and was raised from the dead so we might be adopted into God's eternal family.

By meditating on some of the main events of Christ's life, we will come to know him more intimately and partake of the love that moved him. In his life, Jesus prayed and fasted, relying on the Father's love to direct his steps. We must do likewise. Through meditation and prayer, these exercises will move our whole being to cry out in love to God: "Who are you? What shall I do?" (Acts 22:8, 10).

---

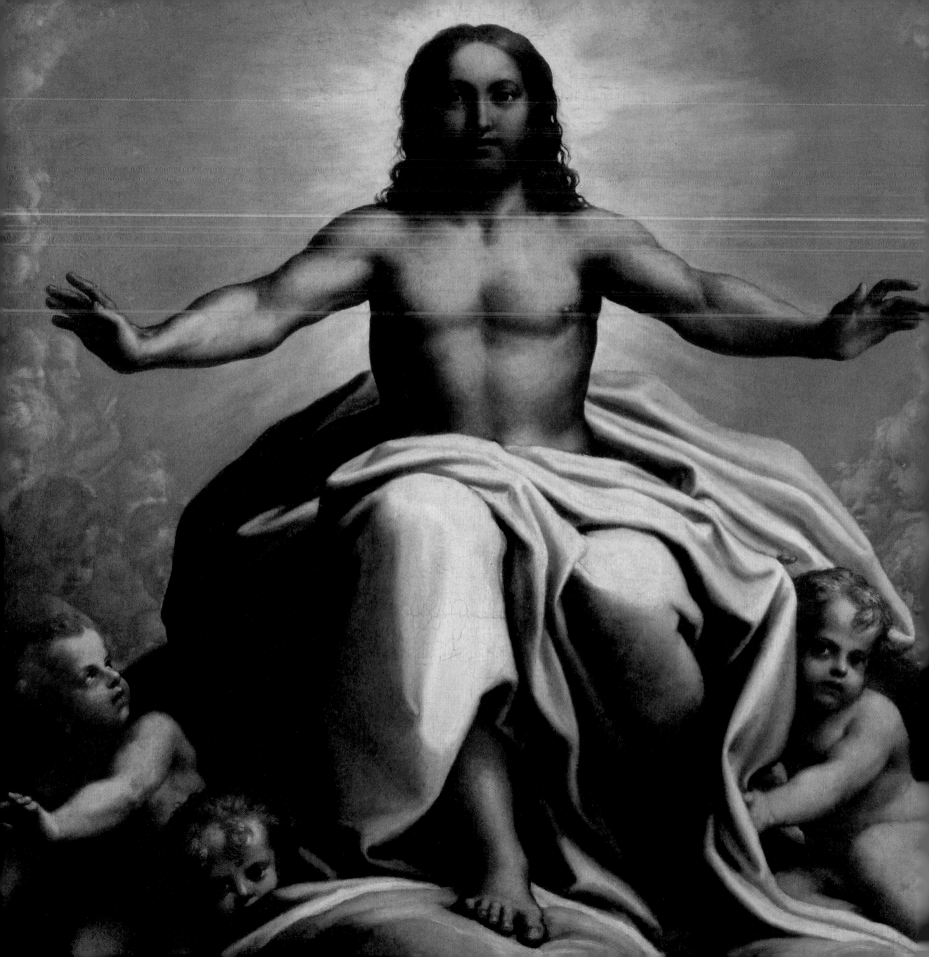

# DAY 13

# CHRIST THE REDEEMER

Antonio Allegri (known as Correggio)
Vatican Museums' Pinacoteca
1523–1524

**THEME:** Christ the Redeemer

**FOCUS OF THIS MEDITATION:** We will become aware that the invitation to follow Christ is both an honor and a privilege. We begin by attempting to understand our Lord and king in relationship to us, but soon realize the life Jesus offers is filled with joy in abundance.

◄ Antonio Allegri, known as Correggio (1489–1534), was the leading painter of the Parma school of the Italian Renaissance. He filled his birth region in northern Italy with sensual and vital works.

The artist's dynamic use of composition, his illusionistic perspective, and his dramatic foreshortening prefigured Rococo art developed in the eighteenth century. His illusionistic experiences, where imaginary space replaces natural reality, predate the stylistic approaches found in the artistic periods of Mannerism (1520–1580) and Baroque (1600–early part of the eighteenth century).

*Christ the Redeemer* was originally the centerpiece of a triptych (artwork divided in three sections) titled *Triptych of Christ's Humanity.* This masterpiece was created between 1523–1524 for the main altar of St. Mary of Mercy. The glorified Christ occupied the center of the triptych while St. John the Baptist and St. Bartholomew were etched onto the side panels.

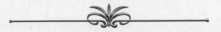

# SCRIPTURE MEDITATION

## JOHN 18:33–37

*So Pilate went back into the praetorium and summoned Jesus and said to him,*
*"Are you the King of the Jews?"*

*Jesus answered, "Do you say this on your own or have others told you about me?"*

*Pilate answered, "I am not a Jew, am I? Your own nation and the chief priests handed you over*
*to me. What have you done?"*

*Jesus answered, "My kingdom does not belong to this world. If my kingdom did belong to this*
*world, my attendants [would] be fighting to keep me from being handed over to the Jews.*
*But as it is, my kingdom is not here."*

*So Pilate said to him, "Then you are a king?" Jesus answered, "You say I am a king.*
*For this I was born and for this I came into the world, to testify to the truth.*
*Everyone who belongs to the truth listens to my voice."*

This painting is entirely Christ-centered, and so our meditation and Scripture passage will likewise direct our attention to focus solely on Jesus. Seated on a throne of clouds, Jesus dominates the artwork, placed dramatically in the center of Correggio's composition. *God's kingdom is not of this world,* the Lord whispers to us.

Christ is enveloped by the glory of the *putti* (chubby child figure, distinctly different from cherubs) who adoringly cuddle next to him on one side, while shying away in awe on the other. The piece of art is an ideal image to regard as we enter this third phase of the Spiritual Exercises, for it highlights Ignatius' intention for us to follow Christ the Redeemer. Jesus urges us to look beyond the allurements of this world, for God's reign is not here. In Scripture, Pontius Pilate wrestles with Christ's words, for he could not fully comprehend a kingdom that was beyond the world he knew and thought he understood.

Notice the aura around Christ with angelic faces dreamily mixed together in the surrounding cloud. Characteristic of the Renaissance, a common element was to paint soft heavenly clouds that would hide angelic children. Our painting has a similar style to that of Raphael's *Madonna of Foligno* that illustrates innocents hidden in hues of blue and white. See in our  image how Jesus is set apart in solar yellows and gold that fade into fleshy pinks as if to trick our eyes to regard these cherubs as roses crowning the Lord of heavenly hosts.

Now focus on the sensual and vital figure of Jesus in this piece. He is strong and self-confident in his pose, yet his facial features are sweetly inviting us. Our Lord's upper body is firmly set,  while his lower physique actively moves forward, one leg stepping toward us. Jesus' glory and kingship is evident, still he is willing to step toward all souls who need him.

Christian theology teaches us that Jesus is fully human and divine, a notion that was not neglected in this portrait. The artist images Jesus' humanity in an attractive hue—sweet and realistic. Yet we gaze upon the Lord as one surrounded in golden light and upheld by the clouds, divine in his countenance. Earthly realities are not presented here, for Christ cannot be compared to any other creature. *The glory of the Lord is our strength*, for Jesus is worthy to receive our whole heart and to be our *pearl of great price*.

As we meditate here on *Christ the Redeemer*, St. Ignatius invites us to ask ourselves some fundamental questions about this person who looks back at us as we gaze upon him. The Lord spoke to Pilate about his reign, challenging him to see beyond his limited scope. Have you turned your anxious questions over to Jesus, the Redeemer? What hinders you from fully trusting in the Lord?

Who is this Jesus who calls me to follow him? The following meditations in this section on the life of Jesus will continue to help us ponder this question. But let's begin by reflecting on what we know of Jesus through Scripture. Jesus is the Son of God and the son of Mary. His presence was

so powerful that those soldiers sent to arrest him did not dare lay hands on him. The authority and character of Jesus challenged all walks of life: kings (Herod), politicians (Pilate), religious leaders (Pharisees), lawyers (scribes), civil servants (tax collectors), friends (Lazarus, Mary, Martha), fishermen (some apostles), and soldiers (at the cross). Devout Jews and pagans, men and women, children and the elderly were all drawn to the person of Jesus. Our glorified Lord invites you to come, for he loves you intimately and personally. Jesus' teaching has affected the world like no other, yet he wants to speak to you. Spend time in prayer enraptured by Jesus' beauty and moral integrity.

When did Christ first call you, and what circumstances have led you to see the Lord in your midst? Perhaps you have experienced the Lord in a steady, simple way through the faithfulness of your family, faith-based education, and the sacraments. Maybe you came to Jesus through a conversion experience that you had later in life. Have you known the Lord in moments of inner peace? Perhaps desperation brought you to Jesus. Regardless of your way to God, Jesus has entered your life and continues to invite you to follow him. The invitation is not a past-tense reality but a daily one. Like the soft light that emanates behind Correggio's Christ, Jesus calls your soul, attracting you to himself. Rest in the love of the Redeemer, recalling how Jesus has called you and has been ever-present in your life.

Why has Jesus invited you? The *Catechism of the Catholic Church* teaches us that "man is made to live in communion with God in whom he finds his happiness" (*CCC* 45). But though our eternal life in God is central, we are called in this life to shed Christ's light on the world so others might experience the love of Jesus. "So we are ambassadors for Christ, as if God were appealing through us. We implore you on behalf of Christ, be reconciled to God" (2 Corinthians 5:20), Scripture says. Consider your relationship with Jesus and spend a few moments contemplating your response to the Lord's invitation. Have you shared Jesus' love with others in your life this week?

At the end of this meditation, we turn our attention to the *putti* in Correggio's painting. Look at the four in the lower register. The celestial toddler on the right cuddles up to Christ in confidence and trust. She

represents for us the little souls who love God, finding comfort in the call and Lordship of Christ. Another child on the left turns away, reaching out while looking back up at his Redeemer. But, the final two figures are hidden and peer out at us as if to ask: *How will you respond to this loving Redeemer who calls you?* As you continue to meditate and pray, let these little ones challenge you to nurture a sincere and loving dialogue with Christ the Redeemer.

# PRAYER AND REFLECTION

Lord, there is no one like you! Help us know you so truly that we will never stop loving you. Let our love for you be sealed so deeply within us that we will never cease to follow you. Amen.

- Recall your favorite image of Jesus presented in the Gospels. What is it about this image of Jesus that touches your soul? Stay with the image for several minutes and allow the Lord to speak to you through it.

- Look upon the image of *Christ the Redeemer.* How will you lean upon the Lord today, entrusting him to work for your good? What pieces of your life need Christ the Redeemer?

- Pontius Pilate experienced Jesus face to face, but he was unable to grasp Jesus' words of life. Jesus speaks to us, too. When are you too busy to hear Jesus' words?

## ~ *Spiritual Exercise* ~

- Place an image of Christ in a space where you will see him often: your screen saver, a small image in your pocket, purse, or car. Let this image of Jesus remind you of your desire to follow in his footsteps. Alternate to another image when this one becomes familiar or is etched in your heart.

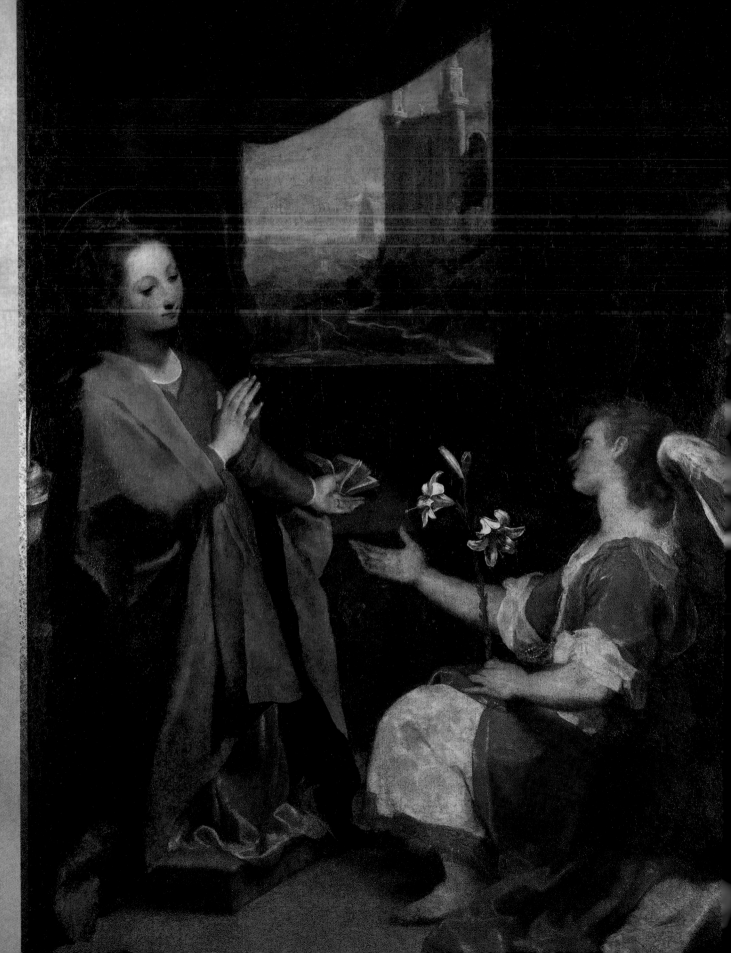

Federico Fiori, also known as Il Baroccio and subsequently Federico Barocci (circa 1533–1612), was a notable Italian Renaissance painter and printmaker whose work was highly esteemed and influential. His works foreshadowed the sensual Baroque works of Peter Paul Rubens.

# ANNUNCIATION

Federico Fiori (known as Barocci),
Vatican Museums' Pinacoteca
1582–1584

**THEME:** The Incarnation

**FOCUS OF THIS MEDITATION:** God's love for us is infinite. Jesus became human, a newborn babe, in order to open the path to heaven for us: *The Word became flesh and dwells among us.* May we come to appreciate the humble love of Jesus, who took on flesh to carry us to God.

◄ *Annunciation* was painted by Barocci in the years 1582–1584 for the chapel of Francesco Maria II della Rovere, duke of Urbino. His chapel was located in the Basilica of Loreto in Italy. The story of the annunciation dominates the composition, but in the background we view a window that opens to capture the duke of Urbino's palace.

Federico's brushwork is amazingly delicate, creating an ethereal quality whose sfumato is rivaled only by that of Leonardo Da Vinci. Depicted here, the sacred event is rendered very simply, full of light and an idyllic atmosphere. The flushed, pale skin created by the artist is reported to have greatly inspired Peter Paul Rubens on his voyages to Italy.

# SCRIPTURE MEDITATION

### LUKE 1:26–38

*In the sixth month, the angel Gabriel was sent from God to a town of Galilee called Nazareth,*

*to a virgin betrothed to a man named Joseph, of the house of David,*
*and the virgin's name was Mary.*

*And coming to her, he said, "Hail, favored one! The Lord is with you."*

*But she was greatly troubled at what was said and pondered what sort of greeting this might be.*

*Then the angel said to her, "Do not be afraid, Mary, for you have found favor with God.*

*Behold, you will conceive in your womb and bear a son, and you shall name him Jesus.*

*He will be great and will be called Son of the Most High, and the Lord God will give him*
*the throne of David his father,*

*and he will rule over the house of Jacob forever, and of his kingdom there will be no end."*

*But Mary said to the angel, "How can this be, since I have no relations with a man?"*

*And the angel said to her in reply, "The holy Spirit will come upon you, and the power of the*
*Most High will overshadow you. Therefore the child to be born will be called holy, the Son of God.*

*And behold, Elizabeth, your relative, has also conceived a son in her old age,*
*and this is the sixth month for her who was called barren;*

*for nothing will be impossible for God."*

*Mary said, "Behold, I am the handmaid of the Lord. May it be done to me according*
*to your word." Then the angel departed from her.*

Now we begin to focus our meditation on the concrete events in the life of Christ and the Holy Family. Learn to contemplate these events as if you are physically present in the Gospel narrative. Ignatius believed we are capable of entering the Gospel stories if we imagine ourselves present therein. Visualize yourself in the Gospel scene we just read, as the angel is announcing to Mary that she would be the Mother of God—bearing Jesus to the world. Bring your senses to the scene. What do you see, hear, touch, and smell? The angel Gabriel casts heavenly light on our young virgin, a prayerful Palestinian woman. What else do you see in the room where this momentous event took place?

Explore the thoughts and emotions of Mary and Gabriel through your senses. Doing this will move your affections more easily. Allow your will and intellect to stay in the narrative. Then direct your prayer to Jesus, committing to more deeply imitate the virtues of those Gospel personalities you are contemplating.

The annunciation is one of the richest and most decisive moments of God's action in salvation history, for this was the moment that we were first told of the Incarnation—*the Word become flesh*. All of salvation history—past, present, and future—ceases movement to reverence this mystery of faith. *God became man and dwells among us. Nothing greater will happen again*, theologians tell us.

It is true that God conversed with the world before. The Creator formed paradise, communicated with Noah before the Flood, spoke to Moses in the burning bush and gave the Israelites the Law, anointed Saul and David as kings of Israel, and finally sent the prophets. Yet something new is about to happen in this little house of Nazareth.

Other powerful movements of historical importance took place simultaneously, likely well known within the Roman Empire, a great worldly kingdom. The Lord chose to enter the world in the wider context of Roman rule. But who recalls other events that took place on the day the *Word became flesh*? Nothing on earth—all the halls, senates, courtrooms, or battlefields—will ever outdo the miracle of this moment. God the Creator asks a lowly creature for permission to enter into human history. Jesus' flesh and blood, soul and divinity are now being knit together in the womb of Mary, *Theotokos*.

Barocci portrays the angel kneeling before the Virgin, signifying God's humility. Gabriel is one of the most powerful angels in heaven. This is the messenger whom God selected to deliver the most critical word to God's people through Mary of Nazareth. Gabriel's golden robes flow with majestic grandeur, signifying regal dignity.

In the fullness of time, when all things are prepared, God sends the heavenly visitor to the poor home of a provincial town. We can imagine what the room must have looked like—it was small, simple, tidy. Yet the artist focuses us on the two figures in conversation by darkening the surrounding space. Notice the angel's pose—as a lover proposing to his beloved, or a knight before a maiden. The divine emissary genuflects in an imploring and respectful gesture. Powerful wings show an otherworldly origin, yet the elegant human form persuades us that this figure is undeniably real. The angel extends a right hand to express the Almighty's request, while the other hand offers a lily to signify the purity of the Blessed Virgin.

In fact, Mary's virginity is a carefully guarded treasure she fears she will lose at this moment. She had already promised herself to the Lord, so she wonders how she will be found with child, having not known a man. Both a contradiction and a mystery—the notion of bearing God to the world would not have been an easy idea to wrap one's mind around. Nor would it have seemed likely to this young woman that God would implore assent from a creature—a woman. Sometimes God tests us by asking us to surrender our treasure to him, yet in reality the Lord is often transforming and purifying our desires. Be open to the prompting of the Holy Spirit, allowing the Sanctifier to nourish and speak to your soul.

See how Mary steps back in uncertainty, with her two hands held up, steadying her as she prepares to respond to the will of God. She takes a moment before responding, with her hands opened as if to form a window into her heart. Did she whisper a prayer to Yahweh during this moment of unknowing? Her left hand is held open reflecting her surprise, confusion, and ultimate surrender. But Mary's right hand is firm and steady, indicating the faithfulness and constancy of this unlikely ark, or God-bearer. The young woman has always been prompt to respond to God's call in her life, yet this experience was different. God was asking her to trust with her whole being that *all things are indeed possible* in her life. Her reason stops in reverence to the mysteries of God. If we desire to see God transforming our lives, we must follow Mary's example of faith.

Reflect upon Mary's quandaries as God acted within her heart. Notice how she pondered and adored the mystery of the Incarnation, though she could not possibly comprehend it all at once. Ask God to speak to your heart now, for God desires to enact great things in you. Undoubtedly the Lord is calling, inviting, and challenging you to respond. Angels come to us in different forms, moving our consciences and inviting us to pray and repent. The Lord invites us to trust more, to love more.

In the foreground of the painting, Mary stands on a small pedestal, enthroned by the artist for her *Fiat*—her "yes" to the will of God. Our first mother's "no" paved the way for the new Eve to set into motion God's new beginning. In the background of this image, an open window leads to the world beyond the mystery. The world was waiting for Mary's response, though no one could have guessed then that this singular event was a salvific moment for all people, encompassing all of time. In the silence of Mary's heart, God's plan took shape. For no one knew God's plan when it was revealed to Mary. Yet her response sealed our common destinies: *Fiat mihi secundum verbum tuum. Be it done unto me according to thy word.*

# PRAYER AND REFLECTION

Lord, we pray with Mary, *let it be done to me according to your word*. Amen.

- Stay with the mystery of the Incarnation. Is God calling you to say "yes" to something today that you do not understand? Reflect upon Mary's response to God's will and pray that you, too, are able to follow her exemplary example of faith.

- Spend time with the Scripture reading that began this meditation. Enter the scene in Nazareth, exploring your senses as you watch the annunciation unfold. Tune in to the voice of God as you meditate upon this momentous event in salvation history.

- Pray for openness to the will of God and the grace to say "yes," asking the Lord to direct your steps today and every day of your life.

## Spiritual Exercise

- Follow Mary's example of service by becoming a servant of another person today. Tend to the needs of others, reflecting positively the gift of service asked of us by mother Church and our Mother Mary. Let God's will be done!

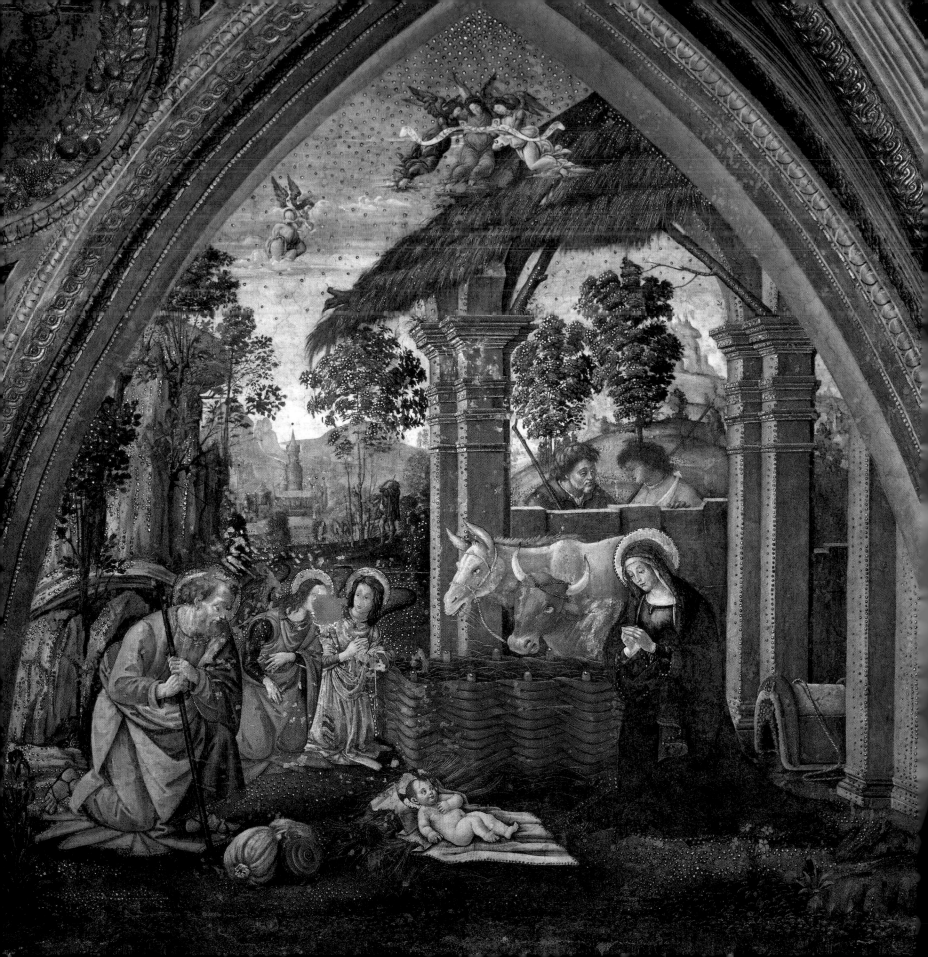

# THE NATIVITY

Bernardino di Betto (called Pinturicchio)
Room of Mysteries
1498

**THEME:** Christ's birth, the Nativity in Bethlehem

**FOCUS OF THIS MEDITATION:** By reflecting upon the birth of Jesus, we are able to see in a new way. This central mystery of our faith unveils for us something of the desire of God as we meet Jesus in an unexpected way, as a newborn babe.

◀ The Room of Mysteries is one of several rooms located in the Borgia Apartments. The Borgia takes its name from the Spaniard Rodrigo de Borja y Doms, who became Pope Alexander VI (1492–1503) and is known for expanding Catholicism to the New World. Today the Borgia Apartments serve as the pope's private chambers, originally decorated by Bernardino di Betto, who is better known as Pinturicchio (circa 1454–1513). Assisted by members of his workshop, he completed the private rooms at a rapid pace between 1492 and 1494. Documents state that the pope suggested multiple ideas to this creative and eclectic painter. We appreciate, therefore, not only the intelligence of the artist, but also the vision for these masterpieces shared by Pope Alexander VI.

One of the techniques Pinturicchio used is called *tempera a secco*, where one paints on a dry surface with colored pigments mixed with egg yolk or another glutinous material. Tempera painting is long-lasting and durable. The technique was used for millennia, having even been found on sarcophagi (funeral receptacles for corpse burial) in the early Egyptian period. This method was primary among artists until it was replaced by oil painting around AD 1500. Michelangelo, too, used *tempera a secco* to create art for the Sistine Chapel. Using this technique enabled Pinturicchio to correct his craftsmen's work where he needed to reach minute perfection.

Pinturicchio also combines other entirely original artistry in this work to embellish the image. Marble, stucco, leather, gold, paper, wood, Spanish tile, and wax are materials the artist uses, harmonizing them uniquely in order to give the luxurious interior warmth and cohesion.

# SCRIPTURE MEDITATION

## LUKE 2:4–20

*And Joseph...went up from Galilee from the town of Nazareth to Judea, to the city of David that is called Bethlehem, because he was of the house and family of David, to be enrolled with Mary, his betrothed, who was with child.*

*While they were there, the time came for her to have her child, and she gave birth to her firstborn son. She wrapped him in swaddling clothes and laid him in a manger, because there was no room for them in the inn.*

*Now there were shepherds in that region living in the fields and keeping the night watch over their flock.*

*The angel of the Lord appeared to them and the glory of the Lord shone around them, and they were struck with great fear.*

*The angel said to them, "Do not be afraid; for behold, I proclaim to you good news of great joy that will be for all the people.*

*For today in the city of David a savior has been born for you who is Messiah and Lord.*

*And this will be a sign for you: you will find an infant wrapped in swaddling clothes and lying in a manger."*

*And suddenly there was a multitude of the heavenly host with the angel, praising God and saying: "Glory to God in the highest and on earth peace to those on whom his favor rests."*

*When the angels went away from them to heaven, the shepherds said to one another, "Let us go, then, to Bethlehem to see this thing that has taken place, which the Lord has made known to us."*

*So they went in haste and found Mary and Joseph, and the infant lying in the manger.*

*When they saw this, they made known the message that had been told them about this child.*

*All who heard it were amazed by what had been told them by the shepherds.*

*And Mary kept all these things, reflecting on them in her heart.*

*Then the shepherds returned, glorifying and praising God for all they had heard and seen, just as it had been told to them.*

In the richly decorated Room of the Mysteries, a room of the faith, Pinturicchio paints an ornamented Nativity scene. The artist gives every scene the royal attention it deserves in his unique style. The painting decorates Pope Alexander VI's chambers, gloriously illustrating the Gospel account of Jesus' Nativity.

Jesus is born as a poor babe, with no place to lay his head. Although his parents arrive in the city of their ancestors, they cannot find a place that has room for them on this holiest of nights. Yet the seed that fell to the earth and died has borne fruit. Jesus' protective branches spread throughout the world in order to renew and recreate the people of God.

Focus your heart and attention on each of the characters in this painting and attempt to experience what they did. Joseph kneels on one knee to the left of the fresco. Mary, having just given birth, marvels along with her husband at the new life before her, *the Prince of Peace*. What must Joseph have suffered just hours before this scene takes shape? He was asked to raise the future king and Savior of the world, yet he finds himself unable to provide warmth and security for his little family.

We often feel inadequate or incapable of accomplishing the work God has ordained for us. St. Joseph can be a great friend to us in these moments, for he could not fathom the call of God, either. But he remained faithful, not to be defeated by danger and unknown paths. Pictured here, Joseph is depicted with a staff in his right hand, symbolizing the authority granted him to provide for the Holy Family in order to protect and guide them. The staff also signifies that Joseph has descended from a long line of patriarchs, the stepfather of the promised Son of David who is now born to us. His posture foretells the task before him. Positioned on one knee, he adores, while he is ready to step off with his left foot upon the command of the Lord. Recall how, after Jesus' birth, an angel spoke to Joseph in a dream, forewarning him of the snares ahead.

Let's now turn our attention to Mary, the Blessed Virgin. Her garb is royal blue, and she is positioned with hands folded. Joyfully she kneels in awe of her newborn child. Keenly aware of the mystery she contemplates, her own flesh witnessed the majesty of the Most High. During her pregnancy, for nine months she must have wondered: *who is this king of glory* growing in my flesh, sewn in my womb? What will he look like and who will he be?

Already she would have spoken to him when she couldn't sleep, prayed to him when she didn't

understand, and contemplated this mystery as she daydreamed. And now, the *Word made flesh* lay before her. She delights to hold and kiss the little one who is the *King of Kings and Lord of Lords*. Beholding God's glory, she is the first to look upon the unseen face of God. What joys must have filled her heart on that day? The wonder must have been overwhelming. Contemplate this moment with Mary and try to see Jesus through her eyes. Ask our Lady to help you see her Son as she did, that you might see and know him more intimately.

The Savior of the world lay directly on the open grass, naked. A rich red cloth is beneath Jesus, and hay from the trough serves as his pillow. He is not tucked away but can been seen in full view by passersby, viewers who adore him from below. Jesus came for all and, even in his first moments, was sent to all. The scene is populated in this painting with those first called to behold his coming.

Two angels who sang from the heavens now converse with one another. Their faces marvel as they behold the sight before them. They had just proclaimed to the shepherds *good news of great joy*, and now we witness them exulting as they sing: *Glory to God in the highest and on earth peace to those on whom his favor rests*. As the Son of God, the angels would have known and worshiped the second person of the Holy Trinity from all eternity.

The mystery of God's love is phenomenal and past all grasps. It is sometimes said that the mystery of the Incarnation is the one that caused Lucifer, the fallen angel, to rebel. How could God become man? The perspective is ours. Though utter nonsense to some, this gift of God's self to the world is our all in all. Depicted here, two angels represent the heavenly hosts who witness the glory of God manifested on this holy night in Bethlehem of Judea.

And now turn your attention to the two men, apparently the shepherds, standing behind the stall and speaking with one another. Scripture tells us that they came with haste to verify what the angel had said. Indeed, they did find the Child lying in the manger. Notice how they came quickly, without delay. If they posed a question, we no longer know of it. The shepherds simply wondered and responded to the invitation of God's messenger.

In our own time, busyness preoccupies our days, our lives. The shepherds did not hesitate to respond to God's message. They set an example for us, witnessing their faithfulness to God's call. Today, even the most faithful struggle to live the message of Jesus. We often neglect prayer, trying to

fit God into our busy schedules only when convenient. Upon hearing the good news the shepherds immediately sought after the Messiah. They soon realized with great joy that this long-awaited one was worth all their attention. Look to the shepherds, following their example of diligence and faith.

The fact that God became man in Bethlehem changes everything. This is the good news we all long to hear and experience. No other activity or moment in our day is more important than spending time with our Lord Jesus, the holy Infant born to us in the most unlikely of places: a cave in Bethlehem of Judea. Lying in the manger, he awaits us still, beckoning us to open our hearts to make room for him in our inn.

# PRAYER AND REFLECTION

Lord, help us to liken our spirits to yours, becoming little so that others may know you. We implore you to assist us to live with humility, obedience, and love by following the example of the Holy Family and the shepherds. Dear Jesus, help us avoid self-interest and vainglory while giving us the courage and love to seek God's will for our lives. Amen.

- Look at Pinturicchio's *The Nativity*. Who do you notice in this image? What virtues does the character that most draws you portray here?

- Heaven and earth collide in this extraordinary event. Angels and human beings worship the newborn king. What homage will you bring to the Infant Savior today? What road do you need to take to arrive at Christ's Nativity?

- Reflect for a moment on your own nativity. Where were you born and how did you enter the world? Why do you think you were born in this place? What mission is God giving you?

## Spiritual Exercise

- Spend time reading with your children or grandchildren. If you are not blessed to have your own, help a friend with his or her children.

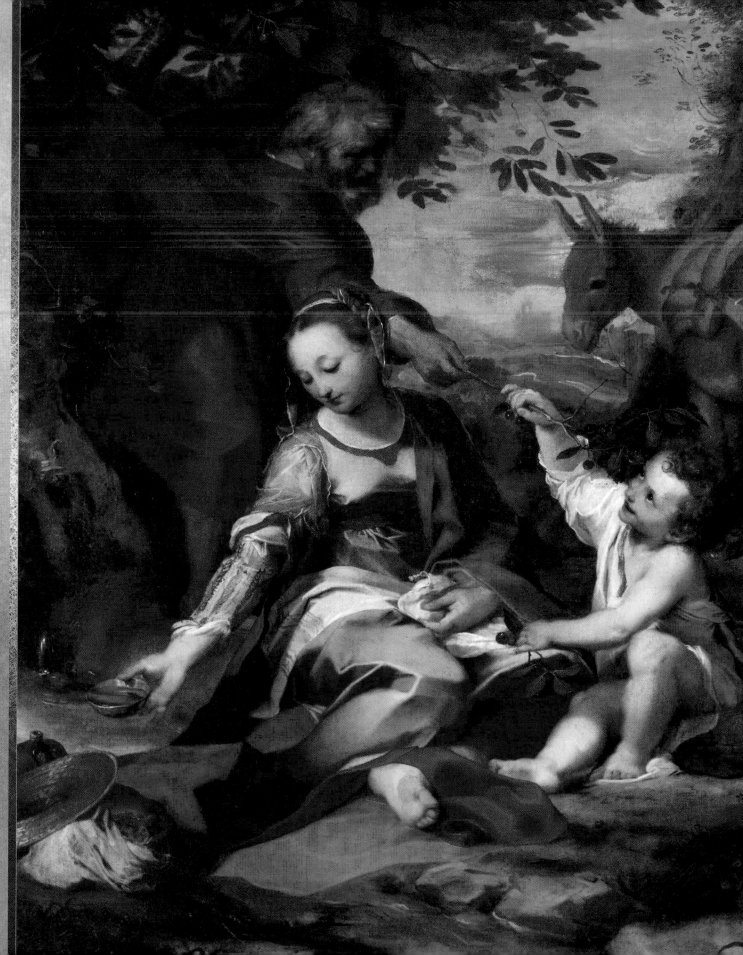

Federico Barocci
(circa 1533–1612)
is considered to
be one of the most
talented artists
of late sixteenth-
century Italy. This
star of artistry came
upon the scene after
Antonio Allegri da
Correggio and before
Michelangelo Merisi
da Caravaggio.
He was born a little
more than ten years
after the death of
Raphael in the same
town of Urbino. The
century claims both
artists with their
masterworks. Briefly
in Rome, Barocci
was inspired by the
works of Raphael and
admired the elderly
Michelangelo.

# REST ON THE FLIGHT TO EGYPT

Federico Fiori (known as Barocci),
Vatican Museums' Pinacoteca
1570

**THEME:** The flight into Egypt

**FOCUS OF THIS MEDITATION:** The hidden years of the Holy Family are veiled in mystery. Still, we are invited to prayerfully enter. Like a window, this painting shows the family of Jesus in flight. May we imitate the virtues and lives of Jesus, Mary, and Joseph as we endure our own personal trials and tribulations.

◄ Rome was taken with the holiness and zeal of the lively Philip Neri, a future saint who arose during this artist's era. In the simple gestures of daily life, Barocci sought to derive artistic form from the teachings of this holy man. In fact, Philip was said to have experienced ecstasy by merely looking upon Barocci's *The Visitation*, painted for the future saint's new church.

In 1563, Federico fled from Rome, having fallen ill with intestinal problems. He suspected that rivals had poisoned him out of jealousy. So he returned eventually to his hometown of Urbino. There he was sought out by patrons from all over the world and continued his painting and design work. More than 2,000 sketches survive from that era.

Fascinated by the elegance and variety of the human form, Federico Barocci fused charm and compositional harmony with an unparalleled sensitivity to color. Tenderness, sweetness, and intimacy are common sentiments experienced by the artist's mix of color, form, and composition.

# SCRIPTURE MEDITATION

## MATTHEW 2:13–23

*When they had departed, behold, the angel of the Lord appeared to Joseph in a dream and said, "Rise, take the child and his mother, flee to Egypt, and stay there until I tell you. Herod is going to search for the child to destroy him."*

*Joseph rose and took the Child and his mother by night and departed for Egypt.*

*He stayed there until the death of Herod, that what the Lord had said through the prophet might be fulfilled, "Out of Egypt I called my son."*

*When Herod realized that he had been deceived by the magi, he became furious. He ordered the massacre of all the boys in Bethlehem and its vicinity two years old and under, in accordance with the time he had ascertained from the magi.*

*Then was fulfilled what had been said through Jeremiah the prophet:*

> *"A voice was heard in Ramah,*
> *sobbing and loud lamentation;*
> *Rachel weeping for her children,*
> *and she would not be consoled,*
> *since they were no more."*

*When Herod had died, behold, the angel of the Lord appeared in a dream to Joseph in Egypt and said, "Rise, take the child and his mother and go to the land of Israel, for those who sought the child's life are dead."*

*He rose, took the child and his mother, and went to the land of Israel.*

*But when he heard that Archelaus was ruling over Judea in place of his father Herod, he was afraid to go back there. And because he had been warned in a dream, he departed for the region of Galilee.*

*He went and dwelt in a town called Nazareth, so that what had been spoken through the prophets might be fulfilled, "He shall be called a Nazorean."*

*Ask Mary to intercede for you*
*and help you trust more deeply*
*in her Son, Jesus.*

———————————————

Barocci focuses his delightful brush on a blissful moment in the life of the Holy Family: *Rest on the Flight to Egypt*. This flight would not have been easy for the young Jewish couple and their toddler. Still, joy and peace reigned in their hearts as they continued to trust in the unfolding of God's plan. Though their story  remained incomprehensible, the Holy Family was content to know that the Lord was directing their path.

The artist magnificently captures for us a day in the life of the young family. They partake of a simple meal while making their arduous journey as if to remind us of Jesus' words: *My yoke is easy, and my burden light*. And their example lights the way for us by encouraging us to carry our daily crosses with grace.

Imagine that after a few hours' journey at the start of the day, the little group stops under a cherry tree to enjoy some moments of rest. The sun is rising, but its effects are still to be felt as both Mary and Joseph carry their coats around them. 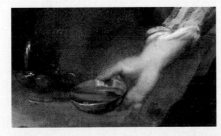 Mary is seated comfortably at the center of the family scene where she busies herself by collecting water. Will she offer 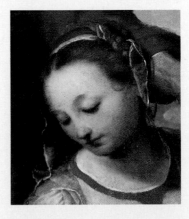 the water to Jesus? Maybe she will use it to wash his little hands. Perhaps she will use the water to wash the cherries before they eat.

Examine Mary's face in Barocci's painting. See how her countenance is full of serenity and joy, even though the woman

seems to be lost in thought or contemplation. She is a mother who carries so many things in her heart. What wondrous daily events had broken into the lives of Mary and Joseph, and what must have the *blessed one* have pondered within her own being? A wellspring of wisdom graced this young maiden *highly favored* by the Lord, and yet God's plan still must have perplexed her in its unfolding. Still she trusted and remained faithful. Speak to the Blessed Mother about her life at this moment. *What mysteries did she contemplate, and what struggles would she have endured?* Ask Mary to share her interior life with you. Take a few moments in prayer to share your own questions and struggles, asking Mary to intercede for you and help you trust more deeply in her Son, Jesus.

St. Joseph is visualized standing behind the Madonna, reaching up into the tree in order to offer a branch to the Child Jesus. His strong arm and hand extend straight downward toward the Child, both hands grasping the wood from opposite ends—one giving and the other receiving. This simple domestic gesture enacted by Joseph foreshadows events to come. The heavenly Father will one day offer Jesus the wood of the cross, asking him to sacrifice himself for the world. And Jesus will joyfully embrace the excruciating task before him. The Virgin remains at Jesus' feet, witnessing the exchange of love between Jesus and his stepfather, an exchange that will 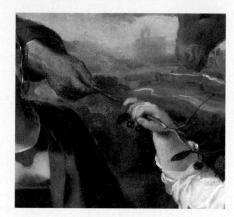 likewise be seen between Jesus and the heavenly Father at the cross when her Son suffers and dies for all the world.

The cherry tree that is providing the family with shade often symbolizes heaven while the sweetness of its fruit denotes the delights of the blessed. Yet in this context, we can also relate  its deep red hue to the suffering and passion that awaits the Holy Family. Joseph's vestments are also a strong red, creating a tonal balance along with the small fruits against Mary's blouse and dress. Although there is a pervading sense of joy and familial warmth in this painting, it also hints at this family's special vocation to bear the cross—something we, too, must do if we are to follow Jesus.

The playful Child sits up energetically, reaching happily toward Joseph, who offers him a new toy that is at once both food and fun. Yet Jesus' gaze as he looks toward his stepfather is one of understanding, composed of maturity beyond his years. This simple family picnic reminds us that every act in the life of Christ was salvific. Small and large events in the daily life of Jesus have shifted our story. This is why we must encounter the events in Jesus' life as if we were present there. His Incarnation, birth, life, passion, and resurrection all brought us our salvation—making us part of Jesus' story.

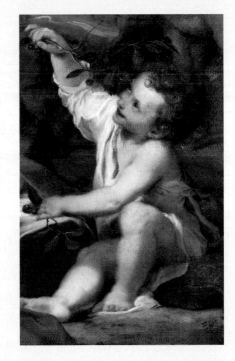

Jesus' saving work took place on earth—Bethlehem, Egypt, Nazareth, Jerusalem—each playing its contributing note as the whole movement of love swelled to a climax on the cross. Similarly, our experiences are fused with God's goodness. There are no acts in our daily lives that are inconsequential if we but love and accept God's graces. Offer this day to God with your whole heart, mind, and strength. Become aware of God throughout your day. How is the Lord moving you, inviting you, and calling to you? *You are my beloved one!*

Two details in this painting hint toward the future of this most special of families. First, an observant beast stands guard in the background—a donkey. This creature that carries the family from the Promised Land to Egypt reminds us of the animal that will eventually transport Jesus on his triumphal entry into Jerusalem. Driven out by an envious king, Jesus will one day be acclaimed as the son of David, Messiah, King of Glory. Still, the family will enjoy many years of simple living between now and then. Jesus will receive formation and loving instruction from his blessed parents before entering into his public ministry, for Mary and Joseph were entrusted with the care of the holy one of Israel.

Secondly, notice how the artist places the heel of the Virgin's foot in full view, likely alluding to how her seed will crush the serpent's head. It is Mary's humility that crushes the serpent, for she willingly submitted to God's plan for her throughout her life. The new Eve rests with her Son, the new Adam, at the base of another tree in a new garden. This time they obediently partake of the fruit of this tree, a bitter journey at times as they are exiled to Egypt even now. But because the Holy Family allowed God to enter their lives, Jesus became the source of eternal salvation for all.

*Offer this day to God*
*with your whole heart, mind, and strength.*

# PRAYER AND REFLECTION

Jesus, provide us with the courage to travel alongside you and your blessed parents on their obedient flight into the foreign land of Egypt. We desire to learn the virtues of your Holy Family in order to live these virtues, though imperfectly, in our own. Amen.

⚜ Though the Holy Family is pictured here at rest, we recall the Gospel passage that tells us they left during the night in haste. Think about the family's flight to Egypt—the place where the Israelites were enslaved. What might those years have been like for Jesus, Mary, and Joseph? What joys and struggles would they have endured?

⚜ Do you have beloved friends or family members who are currently away from you in other cities, states, or countries? Spend a few moments thanking God for the gift of friendship and family. Ask God to bless your relationship with one another by kindling your love for one another, keeping it aflame.

⚜ Jesus entered the world that all might have life in abundance. Yet our world is filled with broken hearts and lives. Abuse, violence, tragedy, cruelty, and arrogance erupt around every corner, even in our own homes. How might you imitate the Holy Family today and restore order by loving those closest to you? Name or list some simple activities that will help you serve your family, coworkers, friends, and enemies.

## ～ Spiritual Exercise ～

⚜ Decide to keep the Lord's day holy by making each Sunday a day of family rest and renewal. Go on a picnic, out to lunch, or visit an elderly relative after Mass.

Born Pietro Vannucci around 1446 in Citta della Pieve, Umbria, Italy, Perugino was a painter of the Umbrian school of the High Renaissance. His best-known student was Raphael, whose work also is featured in this book.

As best as can be determined, Perugino likely began to study painting in Perugia, in local workshops. He was known to have worked with such painters as Bartolomeo Caporali and Fiorenzo di Lorenzo. Some biographers say he worked alongside Leonardo da Vinci.

The painter of Baptism of Christ was one of the earliest Italian artists to use oil. Early works included frescoes for a convent of the Ingessati fathers.

Perugino also painted Adoration of the Magi for the church of Santa Maria dei Servi of Perugia around 1476. In about 1480, Pope Sixtus IV called him to Rome to paint fresco panels for the Sistine Chapel walls. The frescoes included Baptism of Christ.

Despite his moving works of Christian art, Perugino apparently had little belief in religion, openly doubting the immortality of the soul. He died in 1523 as the owner of much property, leaving three sons.

*The Baptism of Christ* is a fresco executed around 1482 to adorn the left side wall of the Sistine Chapel. Placed closest to the altar, it is the first in a sequence of illustrated stories of Christ that parallel the life of Moses in that same chapel. It is situated across from *Moses Leaving to Egypt,* a painting created by Perugino's workshop.

Typical of Perugino, the scene aligns symmetrically with the Jordan River, placed in the center of the image. The river flows toward the viewer, eventually arriving at the feet of Jesus and John the Baptist. A symbol of the Holy Spirit, a white dove, descends upon Jesus from the sky. God the Father is depicted within a luminous cloud, surrounded by flying seraphim and cherubs.

Behind Jesus, two angels patiently hold his robes, perhaps symbolizing the new grace with which the sacrament gifts us. They are surrounded by notable contemporary personalities, not unlike other works that line the side walls of the Sistine Chapel. The landscape in the background provides us with a sweeping view of Rome. Notice the triumphal arch, the Colosseum, the Pantheon, and the lithe trees that were typical of the Umbrian school from which Perugino originated. ▶

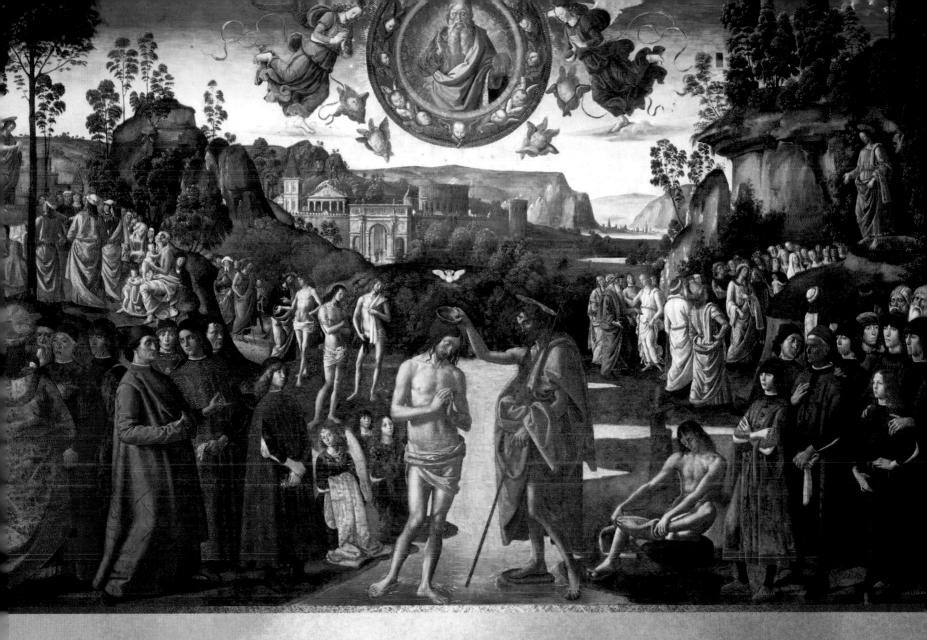

# DAY 17

# THE BAPTISM OF CHRIST

Pietro Vannucci (known as Perugino)
Sistine Chapel
Circa 1482

**THEME:** Baptism

**FOCUS OF THIS MEDITATION:** Baptismal grace strengthens our will to want the good, enlightening our minds to more easily see and accept the truth. In baptism, Christ graced us to become adopted sons and daughters of the Father. May we appreciate the grace of baptism, resolving to follow the beautiful path God has carved out for us as new creations in Christ Jesus.

# SCRIPTURE MEDITATION

## JOHN 1:29–34

*The next day [John the Baptist] saw Jesus coming toward him and said,*
*"Behold, the Lamb of God, who takes away the sin of the world.*

*He is the one of whom I said, 'A man is coming after me who ranks ahead of me*
*because he existed before me.'*

*I did not know him, but the reason why I came baptizing with water was that he might be*
*made known to Israel."*

*John testified further, saying, "I saw the Spirit come down like a dove from the sky*
*and remain upon him.*

*I did not know him, but the one who sent me to baptize with water told me,*
*'On whomever you see the Spirit come down and remain,*
*he is the one who will baptize with the holy Spirit.'*

*Now I have seen and testified that he is the Son of God."*

# We long for the Lamb of God who takes away the sins of the world.

---

St. Ignatius invites us to begin this meditation by placing ourselves in the house of Nazareth and imagining Jesus' last moments with Mary before setting out on his mission into public life. Though there is not a Scripture passage that records this historic moment, we can imagine how Mary and Jesus lived together in harmony and love. Tradition holds that Joseph passed away some time before the beginning of Jesus' public ministry; now Jesus and Mary have one another only. Yet when Jesus feels it is time embark on his mission, Mary no doubt encouraged him to follow God's will. Likewise, she would have helped him prepare for the journey ahead—spiritually and physically. Imagine the scene of Jesus' last few days in his home with Mary by using your creativity. Then consider the separation that followed. Talk with Jesus and Mary about the mysterious moment taking place at the onset of the Lord's public ministry.

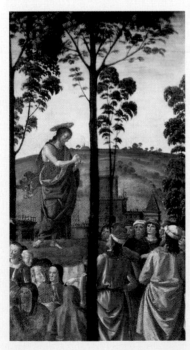

After departing his home, one of Jesus' first acts was to be baptized by John in the Jordan River, as our Gospel reading reveals. He walks decisively toward a life that will be very different exteriorly, but interiorly it will remain the same. Jesus always embraced the will of the Father out of love, and by his example he teaches us to do likewise.

Perugino populates his scene with many figures, and thus it can be difficult to read. The various activities taking place within it might even distract us as we pray. Several scenes are occurring all at once, and they unveil different episodes in the drama surrounding Jesus' baptism.

The key is to focus on each little scene as if it were the only one. In the upper left corner, the Baptist preaches his gospel of

repentance and salvation. He challenges all his listeners to break away from sin by turning toward the Lord Jesus, who is nearby. Changing our hearts and drawing near to God is a goal of these Spiritual Exercises, for God desires to know us and to love us intimately. Discovering the newness of life that is found in Christ then becomes the heart of our quest. We desire the new life preached about by John and offered by Jesus Christ. We long for the *Lamb of God who takes away the sins of the world.*

Open your heart as you pray and tell Jesus how much you want to know him. Renew your baptismal promises by turning away from the temptations offered by the world, the flesh, and the devil.

> *God calls us also to be light for the world and salt for the earth.*

On the opposite upper right corner, Jesus is seen preaching for the last time before entering his baptismal font, the waters of the Jordan. The fervent seekers gather around the Lord as he preaches in the midst of much activity. Jesus' apostolic mission was neither as tranquil nor as serene as Perugino's mural depicts.

In our own lives, activity and bustle sometimes try to swallow us whole. There are so many noises and needs vying for our attention. Perhaps we long for the contemplative life accompanied by silence and serenity as a means to connect with God's presence and grace. It is true that prayer and contemplation are essential within the spiritual life, but God calls us also to be *light for the world* and *salt for the earth.* The Lord longs to enter into the noise, distraction, and mess of our daily lives. We are the hands and feet of Jesus Christ in the world today—a world in need of love, wisdom, mercy, and knowledge of the things of God. God has called you into this particular moment of history to embrace Christ's light and shine it upon all in need of good news.

Just as Jesus was called out of his hidden life at Nazareth into his public ministry through the baptismal waters of the Jordan, we are likewise christened to wade into our daily lives as followers of Jesus. Our baptism has graced us with newness of life, illuminating our beings with the source of all life—God the Father, Son, and Holy Spirit.

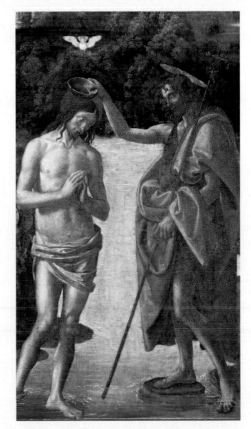

The main focus of the fresco centers on the main event—the baptism of Jesus. The Lord approached John the Baptist, who was busy baptizing others. Notice it is Jesus who seeks out his cousin John. The Son of God wades into the water to be purified by a mere human agent. Thus the Lord's first public act of ministry is to humbly surrender himself to us by being baptized. Though Christ was not in need of purification and forgiveness, he nonetheless steps into the water to show us the way to God. It all begins with our baptism: We must follow Christ, the Way.

Jesus' act was also a sign to John that the forerunner's ministry had ended. The Baptist had accomplished his part by preparing the way for the Lord, and now the one for whom he preached had arrived. Testifying that Jesus is the Lord, John declares, "Behold the Lamb of God!" Contemplate Jesus' humility, asking him for the grace to know him as *the Lamb of God who takes away the sins of the world*. Then determine yourself to humbly follow the Lord's example of service to others.

Jesus' messianic ministry is unexpected, palpably different from our human understanding of power. Powerful rulers through the ages have obliged others to submit to them, often violently dominating their people. But Jesus humbly approaches us with the Spirit of truth, illuminating our flawed understanding of God's way—a way of love. In our skewed world, we are often attracted to the beautiful, rich, and powerful. Yet Jesus tells us we become great when we are willing to serve others. In his ministry, he sets an example for us by cleansing the souls of sinners, dining with the

unwanted, and washing the feet of his disciples. He *lifts up the lowly, humbling those who have been exalted, for the kingdom of heaven belongs to such as these.*

Recollect in prayer Jesus' humility and ask the Lord to teach you to be like him. Where might you find more ways to serve? How will you imitate the Lamb of God, the humble, silent, and innocent one who took upon himself the sin of the world so that you could live?

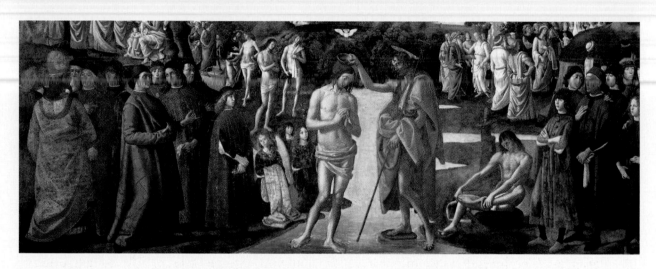

*It all begins with our baptism:*
*We must follow Christ, the Way.*

# PRAYER AND REFLECTION

Jesus, champion of the humble, there is no one like you! May we know you so truly that we never stop loving you, and may we love you so deeply that we never stop following you. Amen.

- Select a scene within the image of the *The Baptism of Christ* to focus upon. What draws you to that particular scene? Imagine you are witnessing the event as well. What do you experience: sight, sound, touch, smell, or taste?

- Think of five people in your life today who are struggling with large or small crosses. Whisper a prayer to Jesus for each of these people, uniting their suffering with your own. Then decide to do a small act of kindness for at least one of the people you brought to the Lord. (Examples: Write an e-mail or a letter, invite him or her to an event with you, or simply give a word of encouragement).

- Jesus humbled himself so we might have life. Can you become little in order to help others find Jesus? Are you willing to love when it hurts to do so?

 *Spiritual Exercise*

- Recall the rite of baptism and how this sacrament drew you into the family of the Church— God's family, the communion of saints. Invite someone you know who has not attended Mass recently to attend with you, or simply welcome that person to visit your own family. If you do not remember the day of your baptism, find out when it was and mark your calendar. Then, on that day celebrate the day you were baptized into the family of God.

The Vatican Museums have an amazing collection of early-Christian sarcophagi that testify to the mature and courageous belief of our early-Christian brothers and sisters. Inspired Christian artists sculpted sarcophagi with biblical stories in the third to fifth centuries. These box-like funeral receptacles were created for the burial of a corpse, but due to expense were often purchased by the more wealthy Christians of that time. These burial boxes are the earliest large Christian sculptures in existence.

These stones would have also spoken volumes to early Renaissance sculptors and painters such as Michelangelo, for they were the earliest and best attempts at biblically inspired art, a form created by classical antiquity.

During this period, the canons of the Old and New Testaments had yet to be formalized, and still Gospel narratives were being etched in stone. Stories in the early centuries were often circulated through oral tradition, though evidently there were recorded texts that we read generally in translation today through Scripture.

Likewise, Christian arguments were being debated and resolved in this era. Consider the formulation of the Nicene Creed in 325 that is currently the most widely used profession of faith in Christian liturgy.

Early-Christian sarcophagi were made of marble and carved in bas-relief (an impression that is raised above the background), a customary art in Rome and Greece for the mortuary. The sculptors gave public and permanent witness about essential truths by creating these burial boxes, for some Christians were still persecuted and martyred at the time they were being created. Artists or their patrons would select stories that reflected themes appropriate for a tomb. For example, the healing power of Christ was one such theme, for Jesus' miracles magnify his victory over sin and death. Christians believe and profess that the one who raised Jesus from the dead will likewise raise them up to eternal life. This particular sarcophagi is a sculpture of a whole series of Gospel stories, including the woman with the hemorrhage. ▶

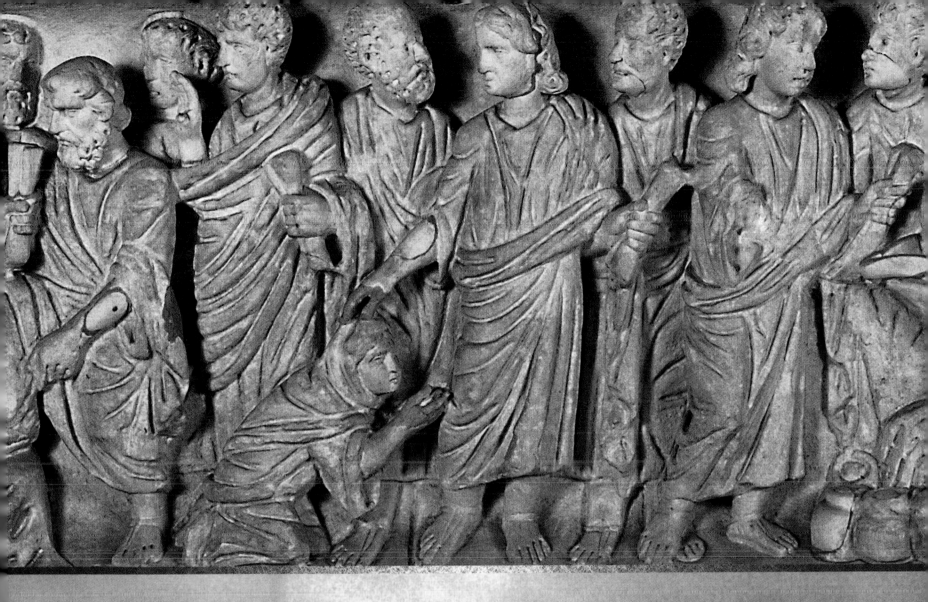

# CHRIST PERFORMING MIRACLES, HEALING SCENES

Unknown artist
Pio-Christian Museum in Vatican City
Circa third to fourth century

**THEME:** The healing touch of Jesus

**FOCUS OF THIS MEDITATION:** No need, weakness, or sin is too small for Jesus to want to help, heal, and forgive. The Lord is never too tired, busy, or important and will always extend his aid to all who ask or are in need. We embrace Jesus, admiring his loving care for us with gratitude and faith. Let us be open to the Lord's healing touch, the one who longs to mend our wounds and help us through afflictions.

# SCRIPTURE MEDITATION

### LUKE 8:40–48

*When Jesus returned, the crowd welcomed him, for they were all waiting for him.*

*And a man named Jairus, an official of the synagogue, came forward. He fell at the feet of Jesus and begged him to come to his house,*

*because he had an only daughter, about twelve years old, and she was dying.*
*As he went, the crowds almost crushed him.*

*And a woman afflicted with hemorrhages for twelve years, who [had spent her whole livelihood on doctors and] was unable to be cured by anyone,*

*came up behind him and touched the tassel on his cloak. Immediately her bleeding stopped.*

*Jesus then asked, "Who touched me?" While all were denying it, Peter said,*
*"Master, the crowds are pushing and pressing in upon you."*

*But Jesus said, "Someone has touched me; for I know that power has gone out from me."*

*When the woman realized that she had not escaped notice, she came forward trembling.*
*Falling down before him, she explained in the presence of all the people why she had touched him and how she had been healed immediately.*

*He said to her, "Daughter, your faith has saved you; go in peace."*

For the first time in these exercises, we will be meditating on a piece of artwork that derives from early-Christian centuries. The strength of this art form is similar to that of the early-Christian faith that expressed belief in a pure and plain way. In the early centuries, a few simple truths were sufficient to inspire thousands of our first brothers and sisters to be martyred as witnesses to Christ's saving power. Likewise, these sarcophagi help us to contemplate the biblical mysteries they depict.

The *Christ Performing Miracles, Healing Scenes* sarcophagus is one that illustrates images of Jesus' miraculous touch in the lives of God's people. Though there are many scenes to contemplate in this bas-relief narrative that illustrates several biblical stories in sequence, we will focus our attention on the healing of the woman with the unstoppable flow of blood.

Imagine yourself in this woman's position. For twelve long years she had endured her ailment, a hemorrhage that could not be stopped. Slowly and constantly she was losing her very life. And try as she might, she could not find any doctors to heal her. She must have submitted herself to all kinds of examinations, tests, and remedies, only to find herself poorer, sicker, and without hope for a solution.

But then she hears the news about Jesus of Nazareth. Perhaps she heard stories of his healing powers. *Surely, this man can heal me, for he has healed others with worse or more complicated infirmities than my own,* she might have thought. *If he can heal them, there is no doubt that he can heal me.* Hope is reborn in her soul as she seeks an opportunity to be near Jesus, to touch him. This hope and conviction drove her to fight through crowds to finally find herself within the reach of Jesus: "If I but touch his clothes, I shall be cured" (Mark 5:28).

Put yourself fully into the scene. Feel the crowd pressing in around you as you catch sight of Jesus ahead. He is speaking to others but moves farther and farther away. Struggle to move forward, as the woman with the hemorrhage does by reaching out to touch his cloak. You might be thinking as she likely did: *How many times have I searched for solutions to my problems outside of Christ?* We try many solutions, but we fail because we do not submit our efforts to the Lord.

Reach out to Christ Jesus, the one who has healed so many others. Our blessed deliverer will overcome all obstacles and barriers for you, making a way where seemingly there is no hope. It

does not matter that you have struggled for many years with this affliction. God always provides healing for the beloved who approach him humbly and with confident faith. Still, not all healing is as we expect it to be. We have to be open to receiving the touch God wants us to receive as *all things work for the good of those who love God* (Romans 8:28).

Jesus, jostled by the crowd, is making his way toward Jarius' house. The synagogue official told him that the man's daughter is close to death, so there is an urgency to arrive at his home. Yet at a certain point, Jesus feels that a power has gone out of him. Someone had touched him—a person of faith. Jesus notices that this touch was different than those of the surrounding crowd. Wondering who had touched him in faith, the Lord asks his disciples: "Who has touched my clothes?" (Mark 5:30). Notice how the sculptor portrays a stern and questioning look on the face of Jesus as the disciples look back at him in bewilderment. They wondered why Jesus is reacting so strangely in this large crowd. *What does he mean by "who has touched me?"*

The posture of the woman illustrated in the sarcophagus tells of her faith and humility. Like Mary who sits at the foot of Jesus or the repentant woman who washes Jesus' feet with her tears and hair, yet another woman moves Jesus to offer his special graces. The sculptor contrasts the strong look of Jesus toward the disciples with a gentle gesture, a touch on the head of this new believer.

"Daughter, your faith has saved you. Go in peace and be cured of your affliction" (Mark 5:34), Jesus tells the woman. He calls her "daughter!" Could he have used a more endearing term? She, who was a total stranger just moments before, has now become a daughter through her boldness of faith, by humbly reaching out to touch the Lord.

Turn to Jesus in prayer, offering your love to the one who is entirely interested in your welfare. Pour your heart out before the Lord and let Jesus heal and help you. Imitate the woman with the hemorrhage by reaching to touch Jesus. He is near you, as close as your breath. Listen for God's voice, touch, or gentle embrace, the one who whispers: *You are my child and I love you!*

# PRAYER AND REFLECTION

Lord, we are amazed by your untiring kindness! Help us to become just a little more like you in our own lives. Let us touch you in faith, that your healing love will transform our lives. Amen.

- What ailment(s) do you have presently that need the Lord's healing touch (physical, spiritual, emotional, intellectual, creative, intuitive)? Ask Jesus to deliver you today from unbelief, physical disease, feelings of worthlessness or helplessness, failures, etc., trusting in the miraculous works of the Lord.

- What was required of the woman in order to be healed of her affliction? What does Jesus require of you?

- Imagine that Jesus comes to you and invites you to walk into a large room. In the room you notice a large sign that says: "Ask and you will receive." The Lord tells you, *I desire to heal you and bring you home. In order to do so, however, you must first believe and desire to be healed. You must admit you are not whole without me.* Speak to Jesus now and ask him to heal your wounds—sin, division, physical ailments, emotional strife, day-to-day problems, and the like. Trust in the one who came to make you whole once more.

## Spiritual Exercise

- Say a prayer or light a votive candle for someone who is sick. And if you are able, visit the sick or infirm.

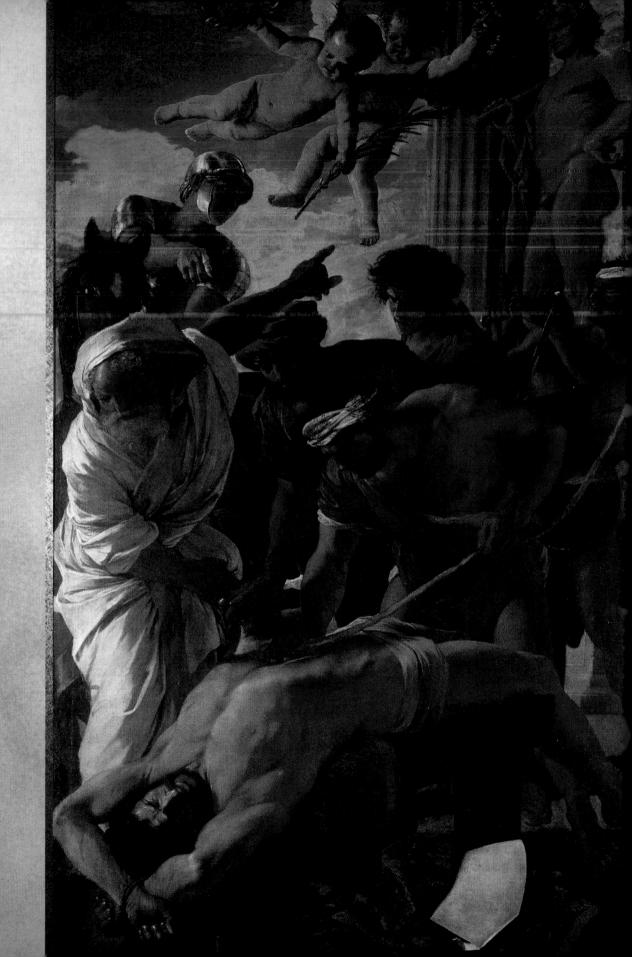

Nicolas Poussin (1594–1665) was born in Les Andelys, Normandy, and worked in Paris from 1612 to 1623. Like many of his peers in Europe, Poussin was drawn to Rome and arrived there in 1624 needing a lot of work to become a great artist.

Poussin brought a new intellectual rigor to the classical impulse in art, as well as a unique, somewhat reticent poetry. His sensitivity to the nuances of gesture, design, color, and handling, which he varied according to the theme at hand, permitted him to bring a focused expression to his art and to create for each narrative a memorable and enduring form. The range of his work includes scenes of tenderness, mourning, revelry, civic virtue, and other states of mind or being.

In Rome, Poussin became part of a group of intellectuals led by archeologist/philosopher/naturalist Cassiano dal Pozzo. Poussin and Cassiano became good friends, and Cassiano became Poussin's patron.

With Cassiano's help, Poussin received his only papal commission, which was Martyrdom of St. Erasmus.

# MARTYRDOM OF ST. ERASMUS

Nicolas Poussin
Vatican Museums' Pinacoteca
1628–1629

---

**THEME:** Free will

**FOCUS OF THIS MEDITATION:** There is a stark difference between the two kingdoms vying for our allegiance: the kingdom of light and that of darkness. Let us choose to live in the light of Christ.

---

◄ *Martyrdom of St. Erasmus* was the first public work completed by renowned French classicist Nicolas Poussin after he arrived in Rome in 1624. He would spend much of his life in the Italian capital, where he developed his unique style. Rather than following the richness of the Baroque, Poussin's works are based in logic, order, and clarity. They are dramatic but not overly so, maintaining a grasp on the Renaissance's fascination with the idea of classical antiquity as a standard of excellence.

The work was originally assigned to Pietro da Cortona but was reassigned to Poussin in 1628. Using Cortona's preparatory sketch, Poussin completed this masterpiece in 1629 for an altar on the right transept of St. Peter's Basilica in Vatican City, where the relics of St. Erasmus are still preserved. But the painting was replaced by a mosaic in the mid-1700s and moved to the pontifical palace of the Quirinale.

Napoleon's soldiers seized the painting under the 1797 Treaty of Tolentino and brought the piece to Paris, a temporary move during the French Revolution. Eventually it was returned to Rome, after which it was installed into the Vatican art collection of Pius VII in 1820.

# SCRIPTURE MEDITATION

## JOSHUA 24:14–25

*"Now, therefore, fear the LORD and serve him completely and sincerely. Cast out the gods your ancestors served beyond the River and in Egypt, and serve the LORD.*

*If it is displeasing to you to serve the LORD, choose today whom you will serve, the gods your ancestors served beyond the River or the gods of the Amorites in whose country you are dwelling. As for me and my household, we will serve the LORD."*

*But the people answered, "Far be it from us to forsake the LORD to serve other gods.*

*For it was the LORD, our God, who brought us and our ancestors up out of the land of Egypt, out of the house of slavery. He performed those great signs before our very eyes and protected us along our entire journey and among all the peoples through whom we passed.*

*At our approach the LORD drove out all the peoples, including the Amorites who dwelt in the land. Therefore we also will serve the LORD, for he is our God."*

*Joshua in turn said to the people, "You may not be able to serve the LORD, for he is a holy God; he is a passionate God who will not forgive your transgressions or your sins.*

*If you forsake the LORD and serve strange gods, he will then do evil to you and destroy you, after having done you good."*

*But the people answered Joshua, "No! We will serve the LORD."*

*Joshua therefore said to the people, "You are witnesses against yourselves that you have chosen to serve the LORD." They replied, "We are witnesses!"*

*"Now, therefore, put away the foreign gods that are among you and turn your hearts to the LORD, the God of Israel."*

*Then the people promised Joshua, "We will serve the LORD, our God, and will listen to his voice."*

*So Joshua made a covenant with the people that day and made statutes and ordinances for them at Shechem.*

We have been meditating on the person of Jesus Christ and the new life to which he calls us. The attraction to sin allures us, but still we desire to be holy and to make an ever-deeper commitment to Christ's kingdom. Tension exists within each of us who strives to follow Jesus.

This meditation comes at an important moment, then, for St. Ignatius invites us to choose Christ—the reign of God. According to the saint, it is essential to present the options before us to our mind and hearts, our whole being. Ignatius is forthright in his approach, startling us a bit with his direct stance.

On one hand we can choose to fall into temptation by following the allures of Satan. The evil one will lead our souls into confusion, fear, and eventually death. He offers earthly power, unfettered pleasure, and unlimited riches in order to lead us away from God. Our soul's condemnation is what the evil one most treasures, as he detests the holy one. In the painting, Satan's domain is represented by those who persecute the martyr and by the Roman god standing upright in the background.

By contrast, through the inspiration of the Holy Spirit, Jesus calls each of us to discover God's promises of love, joy, and eternal riches. But our weak nature tends to seek the easier road, making the path to God difficult. Thankfully, God is meek and humble of heart, patient and understanding of all of our struggles. Though a yoke is sometimes placed on our shoulders, our strenuous road is made smoother by the light and life of the Lord. In order to follow Jesus, we must take up our cross, learn virtue, and fight the good fight of faith. This reign of Jesus unfurls quite a different path, as in this painting Erasmus is martyred for his faith.

Ignatian spirituality calls this "a meditation on the two standards (or flags)." We must choose our path. Do we stand with Jesus or will we be enticed by the world's riches and deceptions? The standards represent two kingdoms, two ideals, and two visions of humanity.

Poussin's painting of the martyrdom of St. Erasmus (also known as St. Elmo) brings this reality gloriously to light. Many early Christian martyrs died because they were unwilling to burn incense as a sign of their obedience to the Roman gods. Though they would give the state their allegiance and respect, they refused to give the gods what only belonged to the one true God—their praise and worship. St. Elmo is one of the most famous among these early martyrs as

his story was recorded in *The Golden Legend*, a medieval bestseller of biographies of saints written by Jacobus de Voragine. In the face of horrendous religious persecution under Diocletian and Maximian, St. Elmo continued preaching the Gospel. An acclaimed hero of Christian martyrdom, this saint illustrated what it means for us to be persecuted for faith in Jesus.

The *Martyrdom of St. Erasmus* painting can give us a sense for the horrific persecution that this martyr endured, though he received many chastisements before the state put him to death. In the painting we witness St. Elmo splayed out upon an altar in the lower foreground of the painting. His tormentor points up toward what we could call the "two flags," the choice of two

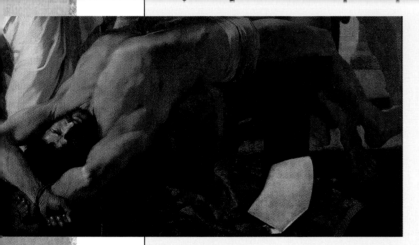

kingdoms. The white-clad Roman priest wanted Erasmus to look toward the statue of the god of Hercules—the son of Jupiter, a Roman god of amazing strength. But St. Elmo had a force of love that no pagan god could compete against. Standing fast, he endured unheard-of sufferings because *his* God was not of this world, but the one to come.

Notice the interrogating faces of his fellow Romans as they lean over his body in anguish. Their mouths are hanging open in disbelief that the saintly bishop could withstand his tormentors, refusing to succumb to the pain that wracks his body. They plead with him to join their ranks and end the torture, an enticing invitation perhaps for one in such distress. But St. Elmo is steadfast, anchored in Christ—he is a rock! He will not accept this passing moment of physical rest, as it would betray the one who offers him an eternity of faithful friendship. The eyes of the martyr are lifted to the heavens as he focuses on the prize set before him (Philippians 3:14). Two puttis lean into his line of vision, holding a palm representing martyrdom and a crown that symbolizes victory.

Though the circumstances may be less dramatic, we are faced with similar choices to fight the good fight. Decide today whom you will serve. Every day we are faced with a choice to follow Jesus or to choose our own way—the way of the world. Will you turn away from sin to follow Jesus?

Let your mind and heart contemplate how diametrically opposed the kingdoms are, each

MEDITATIONS ON VATICAN ART

irreconcilable with the other. God created the earth and all it contains, so to follow Jesus does not mean we should condemn all that is earthly. Instead we must change our perspective by coming to understand that all things are held together in Jesus' love. All of our treasure troves and kingdoms perish without the love of the Lord.

# PRAYER AND REFLECTION

Lord, there is no king, no kingdom like yours. Enlighten our minds so we might see clearly the option set before us in order that we might more intelligently and freely choose you and your reign. Amen.

- St. Erasmus endured unthinkable persecutions for the sake of the Gospel. What struggles weigh on you? Offer up your crosses to God so others might come to know the love of Jesus.

- What lures you away from the life offered in God? Ask God to renew a steadfast spirit in you, that your heart will be inflamed with divine love.

- Resolve to spend extra time in prayer each day to nourish your relationship with the one who offers you eternal life.

## ❧ Spiritual Exercise ❧

- Write down or share an instance when you stood by your principles of faith even when it was not an easy choice to make. Feel content that you were able follow Christ and avoid temptation in that instance.

*Domenico di Tommaso di Currado di Doffo Bigordi (1449–1494) was a Florentine Renaissance painter who was better known as Ghirlandaio, a name meaning "garland maker." This name was given to him when he first apprenticed with his father, a jeweler known for making metal necklaces that resembled garland, a decoration popular among Florentine women. Later Ghirlandaio became well known and had several of his own apprentices, of whom the most notable was Michelangelo.*

In 1481–1482, Pope Sixtus V called Ghirlandaio to Rome to work on the sidewalls of the Sistine Chapel. One of the works is *The Calling of the First Apostles*. At the time Ghirlandaio was working in the Sistine Chapel, Michelangelo had not yet begun to paint the ceiling and altar. His work would not begin until 1508 under the reign of Sixtus' nephew, Pope Julius II.

The scene in *The Calling of the First Apostles* depicts Jesus before Sts. Peter and Paul, a painting situated directly across from *The Crossing of the Red Sea* (a work Ghirlandaio may have created). The call of Jesus is thus viewed as one from slavery to freedom, for we are given new life in him. In the foreground, the Lord stands before Sts. Peter and Andrew, while in the background the artist depicts the call of James and John, who were fishing in their father's boat. ▶

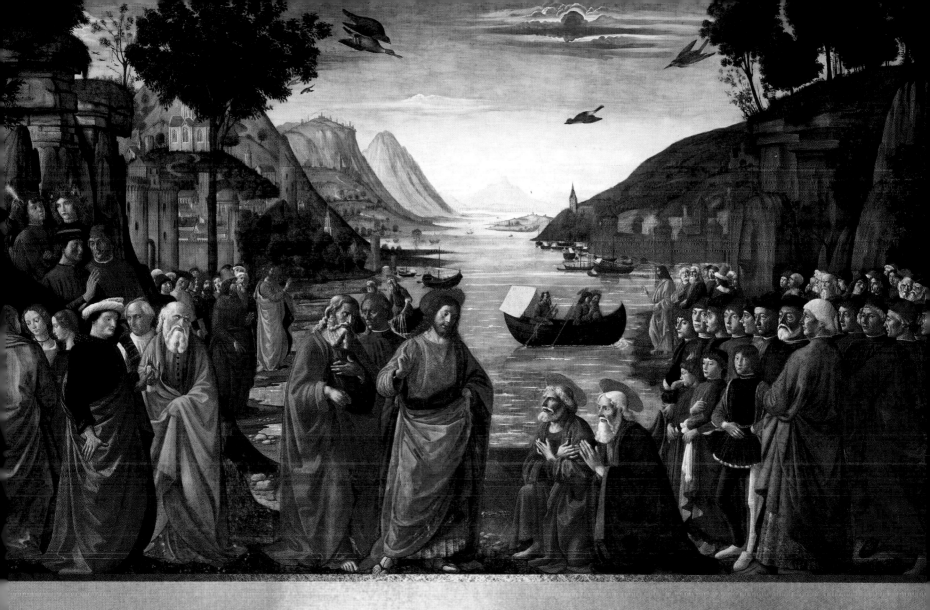

# THE CALLING
# OF THE FIRST APOSTLES

Ghirlandaio
Sistine Chapel
1481–1482

**THEME:** The three paths

**FOCUS OF THIS MEDITATION:** Jesus has placed the grace-filled seed of his Gospel in our souls through the Word we have received, calling us to let it seep into the soil of our hearts so it may burst forth with the fruit of generous service. Let us consider our own personal call, renewing our commitment to the Lord.

# SCRIPTURE MEDITATION

## MATTHEW 13:3–9; 18–23

*[Jesus] spoke to them at length in parables, saying: "A sower went out to sow.*

*And as he sowed, some seed fell on the path, and birds came and ate it up.*

*Some fell on rocky ground, where it had little soil. It sprang up at once because the soil was not deep,*

*and when the sun rose it was scorched, and it withered for lack of roots.*

*Some seed fell among thorns, and the thorns grew up and choked it.*

*But some seed fell on rich soil, and produced fruit, a hundred or sixty or thirtyfold.*

*Whoever has ears ought to hear."*

*"Hear then the parable of the sower.*

*The seed sown on the path is the one who hears the word of the kingdom without understanding it, and the evil one comes and steals away what was sown in his heart.*

*The seed sown on rocky ground is the one who hears the word and receives it at once with joy.*

*But he has no root and lasts only for a time. When some tribulation or persecution comes because of the word, he immediately falls away.*

*The seed sown among thorns is the one who hears the word, but then worldly anxiety and the lure of riches choke the word and it bears no fruit.*

*But the seed sown on rich soil is the one who hears the word and understands it, who indeed bears fruit and yields a hundred or sixty or thirtyfold."*

Today's meditation offers us a different method. The fresco *The Calling of the First Apostles* illustrates the calling of Peter, Andrew, James, and John, but our Scripture passage focuses us on the parable of the sower. The Scripture passage was intentionally selected, even though it does not accompany our art selection. Why? Because our spiritual guide, St. Ignatius, offers this meditation to challenge our commitment to Jesus Christ. We have already meditated on Jesus' call to public ministry. But how will we answer our call to witness the Gospel? Like the seed that is sown and falls on different soil, our hearts are the ground. So let's reflect on Jesus' call to us and our response to him.

Jesus is set in the center of Ghirlandaio's composition. He steps forward, almost off the wall and into the lives of the viewer. Like the disciples, we are singled out, set apart, and called to leave our nets behind on the shore to follow him. Jesus has preached his Gospel, so now he asks: *What are you going to do with this seed that has been sown in your soul?* We find ourselves at a crossroads, as we can imagine the apostles might have been as they first encountered Jesus on the Sea of Galilee. The apostles responded in different ways.

The parable of the sower highlights a variety of responses one might make to the word of God sown in us. God has sown a seed through our baptism and continues to nourish it when we worship, pray, and live our daily lives. How is the ground in your heart? Is it rocky, full of thorns, or rich in nutrients? What do you do to maintain nutrients in the soil of your spiritual life?

Though our hearts long to follow Jesus on the path where the seed is sown, it is essential that the seed take root in us. Perhaps we like the idea of following the Gospel message but know it takes work to live God's call. It is possible we have failed to let God's word take root in our hearts, or maybe we have hardened our hearts, rejecting God's will for us to change. Sometimes our hearts are rocky, with jagged edges containing bitterness, jealousy, cruelty, and hatred. Our attachments, bad habits, preferences, and tough experiences are inhibitors to our full freedom in Christ. We have neglected God, allowing our passions to drive our wills so that the evil one steals away with our all-too-tender desire for conversion.

We might be stronger, though. Perhaps our will really does want to follow Jesus so that we have made some serious steps toward him. Still, we are weak. Though we desire to follow for a

time, we lose our momentum and fail to bear fruit. The thorn-filled world of earthly anxieties combines with an attraction to earthen riches, growing within us and choking the word that began to take root in us.

And finally we encounter the faithful one, the person who allows the call of Jesus to deeply take root in him or her. She is like a gardener who works daily to keep the soil free from rocks, thorns, and weeds; free of all seeds that might rob the rich soil of its minerals. He works the land, tills it, removes rocks, puts up a hedge, and cares for the tender plants. She prunes the plant as it grows, and eventually the awaited fruit appears, producing a rich harvest.

Take time to speak to Jesus, as the two apostles in the fresco are doing. Kneel before the Lord and soak in his call as if you are a tree near the water of life, the person of Jesus. Let God's word seep deeply into your soul as you tell Jesus of your desire to respond. Many people stand on the sidelines within the painting, as there were likewise many in the crowd who heard Jesus preaching. Still, very few responded to Jesus as the two apostles kneeling at his feet. Peter and Andrew would later bring his word to the farthest reaches of the earth.

> *What do you do to maintain nutrients in the soil of your spiritual life?*

We can feel the tug of riches and the desire for an easier life. Furthermore, we do not like suffering, so we frequently fear the will of God. What of the seed? No seed bears fruit unless it dies, is buried, and allows a new shoot to burst out of it. Look at the James and John in the painting. They are sitting in the boat when Jesus approaches in blue on the shore and calls them to set their nets aside. They leave their father Zebedee, the security of their lives, their little business that is their livelihood, and all they have ever known in order to follow Jesus. What did the soil of their hearts look like? Why were they so eager and able to follow the Lord when he first called?

Through this meditation, we are also called to set our lives aside to follow Christ. Two options stand before us, two kingdoms. Today is the day we must say "yes," lovingly responding to God's call. By enacting Christ's will in your daily life, resolve to answer with a love that perseveres and does not wane with time.

# PRAYER AND REFLECTION

Lord Jesus, you have planted a seed in each of our hearts. Nourish the seed you have planted in us that we might respond generously to your love as your apostles Peter, Andrew, James, and John did. Give us the courage to leave our nets behind—our fears, insecurities, and all boundaries that bind us to the world—to follow you. May the fruit that grows in us reap a rich harvest for your reign. Amen.

- The apostles met Jesus and left their nets behind to follow him. Would you have done the same? What do you need to leave behind today to follow Jesus?

- Reflect on your spiritual life. What does the soil in your heart look like? Is the ground rocky, riddled with brambles, or nourished with good nutrients? How might you add nutrients to the soil of your heart, getting rid of rocks and thorns?

- Spend time looking at *The Calling of the First Apostles*. Jesus is also calling you today. Listen to the Lord. How will you respond to his calling?

## Spiritual Exercise

- Spend time thinking about your personal vocation and how you answer God's call on a daily basis. If you have yet to find your vocation, ask the Lord to direct your path.

*Dogmatic Sarcophagus* is one of the most important examples of Christian-Roman sculpture that comes from the Constantinian era. The burial box was unearthed in the nineteenth century when St. Paul Outside the Walls (*San Paolo fuori le Mura*) was being rebuilt due to fires. This sculpture quickly became a gem for theological study. The coffin is also called *Trinity Sarcophagus,* since it holds the first depiction of the Holy Trinity in Christian art.

The front piece is divided into two horizontal registers, one dedicated to two stories from the Old Testament and three in the New Testament. The lower register features a Nativity, two biblical stories, and three figures depicting narratives of St. Peter. This burial box illustrates salvation history from an early-Christian perspective. The stories shown here come from both the Old and New Testaments, beginning with the Trinity in creation. Culminating in Christ, the sculpture also illuminates the early Church through portrayals of St. Peter.

The hairstyles of the men in the carving reflect a particular period of history, enabling historians and archeologists to more accurately state when the artifact was created.

As this coffin was being sculpted, Christians would have most recently resolved (at least on paper) the question of the divinity and humanity of Christ: *Is Jesus human or divine?* Their answer: both. He is fully human and fully divine, a radical notion at the time! As we glimpse the sarcophagus, we see evidence of the theological debate resolved at Nicaea. Trinitarian and Old Testament images are magnified to foreshadow Christ's coming. ▶

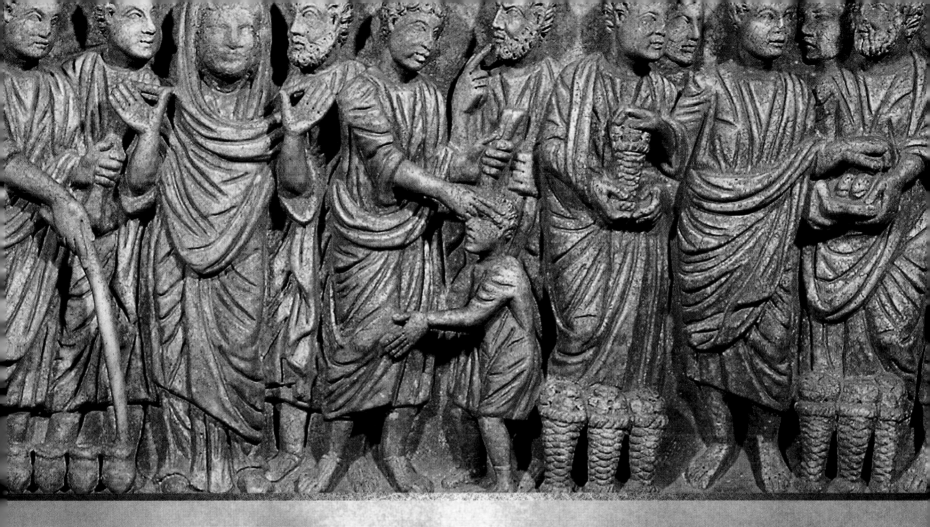

# DAY 21

# DOGMATIC SARCOPHAGUS

Also called *Trinity Sarcophagus*
The healing of the blind man
Unknown artist
AD 325–350

**THEME:** Healing of the blind man

**FOCUS OF THIS MEDITATION:** Jesus responds to Bartimaeus' need for healing—to be able to see. The Lord hears the cry of the poor and will answer our cries for healing. As we meditate, let us appreciate the personal love that Jesus has for all who seek God.

# SCRIPTURE MEDITATION

## MARK 10:46–52

*They came to Jericho. And as [Jesus] was leaving Jericho with his disciples and a sizable crowd, Bartimaeus, a blind man, the son of Timaeus, sat by the roadside begging.*

*On hearing that it was Jesus of Nazareth, he began to cry out and say, "Jesus, son of David, have pity on me."*

*And many rebuked him, telling him to be silent. But he kept calling out all the more, "Son of David, have pity on me."*

*Jesus stopped and said, "Call him." So they called the blind man, saying to him, "Take courage; get up, he is calling you."*

*He threw aside his cloak, sprang up, and came to Jesus.*

*Jesus said to him in reply, "What do you want me to do for you?" The blind man replied to him, "Master, I want to see."*

*Jesus told him, "Go your way; your faith has saved you." Immediately he received his sight and followed him on the way.*

---

We do not actually know the name of the blind man, for Bartimaeus means "son of Timaeus." In Jesus' time, all who were infirm in some way were not viewed as important. In an age where children contributed all they could to the family economy, this young man could do very little to help and was likely considered a burden. His blindness kept him on society's fringes, unable to contribute. He was at the world's mercy. Hope for any kind of meaningful existence was slim for this young man.

On the roadside, at the entrance of the city of Jericho, we are introduced to Bartimaeus, who sits and cries out: *Jesus, son of David, have pity on me.* Was he waiting for the Lord to come? How did he know to call for Jesus? This resourceful young man did what he could to receive the

Lord's touch. Desiring a change for his life, he called out to the streets. How many times before had he cried for mercy from someone, anyone who might ease his sufferings? Listening to his surroundings, the blind man might have thought, *is this the promised Messiah? If there is any hope for me, this is it. I must seize this moment to beg for God's help.*

His attentiveness brought news of the healer's pending arrival. Jesus of Nazareth, a miracle worker, had mended many a blind and deaf man. Some have even said he raised a little girl from the dead. When these stories reached his ears, he moved as quickly as he could to position himself at the gate where Jesus would have to go by.

Diminished sight could not keep the man from responding in faith by begging for the Lord's mercy. As the noise of the swelling crowd engulfed him and the prophet was getting closer, he began to cry out at the top of his lungs: *Have pity on me, son of David.* Though blind, Bartimaeus could see spiritually what others could not. He called out to Jesus using the Messianic title, son of David. Stories of Jesus' signs and wonders led this outcast to be a spiritual insider. The Son who would sit on the throne of David forever would be the bringer of peace, a healer of the blind, and the source of reconciliation. Armed with his faith and courage we witness the blind beggar calling for Jesus to heal him from his affliction.

The world often tries to drown out the cries of the poor and keep them on the periphery. Our greed, selfishness, indifference, and busyness often keep us from perceiving the needs of those around us. Many tried to silence this young beggar, rebuking him. *Do not bother the Master,* they might have said. *Do you think that he cares about you?* His cries are uncomfortable because when he asks for mercy he is also challenging the indifference of those who never answered his call before. But blind Bartimaeus is not discouraged while being chastised. He simply cries out all the more.

Jesus turns as he hears a plea for help. He looks in Bartimaeus' direction, even though the blind man had no way of knowing this. As his cries continue, Jesus says, "Call him!" Though Jesus has many followers along the way, few respond with such great faith. The one on the side of road, though sitting, is a true follower. His weakness holds him back, though he wanted to spring forth into full faith. Jesus wants to free us to become his followers, no matter what obstacles are present within our lives. Bartimaeus' call to God for help is now answered as Jesus beckons the man to

come closer. *So they called the blind man, saying to him,'Take courage; get up, he is calling you.' He threw aside his cloak, sprang up, and came to Jesus.*

Now let's turn to the scene in our sarcophagus. One instant in the life of an otherwise insignificant poor blind man in an obscure Jewish town is about to become immortalized. What developed in a moment of salvation history was so powerfully impressed on the hearts of the disciples that it was transmitted into oral and written tradition down through the ages. Eventually, as evidenced by this coffin, the story was etched in stone on the tombs of the early Christians. Centuries later, it is seen by millions each year in the Vatican Museums.

Our scene comes from one of our most famous sarcophagi—*Dogmatic Sarcophagus*. Its theology is so rich that volumes have been written on the progression of biblical scenes portrayed therein. For instance, the scene of blind Bartimaeus is to the right of another event in the life of Jesus: Magi present their gifts of gold, frankincense, and myrrh to the newborn Savior. Why are these two scenes etched near each other? A passage from the Gospel of Matthew unlocks the mystery for us.

"Land of Zebulun and land of Naphtali, the way to the sea, beyond the Jordan, Galilee of the Gentiles, the people who sit in darkness have seen a great light, on those dwelling in a land overshadowed by death light has arisen" (Matthew 4:15–16). The prophet Isaiah spoke of a Messiah who would come to light the way for the Gentiles beyond the Jordan, "Galilee of Nations" (Isaiah 8:23; 9). Jesus fulfills the prophecy here by healing the blind man at Jericho, a city beyond the Jordan.

Encountering Jesus makes everything change. Our lives take on new color, new meaning, new power. When the young blind man is led to Jesus' feet he hears the same words that Jesus speaks to you today: *What do you want me to do for you?* Stay with your heart now, asking yourself: *What do I need Jesus to do for me? What graces shall I beg from the Lord?* Open your heart entirely, trusting Jesus with your desires. God longs to share the riches of the kingdom with you, providing for your needs and desires.

Spontaneously, Bartimaeus blurts out his need. *Master, I want to see.* Because he asks with such simplicity and love, Jesus grants his desire. The sculptor portrays Bartimaeus as a child, but not by mistake. Like a child, the blind man's faith is simple, joyful, spontaneous, and even playful. He is bold enough to call out to Jesus through the crowd, though many rebuked him. Let us follow his example now as we pray.

# PRAYER AND REFLECTION

Lord, give us an interior eye, enabling us to know you beyond what can be known merely through our senses. You have given us gifts and talents. May we use these provisions of your goodness to find you, our true source of peace and fulfillment. Let us rejoice, even in our defects and limitations, as our weaknesses also grace us to encounter your mercy and power within our lives. Amen.

- Bartimaeus was bold with his request to see. He cried out many times before Jesus called him to himself. What would you boldly ask of the Lord today? Spend time now to reflect upon your deep needs, asking Jesus for healing and new sight.

- Have you ever been one in the crowd to silence the vulnerable in your midst? When have you undermined the kingdom (God's people in your midst) rather than build it up? Think about a concrete action you can enact in your daily routine to build others up rather than tear them down.

- Look at the sarcophagus now, taking in the entirety of the scene. Then focus on the story of Bartimaeus. He approaches Jesus filled with faith, even with his affliction. Do you believe the Lord will heal you from what ails your being? Ask and you will receive.

## ➤ Spiritual Exercise ➤

- Today, make a special effort to see as Christ sees, avoiding judgment of others that could lead to blindness to their good qualities. Learn to see the beauty of Christ who resides in your neighbor.

# JESUS' PASSION AND DEATH

OUR RETREAT is three-fourths complete. We begin this last week by entering into the mysteries of Jesus' passion and death. Recollect how during the second section we reflected on all that separates us from God, attempting to mend our relationship with the Lord while asking him to purify our hearts. Then the third section focused us on the life of Jesus as we meditated on the love that moved him. The Lord has beautifully illuminated a path for us to follow, for Jesus is our way to God. The life of Christ inspires us to decide more fully for him, living in love by accompanying Jesus as we seek to follow God's will.

This fourth section of the Spiritual Exercises will draw us deeper into the life of Christ—that beautiful interior mystery that we began to reflect upon in the third week. But now the life of Christ comes to a tragic end. We might ask, *what does this mean for me? How does the passion and death of the Lord Jesus change my life? What must I do to follow the way of Jesus?*

Our humanity does not find it easy to embrace the cross. When a goal seems distant and out of our control, our motivation tends to wane. Goals within reach seem more attainable: diet, exercise, following the doctor's orders for a healthier and long-lasting lifespan all seem within our reach. To sacrifice for an attainable goal is logical, computable. But this *dying in order to live*—how do we even know our sacrifice is not for naught?

Constant conversion and self-surrender can be a source of fear and uncertainty for followers of Jesus. *Will I be able to keep this up? Am I always going to be able to say "yes" to God's commands for my life? And what if it costs too much to follow? Will I be able to surrender my life entirely to God?* Sooner or later these questions arise for all believers who encounter the crucified Lord.

As we wrestle with the difficulty and doubts that arise before us as we follow, the forthcoming meditations will help us be with Jesus. Therein we learn that Jesus himself had to learn "obedience" through what he suffered. Knowing that Jesus, the Incarnate Word, struggled to understand

the Father's will as a human being brings comfort as we engage in the Spiritual Exercises now. Suffering is a part of the mystery of salvation. Though difficult to grasp, we are invited to glean the wisdom that God offers us through the cross—the passion of the Lord.

"I have been crucified with Christ; yet I live, no longer I, but Christ lives in me; insofar as I now live in the flesh, I live by faith in the Son of God who has loved me and given himself up for me" (Galatians 2:19–20).

We would scarcely be able to carry our cross faithfully if Christ had not gone before us to show the way. The example of Christ illumines our ability to love, forgive, and peacefully endure difficulties. It is the school of Jesus' passion and death that purifies our love, setting our hearts ablaze for God alone. Refusing to enter the passion of Christ keeps us distant from the reality beyond the cross, that is, eternal joy that can only be fully known through suffering and death—our bridge to God. The strength of Jesus lights the path for us, enabling us to embrace with renewed force the one who first loved us, for "while we were still sinners Christ died for us" (Romans 5:8).

Filled with generosity, faithfulness, and a sincere love for Jesus, let us now enter the porthole of Jesus' passion and death through the brush strokes of renowned artists along with Scripture, meditation, and prayer. For our spiritual progress is not based in our own strength, but in the grace of God offered to each of us on this day, at this very moment.

Domenico di Michelino (1417–1491) was an Italian painter of the Florentine school. He took the name Michelino in honor of his former teacher, a carver of bone and ivory. The artist was elected to the *Compagnia di San Luca*, a painter's guild, in 1442 and joined the *Arte dei Medici e degli Speziali* in 1444.

A follower of the style of Fra Angelico, Michelino predominantly painted biblical scenes. His most famous work is titled *La commedia illumina Firenze* (*The Comedy Illuminating Florence*) and can be found on the west wall of Florence's "Duomo" (cathedral), Santa Maria del Fiore. This masterpiece paints Dante Alighieri and the *Divina Commedia* (*Divine Comedy*). Along with Dante and the city of Florence, the work depicts hell, Mount Purgatory, the earthly paradise (with Adam and Eve) and the celestial spheres.

While the identity of Pseudo Domenico di Michelino is unknown, his works are often also attributed to Zanobi Strozzi (1412–1468), a student of Fra Angelico who collaborated with Domenico di Michelino on several notable projects including an altarpiece in the Cathedral of Prato. Originally a miniaturist, Strozzi rose within the workshop developing a reputation as one of Fra Angelico's most devoted followers. ▶

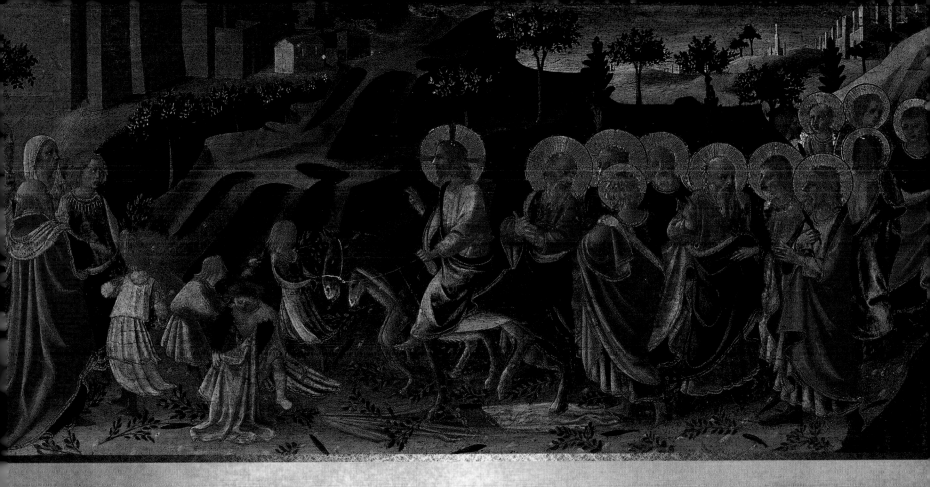

# DAY 22

# THE TRIUMPHANT ENTRY INTO JERUSALEM

Pseudo Domenico di Michelino
Vatican Museums' Pinacoteca
Fifteenth century

**THEME:** The entrance of Christ into Jerusalem

**FOCUS OF THIS MEDITATION:** Like the apostles, we accompany Christ through his celebratory but ominous entry into Jerusalem. He has been rejected by the men and women he had come to love and serve, and we hope to comfort him with our love and faithfulness.

# SCRIPTURE MEDITATION

## LUKE 19:29–44

*As [Jesus] drew near to Bethphage and Bethany at the place called the Mount of Olives, he sent two of his disciples.*

*He said, "Go into the village opposite you, and as you enter it you will find a colt tethered on which no one has ever sat. Untie it and bring it here.*

*And if anyone should ask you, 'Why are you untying it?' you will answer, 'The Master has need of it.'"*

*So those who had been sent went off and found everything just as he had told them.*

*And as they were untying the colt, its owners said to them, "Why are you untying this colt?"*

*They answered, "The Master has need of it."*

*So they brought it to Jesus, threw their cloaks over the colt, and helped Jesus to mount.*

*As he rode along, the people were spreading their cloaks on the road; and now as he was approaching the slope of the Mount of Olives, the whole multitude of his disciples began to praise God aloud with joy for all the mighty deeds they had seen.*

*They proclaimed:*

*"Blessed is the king who comes in the name of the Lord.*
*Peace in heaven and glory in the highest."*

*Some of the Pharisees in the crowd said to him, "Teacher, rebuke your disciples."*

*He said in reply, "I tell you, if they keep silent, the stones will cry out!"*

*As he drew near, he saw the city and wept over it, saying, "If this day you only knew what makes for peace—but now it is hidden from your eyes.*

*For the days are coming upon you when your enemies will raise a palisade against you; they will encircle you and hem you in on all sides.*

*They will smash you to the ground and your children within you, and they will not leave one stone upon another within you because you did not recognize the time of your visitation."*

*Jesus seeks the will
of his heavenly Father,
making no plans of his own.*

———————•———————

Now we depart from Jesus' public ministry in order to enter into his passion. Experiencing Jerusalem with the Lord will change the tone of our faith, as before we were with him in the growing crowds and the excitement of miracles, prophecies, and eloquence. We must now walk the road to Jerusalem with our Lord. Jesus knows what awaits him beyond the crowds, the shouts of glory. But rather than shy away from the cross, he sets his face squarely toward this holy city. We, like the apostles, might be hesitant to accompany Jesus in his passion, but let us at least follow him in this triumphal procession. For the Lord never offers us a cross without giving us the grace to bear it.

This small panel painting forms the horizontal predella, the base of an altarpiece that contains decorated scenes. This particular altarpiece is dedicated to scenes from the passion, beginning with Jesus' procession into Jerusalem on Palm Sunday. Jesus is centered on the altarpiece, sitting nobly on the donkey of peace. The prophet Zechariah spoke of the coming Messiah, bringing clarity to Jesus' strange command to his apostles: *Go into the city and bring me a foal.*

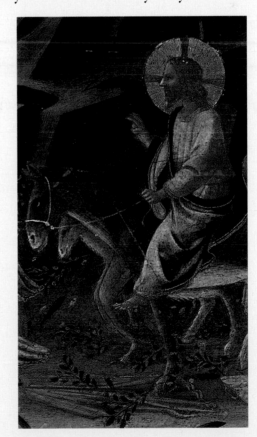

Exult greatly, O daughter Zion!

Shout for joy, O daughter Jerusalem!

Behold: your king is coming to you,

a just savior is he,

Humble, and riding on a donkey,

on a colt, the foal of a donkey.

He shall banish the chariot from Ephraim,

and the horse from Jerusalem,

The warrior's bow will be banished,

and he will proclaim peace to the nations.

His dominion will be from sea to sea,

and from the River to the ends of the earth (Zechariah 9:9–10).

Jesus seeks the will of his heavenly Father, making no plans of his own, yet fulfilling the prophecies that were written of him. Though king of all that is, his reign is not of this world. As he begins his passion, we glimpse a moment of glory as the crowds hail Jesus the holy one of Israel (Luke 19:38).

Unlike most rulers, the Messiah peacefully enters Jerusalem ahead of his disciples on a donkey. Contrast this to the kings and leaders who conquer with arms and brutality, protected by their warriors or bodyguards. Jesus' only weapon is love, focusing his conquest on the hearts of all human beings. Rather than striking his enemy with violence, he goes into the front line of battle—our heart. And he is fully prepared to receive our blows, insults, and affronts in order to convince us that we are loved eternally by his heavenly Father.

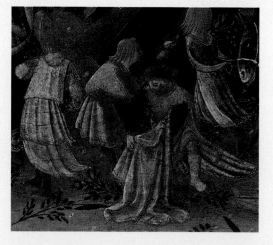

Refocus on the painting and notice that the little children are laying their coats down before Jesus.

These simple souls recognize Christ's divine humility, praising him with their gestures while the people recite messianic acclamations. The love and gentleness of Jesus incites praise, fidelity, and allegiance. They wave olive branches and throw them on him. And how will you respond to the one who invites you to enter his passion? Will you praise the holy one who desires to reign in your heart, even though doing so entails accepting the imminent cross?

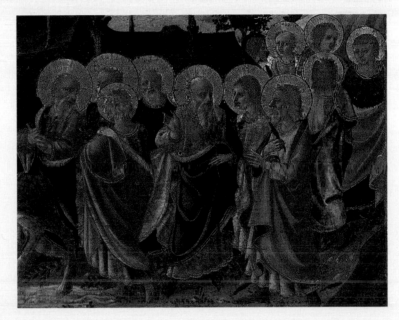

Count the followers of Jesus, that is, those behind him in the painting. There are eleven in the procession with golden halos around their heads. These symbols of holiness and faith highlight the reality that when we follow Jesus into Jerusalem, we prepare our hearts and wills to love him to the end—if we stay with him. Notice, though, that one of the followers is without a halo, with

a black shadow around his head. Judas follows with the other apostles, but he lacks faith. Like Jesus, all the other apostles face toward Jerusalem. But Judas looks away toward another plan, another way. His heart is already set on different path, his own will.

Judas' attitude is so very different than Jesus'. He is hidden in the background while Jesus goes ahead like a captain who leads his troops into battle. Our beloved Savior abandons his will into the hands of the Father, the one who calls him through Golgotha into resurrected glory. Serenely Jesus accepts the praises in Jerusalem that will all too soon be turned into jeers and scorns as he proceeds to the cross.

The scribes and Pharisees turn their backs from us, setting themselves behind the children and blocking the way to Jesus. For as Jesus says to them, "You lock the kingdom of heaven before human beings. You do not enter yourselves, nor do you allow entrance to those trying to enter" (Matthew 23:13).

Our attitude toward the cross either helps us accompany Jesus or leads us to abandon him when hard times come upon us. The cross is either a stumbling block or it becomes our way to God. Prepare yourself out of love to accompany and console Jesus as you begin to enter into his passion. Sadly, too few believers stay with Jesus' agony that was caused by humanity's brokenness.

Stand with the Lord now as he looks upon his beloved city and weeps over those who reject the life God offers to all people. Though Jerusalem will reject him, we can ask the Lord to abide always in our hearts. For through our baptism we have become the heavenly Jerusalem, the dwelling place of God. Still, we must invite Jesus to come in and remain with us always.

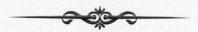

# PRAYER AND REFLECTION

Jesus, our Master and leader, allow us to accompany you through the confusing days of your passion. We praise you with those who exult in your glory as you enter the holy city of Jerusalem, suffering with you as your betrayal approaches. Though our trials, sufferings, crosses, and weaknesses may be many, help us always to stay near you—our true source of happiness and peace. Amen.

- It is easy to stay with Jesus when we feel good and perceive the glory of God. What happens though, when we encounter difficulty? Are you able to remain faithful in moments of darkness and doubt?

- Judas desired Jesus to be something he was not—a ruler who was like the kings and queens of this world. He wanted to fit God into his notion of things. So often we, too, want God to fit neatly into the places we understand. But, Jesus says: *Accompany me to Calvary.* Do you trust God's path for you?

- Read the Scripture passage again while looking upon the painting. What passage or image stands out for you? Stay with this image or passage as you pray.

## Spiritual Exercise

- Triumphal Entry: Offer some act of love to console the heart of Christ, who is praised by many but followed by few.

Cosimo Rosselli (1439–1507) was called from Florence to join Pietro Perugino and others in the decoration of the Sistine Chapel. Rosselli created three of the frescoes: *The Adoration of the Golden Calf, The Sermon on the Mount,* and *The Last Supper,* the piece we contemplate today.

The majority of figures in this Last Supper scene face the viewer, but a lone person has his back to us and a small reddish devil is perched near his ear. It is a depiction of Judas, the betrayer, who is also the one closest to the chalice that symbolizes the bitterness of Christ's approaching passion. Notice that the table is empty except for the chalice, while Jesus holds a host or piece of unleavened bread in his hand.

The painting illustrates both what took place at the Last Supper and continues to be sacrificed in the Sistine Chapel as the Eucharist is celebrated therein. For even today, the Holy Father will celebrate Mass in the chapel. Therefore, a strong theology surrounding the Eucharist offers us a glimpse into the whole passion narrative. In fact, it is the Last Supper that draws us into the passion, for Jesus offered himself as our sacrificial lamb even before he was sentenced to be crucified.

A dog and cat are fighting in the foreground. It could be a domestic detail within the scene or it might be a reference to the struggle that we all have to follow Jesus. Cosimo also hints at the fruit of Judas' betrayal in the scenes depicted in the background windows— pictures within a picture: the Garden of Gethsemane, the betrayal of Judas, and the crucifixion. ▶

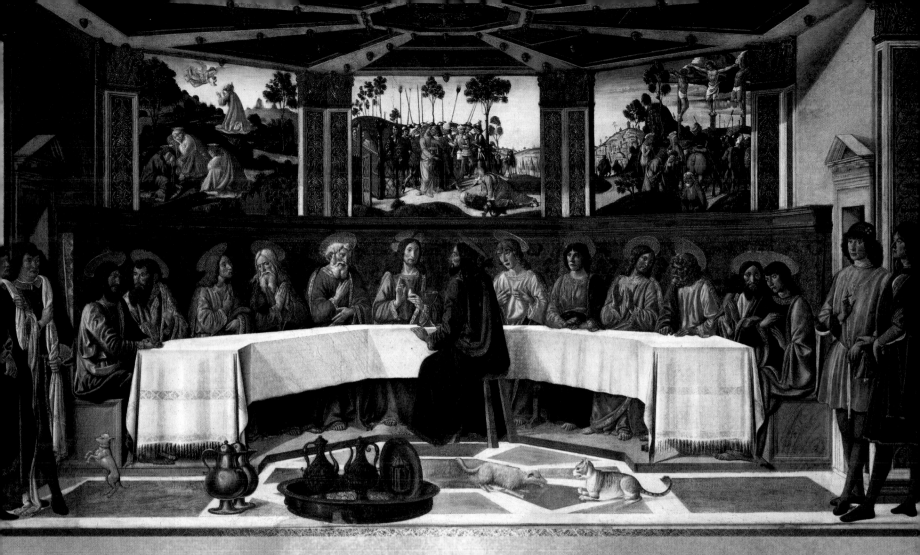

# DAY 23

# THE LAST SUPPER

Cosimo Rosselli
Sistine Chapel
1481–1482

**THEME:** The sacrament of the Last Supper

**FOCUS OF THIS MEDITATION:** At the Last Supper, Jesus' humility and love become apparent while he celebrates the Passover meal. It is at this pivotal moment that Jesus offers himself as the sacrificial lamb for our new and eternal covenant. Accompany Jesus here in this place where he offers his final teaching about Eucharist to us.

# SCRIPTURE MEDITATION

## LUKE 22:14–30

*When the hour came, he took his place at table with the apostles.*

*He said to them, "I have eagerly desired to eat this Passover with you before I suffer,*
*for, I tell you, I shall not eat it [again] until there is fulfillment in the kingdom of God."*

*Then he took a cup, gave thanks, and said, "Take this and share it among yourselves;*
*for I tell you [that] from this time on I shall not drink of the fruit of the vine*
*until the kingdom of God comes."*

*Then he took the bread, said the blessing, broke it, and gave it to them, saying,*
*"This is my body, which will be given for you; do this in memory of me."*

*And likewise the cup after they had eaten, saying, "This cup is the new covenant in my blood,*
*which will be shed for you.*

*"And yet behold, the hand of the one who is to betray me is with me on the table;*
*for the Son of Man indeed goes as it has been determined; but woe to that man*
*by whom he is betrayed."*

*And they began to debate among themselves who among them would do such a deed.*

*Then an argument broke out among them about which of them should be regarded as the greatest.*

*He said to them, "The kings of the Gentiles lord it over them and those in authority over them*
*are addressed as 'Benefactors'; but among you it shall not be so. Rather, let the greatest among you*
*be as the youngest, and the leader as the servant.*

*For who is greater: the one seated at table or the one who serves? Is it not the one seated at table?*
*I am among you as the one who serves.*

*It is you who have stood by me in my trials; and I confer a kingdom on you, just as my Father*
*has conferred one on me, that you may eat and drink at my table in my kingdom;*
*and you will sit on thrones judging the twelve tribes of Israel.*

Let's place ourselves into the artistic scene before us. Cosimo Rosselli depicts this meal in an ornate Renaissance upper room. The apostles are dressed as Roman courtiers and royalty while sitting on benches around a semi-circular table. Bystanders flank the table in pairs as they converse. Elements of the meal service are in the foreground where cats and dogs playfully fill the space.

The moment the artist chooses seems to follow when Jesus breaks from protocol and washes the apostles' feet, changing his clothes into those of a servant. Cosimo Rosselli depicts all of the apostles without their shoes, evidence that Jesus has just washed them only moments ago. We can imagine Jesus kneeling over each one's feet, pouring warm water from the carafes in the front, cleaning the accumulated dust and drying their heels, soles, and toes with a towel. *As I have done to you, so must you do to one another.* The essence of Jesus' gospel is made clear: The greatest are those who serve.

Now Jesus moves from actions to words. He sits and, based on the reaction of the apostles, he must have just said something jarring. All of the apostles have their hands in expressions of disbelief, curiosity, and confusion. *Tonight one of you will betray me.* Jesus' eyes are fixed firmly on Judas, who sits before him with dark hair in a crimson, blood-colored robe. A small red devil, complete with wings and webbed feet, is perched on his shoulder whispering into his ear. In this last moment, Judas has a choice before him—he can still opt to shake off the temptation that he clings to so tightly. Immediately after these events unfold, the Gospel tells us that Judas goes to carry out his pernicious plan, *and it is night.*

This face-to-face meeting between our Lord and his betrayer can lead us to reflect on our own interior response to Jesus' challenges to our own consciences. We often feel the tug to do something below our dignity or demonstrate some other lack of charity. In a split second, Jesus often challenges our hearts to choose him over sin. In these moments of freedom, our moral character is tried and hopefully holds true.

Each of the apostles is surprised at Jesus' reference to betrayal, and they begin to question themselves. They surely doubt that it could be any of them. *Is it I, Master?* Like the apostles, none of us wants to believe we or those around us are weak and capable of betraying the trust we place in them. We really do want to follow Jesus with generosity and believe that others are doing so

as well. Yet if we look at the painting and notice the scenes in the background, we can recall that in a few short hours these scenes will be set in motion. Judas, one of the first priests and chosen apostles, will betray the trust placed in him by Jesus, and the other apostles will flee.

Focus your attention on Peter along with the other apostles. The rock, Cephas, looks kindly at Judas as he beats his breast in penance. It reminds us of his words when he first met Christ— "Depart from me, Lord, for I am a sinful man" (Luke 5:8). Yet Peter did join Christ's company. In John 6:53, when Jesus spoke the words, "unless you eat the flesh of the Son of Man and drink his blood, you do not have life within you," many no longer went with him. Yet Peter responded with faith and love, just like his painted expression in this fresco: "To whom shall we go? You have the words of eternal life" (John 6:68). Peter often stumbles over his words, but he is faithful. Above the head of Christ we see him pinning down the assaulting soldier in the Garden. His faith is energetic and would need to be purified, but there is no doubt it is passionate and committed to Jesus. May our love be the same.

John, the beloved disciple, is found on the other side of Jesus. He brings both hands to his heart as if to question himself or perhaps to remind us that he is beloved by Jesus, an understanding that we all must have if we truly embrace the Lord. John knew that Jesus loved him, trusting fully in the heart of his Lord. There at the Last Supper, John is often depicted leaning on Christ's chest. Because of this union of hearts, he was able to be faithful until the end.

In our hearts we, too, must make our acts of faith, choosing whether or not we will follow Jesus, even to the cross. John faithfully stands at the cross with the Mother of our Lord, both beloved disciples of Jesus.

How can we hope to accompany Jesus through his passion without the nourishment Christ offers us at this Last Supper, also the First Eucharist—his Body and Blood? The bread and wine become Jesus, our manna in the desert and the bread come down from heaven. This bread changes to the full mystery of Jesus and in so doing becomes our lifeline to God, the Way to eternal life. In this bread situated in the middle of the fresco, we find the promise of the resurrection. Although all people will temporarily abandon Jesus, he will never abandon us. The Lord is present always until the end of time in the most holy sacrament of the altar, inviting us to *come to the feast*.

# PRAYER AND REFLECTION

Jesus, before entering your external passion, we desire to accompany you on the internal martyrdom of your heart. While you humbly wash the apostles' feet, they argue about who is first. You call them friends even while Judas escapes into the night to betray you. Here in this supper you open your heart to them and to all who wish to understand and console you. May we draw near to you through the holy Eucharist. Amen.

- Notice the spectators on the right and left sides of the painting. These Renaissance characters are placed within the scene, just as we likewise witness the Last Supper and Jesus' life, death, and resurrection by experiencing him in the holy Eucharist. Do you believe that you experience the fullness of the Lord in the breaking of the bread? Sit with this mystery and pray that God will continue to enlighten your faith.

- Jesus loved Judas, the apostles, and John the same, though each relationship was unique. We are all beloved disciples of Jesus. Do you, like John, believe that you are the Lord's beloved one? If so, how might you follow more closely in Jesus' footsteps today?

- Look at the background scenes in this image. Which one draws you in and why? Silence yourself and pray with the scene you select as Jesus' passion comes nigh.

## ~ *Spiritual Exercise* ~

- The Last Supper: Reflect on Christ's words during the Last Supper and then find a way to make your next eucharistic meal memorable and different. In addition, thank a priest, religious, or lay minister in your church for leading you toward Christ.

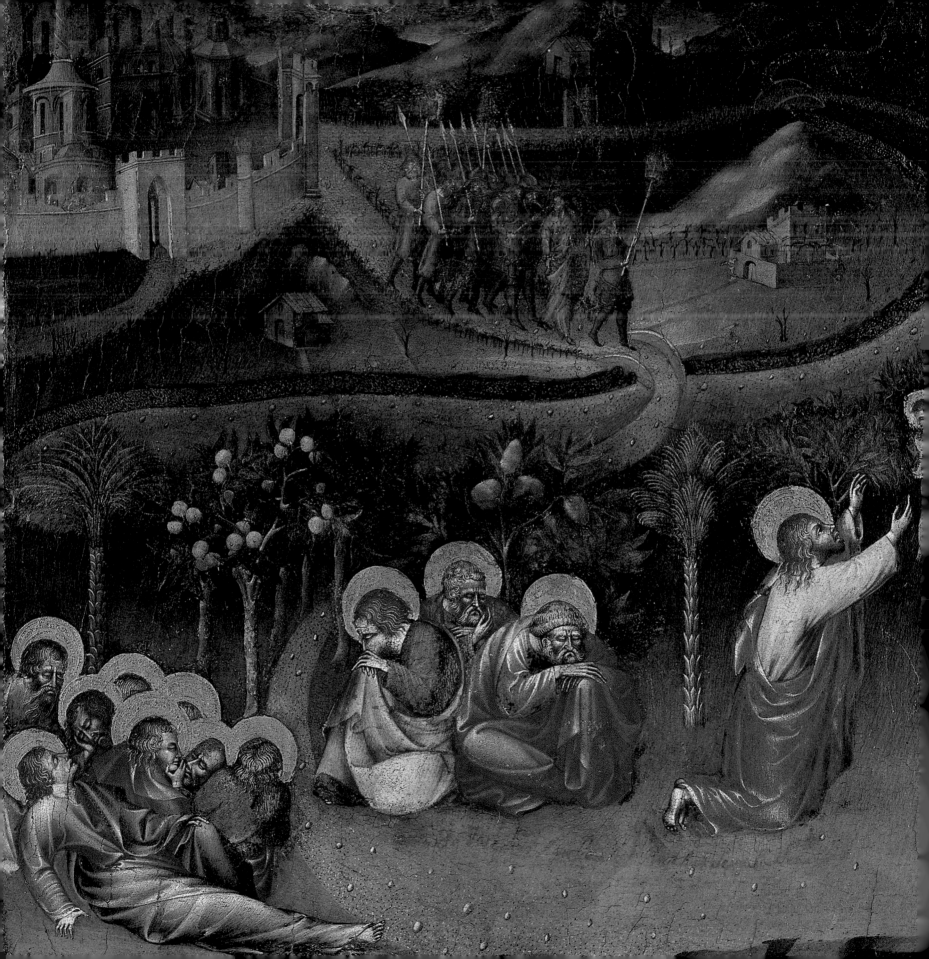

# CHRIST IN THE GARDEN OF GETHSEMANE

Giovanni di Paolo di Grazia
Vatican Museums' Pinacoteca
1440

**THEME:** Prayer in the Garden

**FOCUS OF THIS MEDITATION:** The height of Jesus' internal martyrdom takes place in the Garden as he experiences the full weight of humanity's sin. *Stay with me*, the Lord tells us. *Watch and wait with me, for my hour is here.* Let us be with him now in this moment of agony and strife, for his suffering is transforming our sorrow to joy. *Watch and wait.*

◄ Giovanni di Paolo di Grazia (circa 1403–1482) was an Italian painter who worked mostly in Siena. There he created many pieces of art and illustrated manuscripts, including the works of Dante.

Giovanni's works became important and renowned during his lifetime. He attended the Sienese school, a painting school that thrived in the thirteenth through fifteenth centuries. In his earlier works, one can easily see the influence of the Sienese masters, but later his style became more individualistic. The colors are harsher and cold, and his forms are more elongated. His later works were influenced by the international Gothic style, mastered by artists such as Gentile da Fabriano.

Though the artist might have been influenced and taught by others of his era, his artwork is altogether unique. Many of his works seem to be dreamlike, where the artist takes you out of space and time.

# SCRIPTURE MEDITATION

## MATTHEW 26:36–46

*...Jesus came with them to a place called Gethsemane, and he said to his disciples,*
*"Sit here while I go over there and pray."*

*He took along Peter and the two sons of Zebedee, and began to feel sorrow and distress.*

*Then he said to them, "My soul is sorrowful even to death. Remain here and keep watch with me."*

*He advanced a little and fell prostrate in prayer, saying, "My Father, if it is possible,*
*let this cup pass from me; yet, not as I will, but as you will."*

*When he returned to his disciples he found them asleep. He said to Peter,*
*"So you could not keep watch with me for one hour?*

*Watch and pray that you may not undergo the test. The spirit is willing, but the flesh is weak."*

*Withdrawing a second time, he prayed again, "My Father, if it is not possible that this cup pass*
*without my drinking it, your will be done!"*

*Then he returned once more and found them asleep, for they could not keep their eyes open.*

*He left them and withdrew again and prayed a third time, saying the same thing again.*

*Then he returned to his disciples and said to them, "Are you still sleeping and taking your rest?*
*Behold, the hour is at hand when the Son of Man is to be handed over to sinners.*

*Get up, let us go. Look, my betrayer is at hand."*

———————•———————

At the Last Supper, Jesus prepares the apostles for the moments ahead. He understood the weight of what was about to happen and how it would affect his followers. Judas would betray him, Peter would deny him. *Would the scandal of the cross cause them to scatter? Could they stay with the one who had spoken to them so tenderly for so long?* The way of the cross was scandalous—is scandalous. But we must stay with Jesus here, refusing to be scandalized. In the Garden, the love of Jesus attracts and beckons us to *stay for a little while.*

As we meditate on *Christ in the Garden of Gethsemane*, we want to enter the soul of Jesus, coming to understand just how sincerely he loves the Father that he would offer himself freely to God's redemptive plan. Jesus departs the house of John Mark and walks down the cobblestone streets, leaving the city gate to go down into Kidron Valley. He is silent, prayerful, and somewhat sad. The disciples file in behind him in groups of two and three chatting about the supper. *Did they fully perceive that this would be the last time he dined with them? He had said that this would be the last Passover; what does he mean?* Jesus' contemplative mood seeps through the little group as they approach and finally reach the Garden of Gethsemane in silence. They enter the Garden. *How does this Garden differ from paradise, the other Garden where our transgression first took shape?* Our fifteenth-century painting by Giovanni picks ups here, inspired by the Gospel of Matthew.

All eleven apostles gather around Jesus at the entrance on the left and middle of the fresco. In the Scripture passage, the Lord invites the disciples to sit when he motions Peter, James, and John to come along. As he goes to pray, his demeanor seems heavy, his face downtrodden. He is sad. Our artist depicts the composition to mirror the passage. Jesus, on the right, elevates his hands in prayer, pleading, while the three apostles are found dozing in the center of the work. On the left, eight others are portrayed, also asleep, slumped one against the other.

A privileged place was offered to the sons of Zebedee and Peter. They were invited to suffer more, to watch and pray at this hour of the Lord. *What was it about that hour that caused them to slumber? Did they not perceive the danger ahead for the Lord?* Though Jesus was in agony, perhaps his love was so great that peace emitted from him in this last hour before he was seized by guards.

Seldom did Jesus open his heart in confidence, but in this darkest hour his pain becomes tangible as sorrow weighs down his soul. His agony is so great that he begs the Father to *take the cup* from him, though only if it be God's will. The Lord asks for the company of the apostles, yet they doze several times over. Their flesh is weak. Though they accompany Jesus in the Garden, they rest their bodies while Jesus mentally wrestles the darkness of sin.

And so it is with us. Jesus asks us to be present with him by entering his life and letting him become a part of ours. We are often tempted to fix, act, or attempt to alter the suffering of others. Yet when we truly embrace others, sometimes the best response is to be with them and to love

them through their sorrows. *Watch and pray.* Stand firm. Be faithful by waiting, enduring, and holding fast to the teachings of our Lord.

The artist portrays Jesus in prayer on the right, stretching out his hand toward the cup that is offered to him. Pleading with the Father, he asks if there could possibly be another way: "My Father, if it is possible, let this cup pass from me" (Matthew 26:39). And yet Jesus shows us the way by surrendering his will to that of God the Father: *Not my will Lord, but yours.* Now he feels all the weight of his redemptive vocation, but he does not run from it. Struggling with the enemy, Jesus battles through prayer. What is your attitude toward the crosses and challenges of your life? Offer them to the Father now. Reach out toward God, opening your heart to his will. In prayer, articulate your humble acceptance of the cup offered by the Father.

The apostles do not fully understand the heart of Christ, nor do they understand the transcendence of this moment. They are unable to stay awake and will soon scatter. Their *spirits are willing*, Jesus tells them, but physically *they are weak*. We must set our wills firmly on following Jesus: *usque ad mortem, mortem autem crucis* ("he humbled himself, becoming obedient to death, even death on a cross," Philippians 2:8). Grace strengthens our weaknesses, but we must be open. Our beloved Savior fights and reaches out while the disciples sit, curl up, and attend to their own comforts while ignoring the needs of Jesus. Yet all they had to do was kneel down, stand up, and reach out. In our weakness, when we extend our hands to God in prayer, the Lord rains grace upon us, coming to us in love.

Though the apostles were weak in the Garden, the artist still places halos—signs of their sanctity—around their drooping heads. The image captures a moment of weakness for these first followers of Jesus, not the reality of their lifetimes. We know that their faithfulness withstood the test, for they eventually followed Jesus. Because Jesus showed them the way to the Father, they would each in their own way drink from the cup Jesus drank—draining the chalice dry.

Strangely, the ones faithful to the foot of the cross are not pictured in Gethsemane. Scripture tells us that Jesus' Mother Mary, Mary Magdalene, and Mary the wife of Clopas were there when Jesus was crucified, but they are not mentioned in the Garden. Why? Perhaps Jesus didn't invite them to the vigil, not wanting his Mother to suffer the passion so directly. Once she heard what

was happening, no doubt Mary made haste to accompany her Son as close as she could. We do know that John, the beloved disciple, was in the Garden and at the cross. He was there start to finish. His priestly heart kept him by Jesus' side and invites us to do the same.

There is another person absent from the painting—Judas. But he will soon arrive on the scene as the most intense moments of the passion begin.

# PRAYER AND REFLECTION

Jesus, you are suffering and in need of us. Nothing else matters. Lord, we are here for you. Grace us to *stay and remain* present with you always. Amen.

- Think upon a time when you have disappointed another, perhaps someone who was depending on you to help with a task. Or was it that you failed to spend time with someone who loves you greatly? We are often careless with the experiences and feelings of others. What can you do to correct self-serving behaviors and act more generously toward others?

- Have you ever felt alone and in need of comfort? Jesus longs for accompaniment in the Garden of Gethsemane. Go to him now and share your sorrows with him, listening for his voice, that you might also know the fullness of joy.

- Where are you resistant to the will of God in your own life? Pray for the grace to open your heart to God's will, that he might change your lot.

## Spiritual Exercise

- Gethsemane: Embrace something difficult for you to do and repeat the words Christ spoke, offering your suffering up to God: "Yet not as I will, but as you will."

The Maestro del Crocifisso di Trevi was likely born in Spoleto in the first quarter of the fourteenth century and was an Italian Gothic painter. He is named for a specific Giotto-esque crucifix in the church of St. Francis in Trevi, located In Umbria near Spoleto. Likely a follower of Giotto himself, the Master of the Trevi completed these scenes of the passion on panel with tempera and gold, a typical style of that period.

These scenes derive from the lower register of an altarpiece and would have been the images before the eyes of priests who celebrated Mass. They were meant to remind priests that the sacrifice being celebrated was a real commemoration of the sacrifice of Jesus in his passion and death, while also being a reminder of his glorious resurrection. ▶

# THE KISS OF JUDAS AND THE FLAGELLATION

Maestro del Crocifisso di Trevi
Vatican Museums' Pinacoteca
Circa 1320–1330

**THEME:** Scenes of the passion

**FOCUS OF THIS MEDITATION:** Out of love for us, Jesus suffers through agonizing steps that lead to his death. Let us accompany him throughout this meditation, praying and thanking him for his love and dedication to God's will. Though God is faithful, Jesus meets the silence of the Father when he calls on him.

# SCRIPTURE MEDITATION

## JOHN 18:2–9; 19:1

*Judas his betrayer also knew the place, because Jesus had often met there with his disciples.*

*So Judas got a band of soldiers and guards from the chief priests and the Pharisees and went there with lanterns, torches, and weapons.*

*Jesus, knowing everything that was going to happen to him, went out and said to them, "Whom are you looking for?"*

*They answered him, "Jesus the Nazorean." He said to them, "I AM." Judas his betrayer was also with them.*

*When he said to them, "I AM," they turned away and fell to the ground.*

*So he again asked them, "Whom are you looking for?" They said, "Jesus the Nazorean."*

*Jesus answered, "I told you that I AM. So if you are looking for me, let these men go."*

*This was to fulfill what he had said, "I have not lost any of those you gave me."*

*Then Pilate took Jesus and had him scourged.*

---

A kiss from Judas, and the passion narrative is set into motion. *Why did the betrayer have to be a friend of the Lord?* To be turned over by an enemy is not easy, but when a friend decides to hurt us so, the wind is taken out of us. A hollow ache penetrates our souls with shards of grief, crushing our spirits with an unexpected blow. Jesus was betrayed with a kiss, a sweet touch that did not mirror his heart. The one who offers us new life is now being handed over to die.

This meditation focuses on two pieces of art: *The Kiss of Judas* and *The Flagellation*. The cruelty of both moments penetrates our spirit. The first would have been an emotional blow, saddening Jesus' being. The latter is outright physical abuse. At the end of the trial, Jesus is scourged. He

is cruelly beaten, and the punishment is so horrendous that the blows nearly kill him. Before the trial even begins, this last humiliating step appalls us. Tempted to stand from a distance, we must ask ourselves: *Is it possible that this ugliness exists within me?*

Immerse yourself in the cool night air that envelops the sleeping apostles. Olive branches still lay on the ground from a recent pruning and are now crunched under our feet. Bent over in moral and physical agony, Jesus is at prayer next to the gnarled trunk of the ancient stump. Spring shoots sprout around the base. You hear him say: *Father, take this cup.*

The cup is a metaphor for the events that will come to pass in the hours to come. The taste is bitter, sour, and quite unlike the water that refreshes the body to renew the spirit. This cup is filled with the foul odor of human hatred, oppression, cruelty, jealousy, and spite. Jesus must consume all that has divided us in order to restore our souls to health. He must drink the cup to the dregs, every drop of human misery consumed.

And behold, suddenly, the Lord stands up and walks decidedly toward his captors, already at the gates of the Garden. Now the disciples come to their senses as they hear Jesus' voice: "Get up, let us go. Look, my betrayer is at hand" (Matthew 26:46).

What disbelief, then disgust, anger, and pain must have shot through the hearts of the apostles when they see who is leading the soldiers. Perhaps Judas is interceding with them to allow the Master to pray, but wait…he comes up to Jesus, kisses him, and then steps away. The soldiers step forward decisively to lay hands on him, and Judas steps away, rather than walk toward him to defend or defuse the situation. Soon it sinks in that Judas has betrayed the Master…with a kiss.

A kiss. A tender touch becomes suddenly harsh, ugly, and cruel. *Can you see them embracing there beyond the Garden?* The sealed contract of this movement is different depending on one's perspective. While Judas begins his death march, Jesus accepts the kiss to secure life for all. Judas calls Christ "Master," but Jesus answers him "Friend." Entering his passion, Jesus will die *once for all*—Judas, Peter, John, and the women—all sinners and saints, so thorough is the sacrifice.

Let us meditate now on the moments when we have betrayed Jesus' friendship. Feel the pain, sorrow, and remorse of those sinful choices that have separated you from the tenderness of the Lord. Ask for Jesus' pardon, begging for his mercy. Hear him whispering to you: *Friend, beloved*

*one, I love you!* Jesus did not run from Judas but toward him. Christ offers redemption to all sinners in need of the Father's mercy: "Those who are well do not need a physician, but the sick do. I did not come to call the righteous but sinners" (Mark 2:17).

Armed with a small dagger, Peter stands amidst the crowd in the painting. But what could such a small weapon do against an armed cohort in the background? Still, love does not measure. The apostle swings wildly, quickly moving toward the servant's head while the knife severs his ear completely. But Jesus immediately reacts against this show of violence. Like the lamb led to the slaughter, he is determined that the only blood to be spilled this day should be his.

Not all of the disciples show such valor in an attempt to defend Jesus. Two other apostles pictured in the right foreground maintain a posture of escape: With pointed feet, one lifts a hand while the other pulls up his gown to permit flight. The sheep will scatter, having struck the Shepherd.

And so, the saddest twenty-four hours in history begin. Accompany Jesus through prayer into this humiliating parade through the streets of Jerusalem. Arriving at the house of Annas, the father-in-law of Caiaphas, who was the high priest, Jesus is subjected to an illegal trial where witnesses contradict themselves (John 18:13–14, 19–24; Matthew 26:57–68). Human beings judge and condemn God. Christ Jesus is forced to condemn himself by admitting his divine Sonship.

The sad and lonely night (Matthew 26:67–68) is spent in a dark, dank jail. The soldiers mock him by spitting upon him, punching him, and jeering every possible insult upon him. In the morning, his passion continues before Pilate (Luke 23:1–5; John 18:28–38).

Jesus comes before the highest earthly authority in the region with dignity and serenity. This regal figure intrigues Pilate, who questions him on his kingdom, his followers, and his doctrine. But he finds no fault in this one who speaks with such wisdom and authority (John 18:38).

Hoping that the people will relent, Pilate sends Jesus to be scourged. Look at the painting *The Flagellation*. Depicted in this small oil on wood, we witness our lonely broken Savior abandoned by us all. Alone in the center of the composition, he stands—curled over but strong. *Were you there when they scourged him with the whips?*

*Who is present with Jesus now, as his death approaches?* As we gaze at the scene, we know who is not present. His disciples, family, and friends are somewhere else. *Where are they now—breakfasting,*

*sleeping, praying?* Even God the Father seems distant. Hidden in heaven, God suffers with the Son in silence. By losing the Son for a time, God regains an eternal family. Jesus becomes sin for all humanity. *Were you there...are you there with the one who is making you new?*

# PRAYER AND REFLECTION

Jesus, you suffered all this for us. Help us to enter your passion, compassionately accompanying you as you walk the road to Calvary. We know the story. Help us become part of it by allowing you to heal our wounds, that is, all that separates us from the Father. Though others may abandon you, we desire to be with you now. Amen.

⚟ Do you have the courage to walk the road with Jesus, the path that leads to Golgotha? It is not a pleasant path. You will smell the stench of sweat, the rot of human flesh as you walk the road. Can you stay with Jesus now? Can you be there with him through the passion events?

⚟ Do you believe that the life, death, and resurrection of this man who lived 2,000 years ago has reshaped your destiny? If so, thank him for making a way for you to enter God's home. If not, pray that God will help your disbelief, touching your heart like he did for so many others.

⚟ Have you ever felt betrayed by friends or family? Offer a prayer of reconciliation for those who have harmed you throughout your life, asking God to heal all that has been broken in this world.

## Spiritual Exercise

⚟ Scenes of the passion: Do you wear a crucifix or have one in your home? If not, consider getting a crucifix, and as you put it on or look at it, do so out of love for our Savior Jesus Christ, for the cross reminds us of God's never-ending love for us.

The Master of Fossa was one of the most important painters of Spoleto, in the Umbrian region, before the arrival of the plague known as the Black Death (1348). His work included frescoes and painted wooden statues. Maestro di Fossa's true name is lost to us, but he is called "master" because of his contributions throughout the regions of Trevi, Montefalco, and Fossa, where he realized works. This careful and innovative interpreter of Giotto's school influenced the region, as many grew to appreciate the style of this fourteenth-century artist, whose devotion erupts throughout his artwork.

The five-paneled egg tempera on wood, a polyptych, illustrates a series of moments in the passion of Christ. It is depicted in a size that is devotional in character and intended to lead observers to prayer and meditation. Located in the center of the panel, a unique crucifixion scene reveals the suffering Christ crucified upon the cross. In this central scene, devoted followers look upon this scandalous event with love and devotion while strangers cast lots for his tunic. The smaller scenes that touch this central panel are events leading up to the passion—the Last Supper, the washing of the feet, the agony in the Garden, the arrest, and the carrying of the cross.

The detached panels magnify events surrounding the glorified Christ. On the right, Jesus is removed from the cross in the bottom depiction, and he ascends into heaven in the above scene. The top left panel illustrates Mary at prayer with the disciples in the upper room, while below we see Jesus' resurrected glory. ▶

# DAY 26

## STORIES OF THE PASSION

Maestro di Fossa
Vatican Museums
Circa 1340

**THEME:** The passion

**FOCUS OF THIS MEDITATION:** We now accompany Jesus through the last moments of his passion and death. Let us grow our love for him by willing ourselves to embrace the passion moments he shares with us.

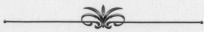

# SCRIPTURE MEDITATION

### LUKE 23:33–49

*When they came to the place called the Skull, they crucified him and the criminals there, one on his right, the other on his left.*

*[Then Jesus said, "Father, forgive them, they know not what they do."] They divided his garments by casting lots.*

*The people stood by and watched; the rulers, meanwhile, sneered at him and said, "He saved others, let him save himself if he is the chosen one, the Messiah of God."*

*Even the soldiers jeered at him. As they approached to offer him wine they called out, "If you are King of the Jews, save yourself."*

*Above him there was an inscription that read, "This is the King of the Jews."*

*Now one of the criminals hanging there reviled Jesus, saying, "Are you not the Messiah? Save yourself and us."*

*The other, however, rebuking him, said in reply, "Have you no fear of God, for you are subject to the same condemnation? And indeed, we have been condemned justly, for the sentence we received corresponds to our crimes, but this man has done nothing criminal."*

*Then he said, "Jesus, remember me when you come into your kingdom."*

*He replied to him, "Amen, I say to you, today you will be with me in Paradise."*

*It was now about noon and darkness came over the whole land until three in the afternoon because of an eclipse of the sun. Then the veil of the temple was torn down the middle.*

*Jesus cried out in a loud voice, "Father, into your hands I commend my spirit"; and when he had said this he breathed his last.*

*The centurion who witnessed what had happened glorified God and said, "This man was innocent beyond doubt."*

*When all the people who had gathered for this spectacle saw what had happened, they returned home beating their breasts; but all his acquaintances stood at a distance, including the women who had followed him from Galilee and saw these events.*

*Ask Jesus to speak to you
so you will see the relevance
of his love and mercy in your life.*

---

Jesus' hour of death is imminent. Led along the *Via Dolorosa*, or Way of Sorrows, Christ begins his ascent up the hill outside the city of Jerusalem toward Golgotha. Only a small group of soldiers, curious onlookers, and bands of convicts surround the place of the skull—that place of death associated with criminals.

Although the artist renders a stylized group of images in this narrative panel, it should not distract us from the reality of the event. Try to place yourself in the midst of the crowd and look around at the different participants. Perhaps some soldiers next to you talk about what they will do this afternoon after their shift is over. You might see the women with their tear-stained faces who try to hide their suffering as they help Mary turn off the road, leading her up to the top of the knoll. See how Jesus is jostled along, barely able to remain on his feet. A strong man, maybe a farmer, seems to have been trapped into helping Jesus with his cross. The two of them tote the weight up the incline before the Lord collapses on the rocky ground, totally depleted of energy.

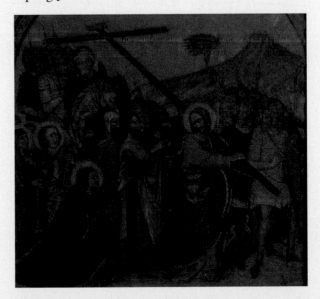

The soldiers push him harshly on his back against the wooden beam as the gruesome crucifixion is enacted. John the Apostle sees what is about to happen and attempts to turn Jesus' Mother away from the scene. She refuses to turn away, but he does manage to bury her head in his shoulder and hug her, a gesture of mutual consolation.

Metal spikes are driven into his hands and feet as the hammer strikes the metal. One, two, three strikes to drive it through flesh into the wooden beam. In a moment of strange silence, an agonizing voice is heard amidst the din of onlookers: *Father, forgive them, they know not what they do.* Let these words stir in your heart. Jesus forgives, even while he is being abused, mistreated, and murdered. Painfully ripping through his flesh, these three strikes repeat as his other hand and then his feet are affixed.

Christ's body is raised against the wooden gibbet and placed in the ground while gasps of horror spread through the crowd. A soldier hangs a wooden sign over the top of the cross: INRI (*Jesus of Nazareth, the King of the Jews*). Pray before Christ crucified, allowing your imagination to stand on the hill among the soldiers, near Mary and John. Enter in with all of your senses and feel the magnitude of this event that beckons you to open your heart. In this hour of darkness, even nature testifies with an eclipse of the sun. Express your sorrow, love, and presence to the Lord as you stay at the place of the skull. Do you feel Jesus' love for you?

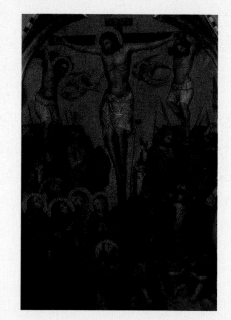

Look closely at the panels, particularly the crucifixion scene that illustrates a rendition of the Gospel narrative. The soldiers are armed with spears, wearing armor, and mounted on warhorses. Those among them who were more practically minded could have wondered whether all the weaponry was really necessary. Some had captured him in the Garden, where Jesus himself told his followers to stand down.

Onlookers gaze at the scene, commenting on what is right in front of them. They are not unlike those of us who sometimes disconnect from Christ out of selfishness, inconvenience, or boredom. Who is Christ in your midst today? The abandoned woman, an enslaved child caught in the trafficking trade, overseas employees trapped in cycles of poverty, the rich unbeliever in your place of employment whose heart is far from God, the family who has just endured great loss from gun violence.

We see Christ in our midst but often make excuses: *There are too many problems in the world, it*

*is not safe to get involved, they are strangers,* and the list goes on. If we want to encounter the cross of Jesus, we must passionately enter the narrative. *Christ died for us—all of us.* He did not just die for the most beautiful and successful—the *fittest.* Jesus died so that all may have life in abundance. Our lives then, if we belong to Christ, must connect to others—the direst of sinners, the forgotten, even those who are cruel now belong to the fold. *Love one another,* Jesus whispers from the cross, *as I have loved you.*

It is tempting for us to imagine ourselves far away, as if we were not part of the unraveling events. But at Calvary it was our sins that Jesus was expiating. We are very much a part.

Take yourself back there in your prayer. Are you a passerby, someone who gazes from a distance? Or do you enter the passion of Jesus and accompany him very close to the cross. Make yourself a part of the scene, for indeed your salvation is at work. There is a wound in all of our lives that can only be healed by one person—and it is happening now. *The cross is for you.* Jesus is making you whole today, as he does every day you connect to the mysteries of his life, death, and resurrection. He is healing you by accepting the cross with love. He invites you to do the same. Surrender to Jesus. Ask him to speak to you, that you will see the relevance of his love and mercy in your life.

Leaders of the Sanhedrin are there to ensure that the mandate they coaxed out of the Roman authority would be carried out. Their insecurities, fears, and perhaps even their faithfulness cost them their sight. Could they not see that Jesus was dying for them? Are we able to see that Christ has died for us?

Other criminals share in his condemnation. One angrily taunts Jesus, mocking as he jests about Christ's powers of salvation. The insult reveals his lack of faith, for he thought, *he would not be here on this cross if he was truly powerful.* The other thief, now called "good," displays evidence of a changed heart. Having witnessed the quiet strength and virtue of Jesus, he became convinced that the Son of Man is trustworthy. Perhaps his eyes even crossed with those of Mary, an instant flickering of faith igniting his heart. The good thief wonders: *Could I possibly be a recipient of this man's love?* He suddenly acts in faith as he turns toward the Lord: *Jesus, remember me.* And Jesus responds: *Amen, I say to you, today you will be with me in paradise.*

Listen to Jesus now, for he offers you these same words: *You, my beloved child, will be with me in paradise.* Jesus continues to suffer through his agonizing death. Mary and John watch and wait with him, and suddenly Jesus speaks to both of them, entrusting them both to the other's care. Finally, we hear him cry: "Father, into your hands I commend my spirit." With those words, he draws his last breath. *It is finished. The price has been paid—our ransom received.*

In silence, adore the Lamb of God. Thank God for the price Jesus paid for your liberation. After some time, turn your gaze toward the sorrowful Mother. She prayerfully offers her wisdom: *Let it be done unto me according to your word.* Do you have the courage to utter these words to God?

*Amen, I say to you,
today you will be with me
in paradise.*

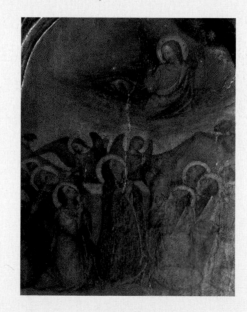

# PRAYER AND REFLECTION

Like the good thief, we entrust ourselves to your mercy and love, dear Jesus. You have changed our lot, suffered all of this for each one of us. Lord, we are not worthy. But you have promised us paradise, asking us only to be faithful to you; to believe in you. Your Mother accompanies us. Mary, our Mother, help us see your Son through your eyes. We desire to stay with you in these last moments while Jesus breathes his last. Amen.

- We are invited into the passion, not as a past event, but one that shapes our lives today. *Were you there when they crucified the Lord?* Are you there at Golgotha now?

- Do you hear Jesus calling you to the cross today? What are you doing to bring healing and wholeness to those suffering in your own life? How might you serve another in need?

- Selfishness is sin's crown. Jesus reversed the wound of sin by offering himself up for all humanity—to show us the *way of love*. How radical is your love for others, particularly those who are wounding you now? *Pray for those who persecute you so that Jesus will enable you to love as he does.*

## Spiritual Exercise

- The crucifixion: Stay with Jesus crucified. Surrender your entire self to this mystery, allowing God to speak to you in silence now.

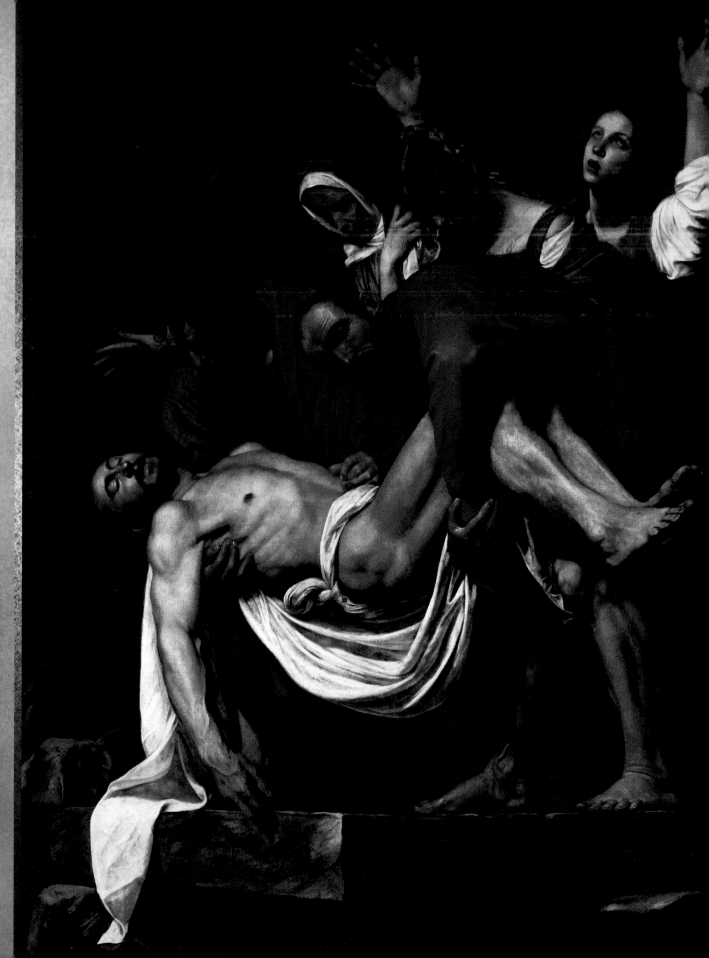

Michelangelo Merisi da Caravaggio (1571–1610), known as Caravaggio, painted this masterpiece circa 1600–1604 while in Rome. Caravaggio was a protagonist in a revolution of light and shadow, creating sharp tenebrism and focusing on singular light sources to create dramatic scenes. His gestural and lifelike figures lit the canvas with their stark realism, making him the most important of the seventeenth-century realist painters.

# THE DEPOSITION OF CHRIST

Michelangelo Merisi da Caravaggio
Vatican Muscums' Pinacoteca
Circa 1600–1604

**THEME:** Death

**FOCUS OF THIS MEDITATION:** Feel the pain that Jesus' disciples experienced when they lowered Christ from the cross. Jesus was faithful until the end. We now stop and give thanks to God, who sent his beloved Son to liberate us from sin and death.

◀ This painting, also referred to as *Deposition From the Cross* and *The Entombment of Christ*, was commissioned by Alessandro Vittrice for his family's chapel in Santa Maria in Vallicella, a church built for the Oratory of St. Philip Neri.

A Counter-Reformation painting, this representation was both revolutionary and widely admired by critics and devotees alike. Built around a diagonal cascade of characters, this work depicts the many stages of grief known by mourners, onlookers, and those bearing Christ's body to the tomb. Characters portray emotion as the limp, lifeless Christ is placed on a cold stone: the sorrow and acceptance of Mary of

Clopas and Mary of Nazareth, John and Nicodemus resolved yet grief-stricken. Finally silence ensues as these faithful ones face the death of God.

Caravaggio's figures are inarguably gestural. Following the arms of the laborer we see a hand entering the wound in Christ's side, as if to emphasize the dead Christ's inability to feel pain. Meanwhile the grieving Mary Magdalene gesticulates to heaven in a stark contrast to Christ's limp body that falls onto cold stone. The Virgin herself is traditionally depicted as perpetually youthful, but the despair of losing her Son is written clearly here across her weathered face.

# SCRIPTURE MEDITATION

### LUKE 23:46–56

*Jesus cried out in a loud voice, "Father, into your hands I commend my spirit";
and when he had said this he breathed his last.*

*The centurion who witnessed what had happened glorified God and said,
"This man was innocent beyond doubt."*

*When all the people who had gathered for this spectacle saw what had happened,
they returned home beating their breasts;*

*but all his acquaintances stood at a distance, including the women who had followed him
from Galilee and saw these events.*

*Now there was a virtuous and righteous man named Joseph who, though he was a member
of the council,*

*had not consented to their plan of action. He came from the Jewish town of Arimathea and
was awaiting the kingdom of God.*

*He went to Pilate and asked for the body of Jesus.*

*After he had taken the body down, he wrapped it in a linen cloth and laid him in a
rock-hewn tomb in which no one had yet been buried.*

*It was the day of preparation, and the sabbath was about to begin.*

*The women who had come from Galilee with him followed behind, and when they had seen
the tomb and the way in which his body was laid in it,*

*they returned and prepared spices and perfumed oils. Then they rested on the sabbath
according to the commandment.*

*The light of God*
*illumines our true nature,*
*unveiling what is...noble.*

Caravaggio's painting *The Deposition of Christ* was both an altarpiece and a meditation on Jesus' death. Jerome Vittrice had just died when his nephew, Alessandro Vittrice, commissioned this piece for the family chapel in St. Philip Neri's Chiesa Nuova, located over the bridge that leads from the Vatican to the Tiber.

The traditional scene for the moment of deposition is altered by the artist, who chooses to focus our attention on the precise moment in which Christ's disciples rest the corpse on the stone slab for its anointing. Presuming that his body needs preserving, they perform the customary burial rite. Did they hope that Jesus would rise from the dead? Soon they will place him in the shroud and lay him in the tomb, sealing it with the anointing stone.

An immense darkness envelops the scene, hiding all that is in the background. The incandescent body of our limp Savior reflects light on the figures who witnessed his passion and death. The brilliance of the artist shines forth as he contrasts light and darkness to draw us into the scene. This tactic and hallmark of Caravaggio gives those viewing the piece a sense of the real drama experienced by Mary of Magdalene, John, Mary of Nazareth, Nicodemus, and Mary of Clopas. This revolutionary artist was the first to use this technique where light and shadow enable us to see 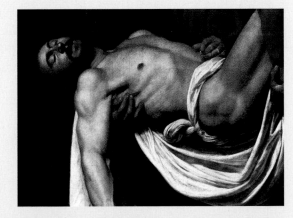 events as they are. So through the artwork, we likewise perceive a hidden spiritual truth for us.

Light has conquered darkness. Though the path was not easy, Jesus is victorious. When grace abounds and conquers sin in our lives, our moral stature testifies to the victory that Christ

gained on Calvary. We ought not shrink back from the light of Christ that we glean through our participation in the paschal mystery, that is, the life, death, and resurrection of Jesus that encompasses all of salvation history. When we abandon the grace and goodness of God, we keep ourselves from receiving the generous gifts bestowed on all children of the Father.

As we approach Christ and embrace the mystery, God bathes us in the merciful waters of sacramental grace. The light of God illumines our true nature, unveiling what is most noble and beautiful in each one of us. The source of light is not in us, but through grace Christ ignites our hearts with life—residing there within all who are baptized. Do not run from the cross, for it tells us of ourselves—our way to the Father. Learn with patience and courage to embrace, therefore, the malady of our beloved Savior who has made us whole, for Jesus is the true light that shines upon all of humanity.

Consider Nicodemus' courageous example. He was a just man who came to Jesus by night for fear of the Jews (John 3:1–21), but he now steps forward into the light. His burly figure and  weathered face show a man who has struggled and worked to accept the light, and now he holds the final prize in his hands. Jesus had taught that he did not come to condemn but to save, issuing these final words to Nicodemus: "But whoever lives the truth comes to the light, so that his works may be clearly seen as done in God" (John 3:21). The disciple witnesses and testifies to the light in this last scene before the burial of our Lord. Some would see in Caravaggio's Nicodemus the face of Jerome of Vericelli, the dearly departed one for whom the painting was commissioned.

Place yourself in the scene that takes place after the events illustrated by our artist. See Christ's body laid out. The men step back while the women approach and begin to cleanse away the sweat, dirt, and blood. Once done, they tenderly rub ointment onto his skin in order to preserve the body as well as possible. Delicate love and care now touch the flesh of Jesus, a contrast to the scourges, thorns, insults, and nails that were driven into his flesh just hours before. This remnant of faithful followers now mourn as they gently anoint the dead body of Jesus. Here they are lost in grief, as

the realization strikes them that death has vanquished the life of the one they loved. Mary is most absorbed in this final gesture of maternal protection. Where would her heart have gone? What memories of Jesus' life would have welled up there, producing tears in her eyes?

Mary of Clopas now rests her forehead on her hand, unable to look upon the lifeless body that once was her Savior. The light caresses her hand and shoulder while leaving her face downcast in a shadow of reflective mourning. Christ had revived lives but did not do the same for himself. He was no longer here—*where has he gone?*

This altarpiece also makes an unmistakable connection to the Eucharist. The priest elevates the host in consecration as he pronounces the words of Christ, *Hoc est enim corpus meum* (This is my body). *I am the bread come down from heaven, he who eats my flesh and drinks my blood will have life.* Christ has become the cornerstone of the temple, the people of God, and these words were not lost on Caravaggio when he painted this piece. The artist's message could not be more effective nor more easily understood. Christ is the stone rejected by the builders and has become the cornerstone.

Turn your attention now to John, the beloved disciple. As he holds the body of Jesus, his finger enters the wounded side from which blood and water had poured. John's gesture reminds us of Thomas, who finds his faith by touching the hands and side of Christ, declaring, *my Lord and my God.* Examine your faith. Do you believe Christ died for you?

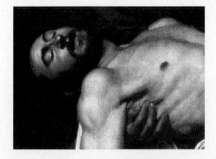

Even the angle of Caravaggio's stone reaches out to us, inviting us into the scene. John and Nicodemus lay the Lord on this stone that strongly resembles an altar. Christ is the rock on which we build our lives and the solid ground on which our feet are firmly planted. *Come to the cross—come to the banquet of the Lord*, the witnesses of Jesus' death beckon. *Will you follow Jesus, too?*

# PRAYER AND REFLECTION

Lord, your love has no limits. You have come to show us the way to God, completing your life by hanging on the cross as a testament to your love for us. Surrendering your soul to the Father, your body is buried. Help us to know your generosity that we also will be able to offer sacrifices ourselves out of love for others. Amen.

- Stay awhile with those faithful ones who have prepared Jesus' body for burial. How do their experiences teach you about the paschal mystery, that is, Jesus' life, death, and resurrection—the events that encompass all of salvation history, including the present? Do you believe that you, too, share in the cross of Christ? Why or how so?

- Imagine you are one of the figures in Caravaggio's painting. Why did you choose this figure, and what do you experience through him or her?

- Speak to Jesus tenderly as if you have lost your *pearl of great price*—the Lord—who has now died. Ask Jesus to enable your sight regarding this event as if it was taking place for you right now. Are you able to encounter the cross with the disciples of Jesus? Who do you see standing near you (disciples of the past, family members, heroes of the faith)?

## ~ Spiritual Exercise ~

- Jesus was faithful to the end. Pick one project that you are putting off because you do not like to do it and spend some time bringing it to completion.

# LIVING THE BEAUTY OF RESURRECTION

FROM THE CROSS, Jesus offers us new life. Likewise, our sufferings lead us into the loving embrace of Christ who is risen, triumphant! Jesus has conquered death and sin, and now he enables us to drink from the wellspring of life, basking and dancing in the Spirit of God. *Hallelujah, he is risen*, early Christians would sing to one another, and then respond, *he is risen indeed*. This truth made all the difference for early Christians who believed in a God who was alive, all-powerful, and able to overcome the oppressive forces that persecuted them. And if we are truly convinced of our faith, it will also be true for us today. This Easter antiphon is still chanted in the Catholic liturgy during the Easter octave to remind us of the joy, peace, and life that God offers us continually through the risen Christ.

Out of the tomb, we conclude this retreat by meditating on the resurrection. This twenty-eighth day, then, is also our eternal day because resurrected life has re-created us. The resurrection responds to all of the desires of our hearts, for though we experience suffering here on earth, our hope is to rise again into new and everlasting life. Three options are given for this twenty-eighth day, allowing you to choose the reflection of your choice for this final day of the retreat. Still, you are invited to come back to the other meditations in the months and years to follow.

Our hearts will burn, like those on the road to Emmaus, by allowing the resurrection event to seep into our hearts. *Wake up, O people of God, for you are invited to the banquet of the Lamb.* Allow this final meditation to bear fruit in your heart as Jesus speaks to you. *Come, my child, my friend, my beloved one.*

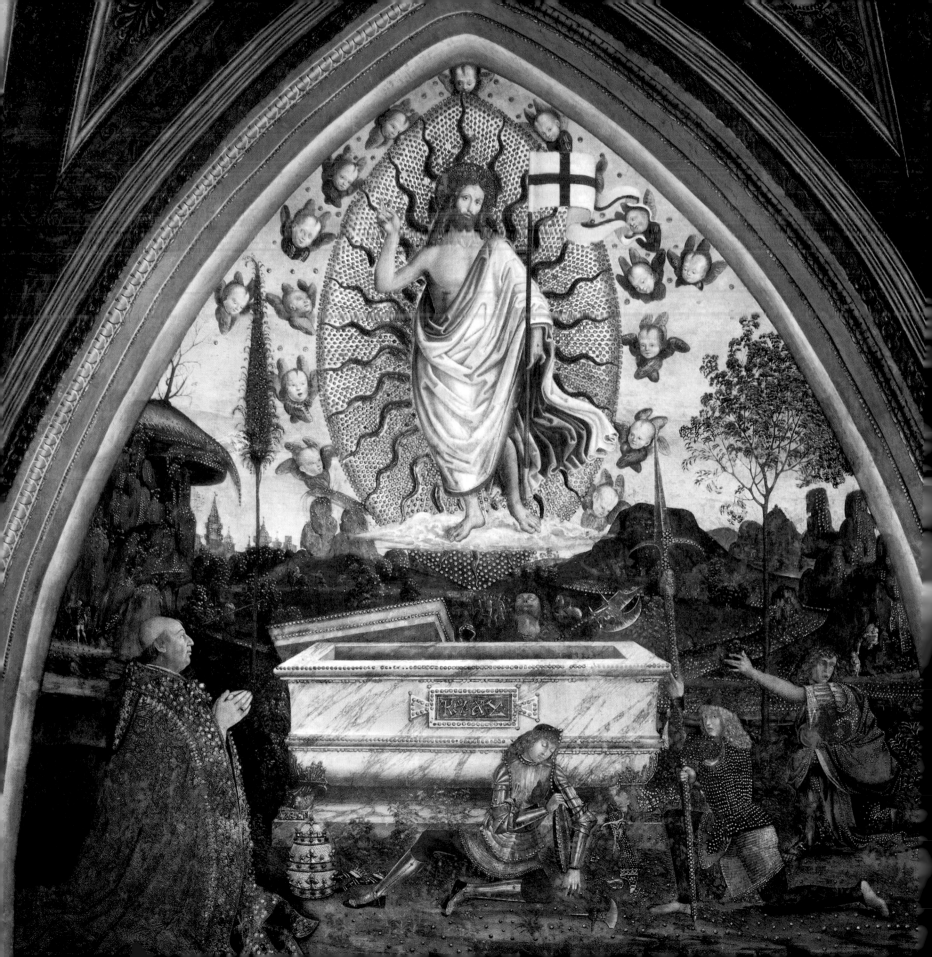

# THE RESURRECTION

Bernardino di Betto (Pinturicchio)
Room of the Mysteries of Faith (Borgia Apartments)
Circa 1492

**THEME:** Resurrection

**FOCUS OF THIS MEDITATION:** Let us immerse ourselves in the immense joy of Jesus Christ, who shares his glorious victory over sin, suffering, and death with all people. Having accompanied him through his life, passion, and death, we now celebrate his glorious resurrection. Our hearts overflow with life, having followed our all-powerful Savior, who has vanquished death.

◄ Bernardino di Betto (1454–1513), known as Pinturicchio, created ornate frescoes in the Borgia Apartments for Alexander VI between 1492 and 1494 using a variety of materials. The last room in these apartments illustrates the Mysteries of the Faith, which include *Annunciation, The Nativity, Adoration of the Magi, The Resurrection, Ascension,* and *Pentecost.*

Spanish culture and the personal taste of Pope Alexander VI are evident in these images. Pinturicchio had a reputation for ornate works, for the pope selected him for this task in order to beautify the rooms with artwork reflecting faith. The rooms are embellished with rich golden frames that surround the scenes on the walls and rib the ceilings. Even today the Borgia Apartments represent one of the major examples of "artistic taste" and style at the end of the fifteenth century, reflecting the magnificence of Alexander VI.

These unique works are augmented by the use of three-dimensional elements such as wax, leather, plaster, metal, and gold leaf. Several portraits of contemporaries appear in this room. *The Resurrection* portrays Alexander VI kneeling; the central soldier, with a lance, may be a portrait of Cesare Borgia.

# SCRIPTURE MEDITATION

## JOHN 20:1–18

*On the first day of the week, Mary of Magdala came to the tomb early in the morning, while it was still dark, and saw the stone removed from the tomb.*

*So she ran and went to Simon Peter and to the other disciple whom Jesus loved, and told them, "They have taken the Lord from the tomb, and we don't know where they put him."*

*So Peter and the other disciple went out and came to the tomb.*

*They both ran, but the other disciple ran faster than Peter and arrived at the tomb first; he bent down and saw the burial cloths there, but did not go in.*

*When Simon Peter arrived after him, he went into the tomb and saw the burial cloths there, and the cloth that had covered his head, not with the burial cloths but rolled up in a separate place.*

*Then the other disciple also went in, the one who had arrived at the tomb first, and he saw and believed.*

*For they did not yet understand the Scripture that he had to rise from the dead.*

*Then the disciples returned home.*

*But Mary stayed outside the tomb weeping. And as she wept, she bent over into the tomb and saw two angels in white sitting there, one at the head and one at the feet where the body of Jesus had been.*

*And they said to her, "Woman, why are you weeping?" She said to them, "They have taken my Lord, and I don't know where they laid him."*

*When she had said this, she turned around and saw Jesus there, but did not know it was Jesus.*

*Jesus said to her, "Woman, why are you weeping? Whom are you looking for?" She thought it was the gardener and said to him, "Sir, if you carried him away, tell me where you laid him, and I will take him."*

*Jesus said to her, "Mary!" She turned and said to him in Hebrew, "Rabbouni,"*
*which means Teacher.*

*Jesus said to her, "Stop holding on to me, for I have not yet ascended to the Father. But go to my*
*brothers and tell them, 'I am going to my Father and your Father, to my God and your God.'"*

*Mary of Magdala went and announced to the disciples, "I have seen the Lord,"*
*and what he told her.*

*On the evening of that first day of the week, when the doors were locked, where the disciples were,*
*for fear of the Jews, Jesus came and stood in their midst and said to them, "Peace be with you."*

*When he had said this, he showed them his hands and his side. The disciples rejoiced when*
*they saw the Lord.*

———————————————

We have spent several weeks meditating on the life of Jesus Christ: his birth, childhood, early public life, and finally his passion and death. But we would not be convinced of his divinity if he had not risen from the dead. Though his teachings were phenomenal, they would be void of true power. It is the resurrection event that proves to us that Christ is who he says he is—the Son of God—and what he taught was divinely approved.

Eyewitnesses gave their testimony about Jesus' resurrection. The tomb was empty. Peter saw and experienced the resurrected Lord on the seaside of Galilee. Mary Magdalene loved Jesus, but after witnessing his horrible death she was only consoled after having seen the Lord alive in the garden. And with renewed faith and love she ran to proclaim the good news to the apostles. Paul encountered the resurrected Christ on the way to Damascus and professed that *if Christ has not risen, our faith would be in vain.*

Every Christian is invited to experience the love and power of the risen Christ, who has conquered sin and death. Jesus calls us to fullness of life, joy, victory, freedom, and love. Though the cross is necessary, it is only because Christ has shown us the way to love that we will ourselves

to endure suffering and hardships. We follow him because he came that we might have life in abundance (John 10:10).

Imagine it is Easter morning, yet your heart is still heavy with grief. In the last few days you have lost the one you most dearly loved—the one who finally made the desires of your heart make sense. Mary of Magdala sadly saunters down the path early in the morning, for she needs to be near her Savior, even though she does not understand. Her only love has passed from the world, the one who knew her and nourished her soul by speaking words of everlasting life. One final gesture of love occurs to Mary: *I will change his linens once more.* But suddenly she realizes the tomb is empty. Surprised and perplexed, Mary runs to fetch Peter and John. The apostles look into the empty tomb and are likewise confused and amazed. Peter and John depart to bring other disciples to the tomb, and Mary is once again left alone to try to make sense of this moment.

Read the Scripture passage again, putting yourself in Mary's place as if you were there on that first Easter morning. Suddenly a person speaks to you, but you do not recognize the man. The voice is sweet: "Whom are you looking for?" Then, you hear your name: "\_\_\_\_\_", *I am here with you*, Jesus whispers. *Are you looking for me? Do not be afraid, trust my love, my mercy, my faithfulness. I have conquered all things!*

Think upon the events that came to be after Jesus had risen from the dead. On the same Easter morning, two followers on the road to Emmaus were animated by the news that the tomb was empty. But they did not recognize Jesus as he accompanied them along the way until he broke bread with them. The Lord appeared to the apostles in the upper room and on the Sea of Galilee, but Thomas was not there. Eventually Jesus appeared to Thomas, who touched Christ's hands and side. Jesus ate fish with his disciples by the sea. What do you imagine Christ's resurrected body to look like? Many did not recognize Jesus at first, but he had to open their eyes to see. Spend a few moments in prayer looking at the resurrected Lord. Then imagine yourself risen from the dead.

MEDITATIONS ON VATICAN ART

It is this living experience of Jesus that continues to attract followers today. *He is risen. Christ is alive.* Saints and martyrs through the centuries have found courage and life through the knowledge that Jesus has overcome all barriers in order to draw us to God.

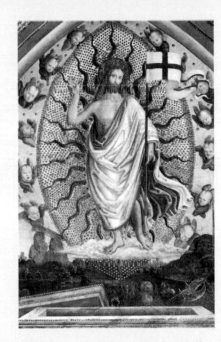

Now spend some time looking at Pinturicchio's fresco. *The Resurrection* is placed just over the main door in the Borgia Apartments. In a lovely flowering garden, the coffin is depicted as an altar, but the top is removed and placed behind the open grave. Christ floats atop the image, illustrating his victory over death. On the right, the pope kneels in adoration of this mystery that was as important in 1492 as it was near the sepulcher in Jerusalem, and furthermore is still today!

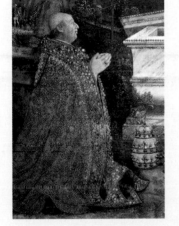

While Pinturicchio was painting his frescoes, Christopher Columbus was discovering the New World, having set sail earlier that same year. In fact, it is speculated that the first depiction of a Native American in European artwork is presented in this piece of art. It appears that news had reached the Vatican about discoveries of the New World. Behind the sarcophagus, notice a Native American looking upward to behold the glory of the risen Jesus.

Jesus' resurrection changed everything: The world is new. Christ, our hope, invites each of us to live his victory over the evils of this world and to trust that death does not have the final word. The risen one shares his glory with us, and we encounter him through prayer, worship, and the sacramental life of the Church. Rejoice, friends in Christ, because through our baptism we have become children of God: "For you have died, and your life is hidden with Christ in God. When Christ your life appears, then you too will appear with him in glory" (Colossians 3:3–4).

# PRAYER AND REFLECTION

Jesus, your faithful abandonment to the love of the Father has led you to new life. God has given you victory over the grave because you trusted in the Father's holy will. May we be graced to receive the Holy Spirit that was breathed on the apostles after you rose from the dead, descending also onto the disciples in the upper room. Come, Holy Spirit, teach us wisdom that we might understand the life you offer through our resurrected Savior. Amen.

⚜ Our lives on earth are brief, but God expects great things from all who are baptized. Do you believe in the resurrection of Jesus? If so, how has this dramatic event reshaped your life?

⚜ In Pinturicchio's painting some are watchful in prayer while others seem to have fallen asleep. If Christ were to return in glory today, how would he find you?

⚜ Recite the following nineteenth-century hymn as a personal prayer and invite Jesus to show you the way to God:

Prayer is the soul's sincere desire,
Unuttered or expressed;
The motion of a hidden fire
That trembles in the breast.

Prayer is the burden of a sigh,
The falling of a tear
The upward glancing of an eye,
When none but God is near.

Prayer is the simplest form of speech
That infant lips can try;
Prayer, the sublimest strains
That reach The Majesty on high.

Prayer is the Christian's vital breath,
The Christian's native air,
His watchword at the gates of death;
He enters Heav'n with prayer.

Prayer is the contrite sinner's voice,
Returning from his ways,
While angels in their songs rejoice
And cry, "Behold, he prays!"

The saints in prayer appear as one
In word, in deed, and mind,
While with the Father and the Son
Sweet fellowship they find.

No prayer is made by man alone
The Holy Spirit pleads,
And Jesus, on th' eternal throne,
For sinners intercedes.

O Thou by Whom we come to God,
The Life, the Truth, the Way,
The path of prayer Thyself hast trod:
Lord, teach us how to pray.

**JAMES MONTGOMERY, 1818**

## ⁓ *Spiritual Exercise* ⁓

⚜ Make a list of your primary fears and then speak to Jesus about them, asking him to provide you new confidence in his love for you and his power to assist in good times and in bad.

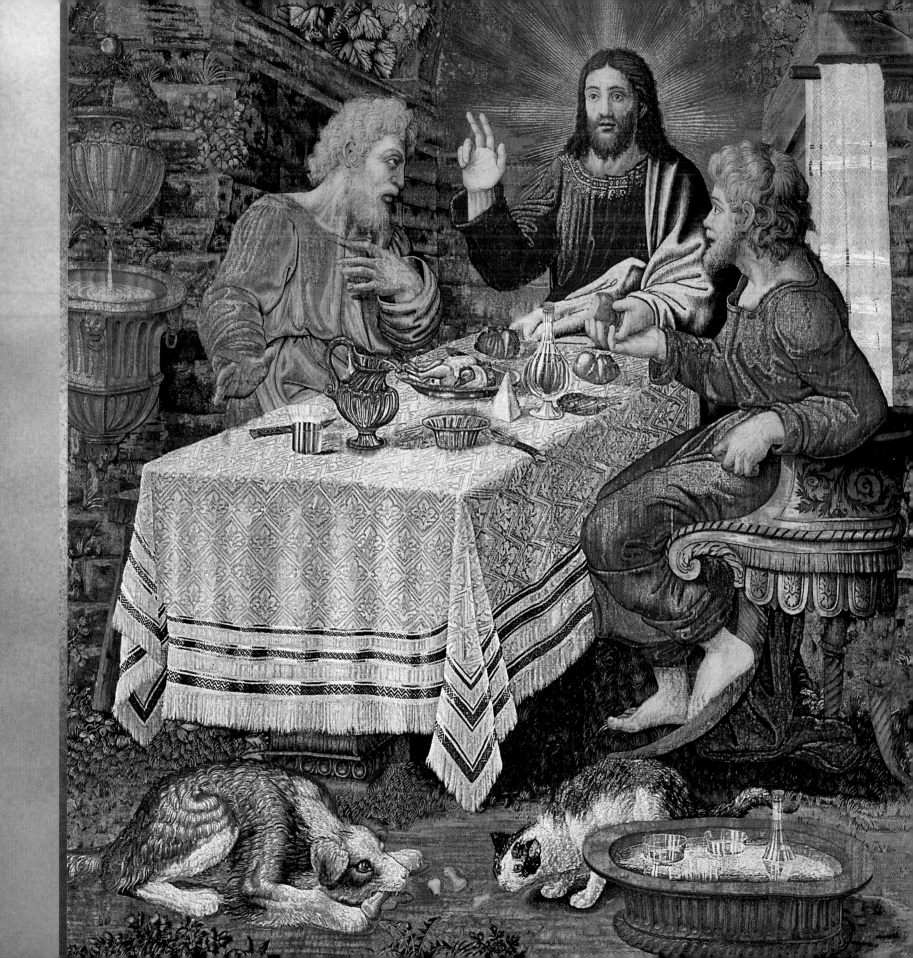

# JESUS AT EMMAUS

Workshop of Pieter van Aelst
From a cartoon by Raphael Sanzio
Gallery of Tapestries
Circa 1525

**THEME:** The road to Emmaus

**FOCUS OF THIS MEDITATION:** Jesus Christ walks the road to Emmaus with two disciples who were speculating about the empty tomb. For a time he accompanied them, teaching them about the Scripture, and their hearts were ignited by his words. We rejoice because God has unveiled to us in Jesus the mysteries of our salvation. Jesus will ignite our hearts with joy, if we but ask him to do so.

◄ Located in the Vatican Museums' Gallery of Tapestries since 1838, *Jesus at Emmaus* is one of the *Scuola Nuova* (new school) works. These tapestries were woven in the Brussels workshop of Pieter van Aelst from designs that Raphael's pupils created during the time of Pope Clement VII. The *Scuola Nuova* works were woven between 1524 and 1531 and comprise events in the life of Christ, including the Adoration of the Shepherds, the Adoration of the Magi, Jesus' Presentation in the Temple, the Massacre of the Innocents,

Jesus' Resurrection, his Appearance to Mary Magdalene, and the Supper at Emmaus.

The "new school" works are distinguished from the *Scuola Vecchia* (old school) works on display in the Vatican Museums' Pinacoteca that were woven in the Pieter van Aelst workshop from cartoons by Raphael drawn during the time of Pope Leo X.

# SCRIPTURE MEDITATION

## LUKE 24:13–35

*That very day two of them were going to a village seven miles from Jerusalem called Emmaus, and they were conversing about all the things that had occurred.*

*And it happened that while they were conversing and debating, Jesus himself drew near and walked with them, but their eyes were prevented from recognizing him.*

*He asked them, "What are you discussing as you walk along?" They stopped, looking downcast.*

*One of them, named Cleopas, said to him in reply, "Are you the only visitor to Jerusalem who does not know of the things that have taken place there in these days?"*

*And he replied to them, "What sort of things?" They said to him, "The things that happened to Jesus the Nazarene, who was a prophet mighty in deed and word before God and all the people, how our chief priests and rulers both handed him over to a sentence of death and crucified him.*

*But we were hoping that he would be the one to redeem Israel; and besides all this, it is now the third day since this took place.*

*Some women from our group, however, have astounded us: they were at the tomb early in the morning and did not find his body; they came back and reported that they had indeed seen a vision of angels who announced that he was alive.*

*Then some of those with us went to the tomb and found things just as the women had described, but him they did not see."*

*And he said to them, "Oh, how foolish you are! How slow of heart to believe all that the prophets spoke!*

*Was it not necessary that the Messiah should suffer these things and enter into his glory?"*

*Then beginning with Moses and all the prophets, he interpreted to them what referred to him in all the scriptures.*

*As they approached the village to which they were going, he gave the impression that he was going on farther.*

MEDITATIONS ON VATICAN ART

*But they urged him, "Stay with us, for it is nearly evening and the day is almost over."
So he went in to stay with them.*

*And it happened that, while he was with them at table, he took bread, said the blessing, broke it, and gave it to them.*

*With that their eyes were opened and they recognized him, but he vanished from their sight.*

*Then they said to each other, "Were not our hearts burning [within us] while he spoke to us on the way and opened the scriptures to us?"*

*So they set out at once and returned to Jerusalem where they found gathered together the eleven and those with them who were saying, "The Lord has truly been raised and has appeared to Simon!"*

*Then the two recounted what had taken place on the way and how he was made known to them in the breaking of the bread.*

———————————————

Two travelers are walking toward their hometown from Jerusalem when Jesus finds them along the road. They are animated about the events surrounding the empty tomb, wondering what sort of oddity it is that it is empty—and witnesses are reporting seeing visions of angels.

Place yourself alongside these two and join them in their conversation. It is likely that the two are disciples of Jesus who want to make sense of things. *Has someone stolen the body of Jesus? Could it be true that the women have truly seen a vision of angels? And if it is true, what does this mean?* Their confusion is tangible, their hearts distraught. But perhaps they are looking for a sign to keep their hopes alive. As twenty-first-century followers of Christ, we sometimes miss how extraordinary the resurrection and the events leading up to it must have been for those who believed that Jesus was the promised one of Israel.

Discussing the events along the road is more than a mere curiosity for them. It is a means to comfort one another and try to make sense of it all. As followers of Christ, their hopes were dashed when Jesus died on Calvary. With the tomb empty, they are attempting to make sense of the scandal of the cross and the fear that is overtaking them. *What if Jesus was just a man—a great man but merely that?* Struggling to believe, they question: *What is taking place here?* How often are

our hopes crushed by those moments when our prayers seem to go unanswered, when tragedy strikes, or our trust is betrayed?

And now a stranger suddenly appears, his footsteps approaching from behind these two travelers. They hear him draw near to them. Instead of walking past, he begins to join in the travelers' conversation. *What are you discussing?* Jesus asks them. The travelers are appalled to hear that Jesus does not know what is taking place in Jerusalem. Yet they seize the opportunity to fill the stranger in on these hot topics in the city they just left. While they unburden their hearts by sharing the story of Jesus, the Lord patiently listens to them.

They speak of Jesus the Nazorean—not Jesus the Messiah or Son of God. In their present speech, Jesus is merely a man from a small town. Although he appeared to be accompanied by signs and wonders, it turns out he was not what they had hoped. Another prophet had come to Israel; but not the Messiah.

The companion who has joined them is God, but the men's eyes are blind to see the risen Lord in their midst. God does not often come to us in a way we expect. We encounter Christ in the brokenhearted, the downtrodden, the poor child, or the annoying office mate. And revelation comes through prayer as we tune our hearts into *the still, small voice of God.* These travelers have lost hope, their faith dimming even as they try to console one another. The mystery of the cross was yet to be resolved by the experience of the resurrection. Still it had to be this way. How could anyone comprehend the resurrection of Jesus if it were not revealed to them?

So the Lord begins to interpret the Scriptures for these would-be disciples on the road to Emmaus. The Scriptures come to life as Jesus interprets the Law and the Prophets in order to help them understand what he had to do in order to bring salvation to all. As he speaks so passionately, their hearts begin to blaze! *So maybe we are not mistaken after all….But how can all this be?* Jesus' passion and death is too much without the resurrection.

When they arrive in Emmaus, their new friend states he will continue along the road. But the travelers insist—as we also should in prayer—that Jesus "stay with us!" *We need your presence to enlighten our faith, inspire our hope, and inflame our love,* they tell the Lord. Jesus accepts. There is nothing Christ desires more than to be with his disciples whose faith is weak. He has promised to be with us for an eternity.

Pieter van Aelst's tapestry depicts the moment that the disciples of Emmaus realize who Jesus

is. Jesus is both physically present at the table in his human form and about to be sacramentally present in the breaking of the bread. As the bread is being broken, the disciples finally realize they are with the one about whom they were speaking. And their hearts overflow with joy as they come to understand. He is risen! Jesus is alive!

God is always present to those who seek the Lord with all their hearts. Our crosses are transformed by the resurrection of the promised Messiah. *Come, Lord Jesus*, inflame our hearts with your love.

# PRAYER AND REFLECTION

Jesus, fear and discouragement sometimes take hold of our souls. Even though we have seen your love and have the advantage of knowing the whole story, at times we lose focus. The joy you offer in the Eucharist and nurture through prayer is lost in the distractions of our lives. But we rejoice knowing that when we pour out our hearts and confide in you, you always hear us and bring us joyfully back to you.

⚜ Look at the tapestry and regard how suddenly the two travelers are able to see the risen Lord. One points to himself while the other holds Christ's hand. Does the resurrection cause you to question yourself or to reach out and touch Jesus?

⚜ Spend a few moments meditating on the Eucharist. Jesus is fully present to us in the breaking of the bread—his life, death, and resurrection. How has the Eucharist shaped your life?

⚜ Recite your own resurrection prayer, considering the events that unfolded in first-century Jerusalem, comparing these to how Jesus has arisen in your own heart and life circumstances.

## Spiritual Exercise

⚜ How is Jesus especially present in your life? Through the sacraments? Through those who love you? Thank Christ for his presence and resolve to be more present to him.

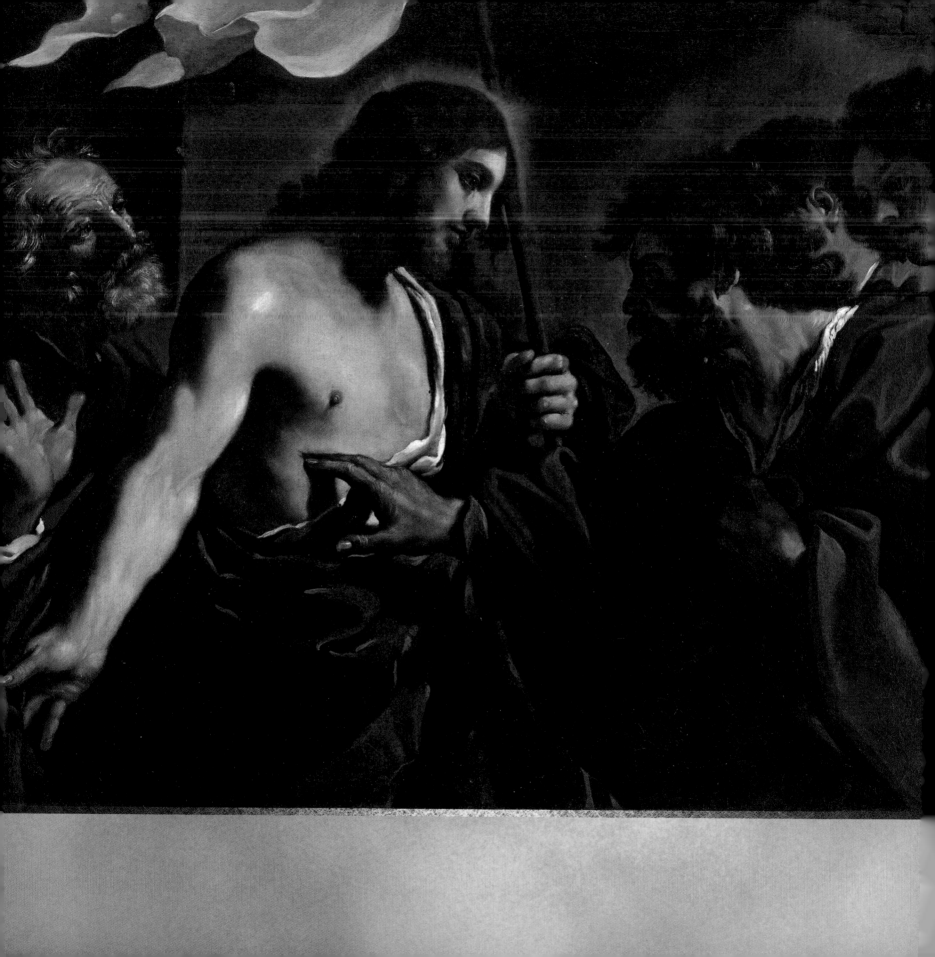

# THE INCREDULITY OF ST. THOMAS

Guercino (Giovanni Francesco Barbieri)
Vatican Museums' Pinacoteca
Circa 1621

**THEME:** A meditation to attain love

**FOCUS OF THIS MEDITATION:** We desire to obtain a real and personal knowledge of Jesus Christ's love in our lives. May Christ become the center of our lives in a new way. Motivated by the experience of the love of Jesus, we strive to love him in return through out thoughts, actions, words, and desires.

◄ Giovanni Francesco Barbieri (1591–1666), best known as Guercino, was an Italian Baroque painter. His lively and luminous style is similar to that of Caravaggio, and his later works have a likeness to those of Guido Reni.

An Italian aristocrat, Marchese Enzo Bentivoglio, recommended the artist to Pope Gregory XV. Guercino thus came to Rome, where he created some of his best-known works. After the pope's death, Guercino returned to the North and eventually became the main painter in Bologna after the death of Guido Reni.

# SCRIPTURE MEDITATION

## 1 CORINTHIANS 13:1–13

*If I speak in human and angelic tongues but do not have love, I am a resounding gong or a clashing cymbal.*

*And if I have the gift of prophecy and comprehend all mysteries and all knowledge; if I have all faith so as to move mountains but do not have love, I am nothing.*

*If I give away everything I own, and if I hand my body over so that I may boast but do not have love, I gain nothing.*

*Love is patient, love is kind. It is not jealous, [love] is not pompous, it is not inflated, it is not rude, it does not seek its own interests, it is not quick-tempered, it does not brood over injury, it does not rejoice over wrongdoing but rejoices with the truth.*

*It bears all things, believes all things, hopes all things, endures all things.*

*Love never fails. If there are prophecies, they will be brought to nothing; if tongues, they will cease; if knowledge, it will be brought to nothing.*

*For we know partially and we prophesy partially, but when the perfect comes, the partial will pass away.*

*When I was a child, I used to talk as a child, think as a child, reason as a child; when I became a man, I put aside childish things.*

*At present we see indistinctly, as in a mirror, but then face to face. At present I know partially; then I shall know fully, as I am fully known.*

*So faith, hope, love remain, these three; but the greatest of these is love.*

# When did you first experience the love of Jesus?

———————————————————

This meditation crowns our twenty-eight days as it focuses our hearts on experiencing God's love for our souls in a whole new and highly personal way. In our daily lives, when we focus on Jesus' love, we experience new life and are energized by the glory of the Lord.

In this meditation to attain love, St. Ignatius invites us to take inventory of all the ways in which God loves us. Our love is a response to God's love. When we have been loved, we are capable of loving. It is because someone loved us that we are able to say, "I am loved." Look on the ways God has loved you. When did you first experience the love of Jesus? Was it the kiss of your mother or father on the first day you entered the world, your baptism, the myriad moments when a friend or family member cared for you? Love cannot be forced, but when we are open, we can hear Jesus whisper: *You are my beloved one!* Open your soul and consider your life in faith, directing your attention to the love God has bestowed on you in Christ Jesus: "In this is love: not that we have loved God, but that he loved us and sent his Son as expiation for our sins" (1 John 4:10).

Take a moment and consider your personality. What physical and spiritual qualities do you have, what virtues and talents do you possess? Though these attributes might be a great good, they are not what make you lovable for God. For the Lord has formed you, gifting you with certain strengths and talents. You have been created to love and be loved. And God loves every unique part of you. Rejoice, O children of God, for your names are written in the book of life.

Reflect upon all that God has given to you. The surrounding beauty of creation, your family and friends, your daily work, peace of mind, a nourished heart. All of these have been offered by our loving Creator. The Lord provided humans with five senses. We see rays of colors and have eyes to see. Textures allow us to feel different sensations when we encounter persons and things. The food we eat and the liquids we drink provide us a taste for the living God, as we delight in

these gifts that nourish our bodies. In nature we hear a symphony of sounds that direct our senses to heaven, and music reaches the very center of our souls, drawing us even unknowingly to God, who made us. Though some of us do not possess all of the five senses, the Lord has heightened our interior senses to see what others cannot.

Let us also consider the spiritual graces God has showered upon us. The grace of baptism enables us to experience the life of the Blessed Trinity. Jesus died on the cross so we may have life in abundance. The sacramental life of the Church enables God's children to remain in his love. And finally, the Lord has provided a community of believers who help to strengthen and enhance our faith as we make the long journey to the heavenly Jerusalem.

Each person in your life is a gift of God: your family, friends, colleagues, and even your enemies. These are each a unique expression of God's love and care for you. God only wills the good for your life but does permit evil. Though God does not desire evil for us, sin exists, and we sometimes experience the hurt caused by others who have not yet become perfect in love. Furthermore, there are certainly moments that are beyond our understanding, as is the case in the tragic death of those we dearly love. But through the hardships in our lives, God allows us to know spiritual liberation, enabling us to forgive and be forgiven.

The love that God has for your soul is personal, attentive, and tender. Recall moments in your life when you have wondered if God is truly there. And then, all of a sudden you are graced with the light of God's love. A gentle touch from a friend, a new job opportunity, an unexpected gift; though small, the gesture is just enough to help you keep the faith. Even when you turned your back to God, the Lord remained with you, whispering: *I love you!*

What does God ask in return for all he has given us? The Lord simply asks that we *go and do likewise, love one another as I have loved you.* We each touch another's life in a personal way, and God is inviting you to share your life with those most in need of Jesus' love. "Whatever you give me outside of yourself does not interest me; for I do not seek the gift but I seek you" (*Imitation of Christ*

IV, 8). Our small, faithful acts each day draw us ever closer to the one who is constant in his love for us. Let us pray with St. Ignatius this humble prayer: Take Lord, receive all I have and possess. You have given all to me and now I return it.

All of these gestures of Christ's love can be summed up in the painting *The Incredulity of St. Thomas*. Turn your attention to the beautiful image of St. Thomas, who peers into the wounded side of Christ. Jesus comes to Thomas in his need to believe and offers him all the evidence he can. Each of the gifts you have received are divine efforts to help you peer into his heart and see his love for you. We are all tempted to doubt and wish we could "touch" Jesus more in our lives. Like Thomas, we also know Jesus. We have seen his works, his miracles, and have listened to his words that have generated new life in all. Yet we have suffered and need confirmation of his love and resurrected presence in our souls. In the time of prayer that remains, review all the graces you have been given and strive to be near to the heart of Jesus, who loves you so much.

*Take Lord,*
*receive all I have and possess.*
*You have given all to me*
*and now I return it.*

# PRAYER AND REFLECTION

Lord, we wish to know the goodness of your love for us. Thank you for your constant love. Even while we were blind to your presence, you were always faithfully awaiting our affections. Take our hearts, Lord, and give us a renewed appreciation for your love.

- Imagine you are Thomas. Others have seen the Lord, but you have not. How does it feel to be an outsider to others' experiences of God? And when Jesus finally appears to you, what do you experience?

- Do you believe you are eternally loved by the risen one? Follow the example of Thomas, who though he doubted, accepted finally that he was also beloved uniquely by Jesus.

- Spend time in quiet, offering a prayer of thanksgiving for the life, death, and resurrection of Jesus.

## Spiritual Exercise

- Make a list of all the ways in which God has loved you by giving you so many gifts in different areas of your life: personal talents, material gifts, spiritual graces, etc. Think of persons, places, and things that are gifts and occasions of God's grace. Keep this list handy so you can go back to it regularly and remind yourself how immensely God loves you!